Paul Klee

Figures and Faces

Margaret Plant

Paul Klee
Figures and Faces

131 illustrations, 31 in color

Thames and Hudson

Library of Congress Catalog card number: 77-92270

Color plates originated in Switzerland by Clichés Lux,
Neuchâtel, and printed in Great Britain by Balding & Mansell,
Wisbech

Monochrome filmset and printed in Great Britain by BAS Printers
Limited, Over Wallop, Hampshire

Contents

Acknowledgments

The early stages of this study were directed by Professor Leopold Ettlinger and the late Franz Philipp, of the University of Melbourne.

Publication was made possible by the University of Melbourne Publication Committee; the Faculty of Arts Research Fund and the Department of Fine Arts, University of Melbourne; and the Visual Arts Board of the Australia Council. To these bodies I owe particular thanks for active support and encouragement, as also to Mr Laurence Course and Professor Joseph Burke of the Department of Fine Arts, University of Melbourne.

Acknowledgment is made to the Pro Helvetia Foundation, Zürich, and the Paul Klee-Stiftung, Berne.

I owe a debt of gratitude to readers and typists for fortitude, care and wit expended in the preparation of the manuscript: in particular Brian Thompson, Anna Denton, Dr Denise Ryan and Erwin Rado.

My grateful thanks are due to Mr Felix Klee for supplying photographs and for his great patience in dealing with queries; without his help, many of the illustrations in this book could not have been found.

The debt to the late Franz Philipp is very great, not only for his attention to the manuscript, but for his inspirational teaching and his particular encouragement of my interest in the interaction of the arts. It is to his memory that this book is dedicated.

Note on References

Numerals given in parentheses in the text are page numbers in Paul Klee, *The Diaries 1898–1918* (edited and with an introduction by Felix Klee), University of California Press, 1964. Arabic numerals in the margin refer to black and white illustrations, Roman numerals to colour plates.

Introduction: Klee's Allegory

Klee's way with nature has received much attention: his use of a line set in motion to capture the processes of growth, his famous escort offered to the line that goes for a walk.[1] We have some understanding of the way in which Klee stands in that poetic German tradition that focused on nature and her processes, stretching back to the enquiries of Goethe and Herder.[2] We are familiar with Klee the musician and we know of his readiness to find musical analogies in painting.[3] Although the most poetic entries in his diary have been extracted and published as utterances of the Dada poetry circle,[4] we rarely think of him in connection with a literary tradition, and only marginally in relation to drama and theatre. As a young artist, however, he made for himself a conscious, deliberate programme which aimed at expanding his knowledge of the arts, and his experience, in particular, of theatre and opera.[5] Between November 1911 and December 1912 he wrote regular reviews of art, music, opera and theatre as the Munich correspondent for his native Berne's magazine *Die Alpen*.[6]

During the time of this self-education, Klee was concerned in his art almost exclusively with the human face and figure. Nature was not an important subject. He set himself quite consciously the task of making a satirical and moral comment on human nature.

His taste in the arts was exceptionally broad, but his own early etchings, which constitute his first coherent body of work between 1903 and 1905, are single-mindedly satirical. They announce a preoccupation, to remain constant in his oeuvre, with the nature of male and female relationships and the view that human life is precarious and burdensome. For Klee saw man as 'a prisoner, half borne on wings', and his early perception stayed with him.[7]

Klee's diary contains many references to his reading and his theatre-going, especially between 1902 and 1909.[8] He had read the great classical dramatists and writes of them with familiarity: Calderón and Tirso de Molina, Shakespeare and Aristophanes, Molière, Goethe and Schiller, Chekhov and Gorki.

The special atmosphere of the theatre is suggested in one of the earliest theatre entries in the diary: in 1901 Klee went to the Dramatico Nazionale in

Rome to see Réjane, the legendary Parisian actress, who was at the height of her fame at the turn of the century. She played in a farce by Henry Becque, *La Parisienne*, an attack on immoral bourgeois life. For Klee, it was 'a walk through an almost forgotten world into a slice of actual life'. He described the pull of the theatre: 'As I entered . . . I was surrounded in the loges by fairy-tale apparitions like those in my early daydreams. A kind of melancholy came over me, as when listening to Schubert' (342). Some nights before in Rome, Klee had seen one of the greatest tragediennes of the time, La Duse, who played in one of her successes, D'Annunzio's *Francesca da Rimini*. Klee must have seen one of the first performances of the play.

His acquaintance with opera was wide – Donizetti, Verdi, Wagner, Berlioz, Gluck.[9] He was interested in contemporary opera, especially the works of Hindemith, which he heard during the Bauhaus years. He wrote in 1909 that the most beautiful opera since Wagner's death was Debussy's *Pelléas et Mélisande* (847). Many years later, in 1920, in a Bauhaus lecture on pendulums and movement, he said: 'Let us take a very long hair (one of Mélisande's), attach a dead weight, and let the hair hang slack . . .'.[10] But Klee's favourite composer was Mozart. *The Marriage of Figaro* was 'that incredible work' (743) reaching 'the very highest level of ethos' (765). 'A quintet as in *Don Giovanni* is closer to us than the epic motion of *Tristan*' (1081).

Many of Klee's comments concern the performance and are of a musical kind. He himself played in the Berne orchestra, and wrote of 'the little *Così fan Tutte* overture, that most wonderful of works' (598). There are many reminiscences of his musical evenings at the Bauhaus, and we know of his attendance at an opera just before his death.[11]

As well as being an avid reader of *Weltliteratur*, Klee was greatly interested in the drama and theatre of his own time. He was at work during the fervent period of German Expressionism, with which he is often linked.[12] He read and attended plays by Strindberg, Oscar Wilde, Ibsen and Wedekind that were almost contemporary, and were considered revolutionary in their investigations of human relationships.[13] His diary notes in 1903 his intensive reading of the older German dramatist Hebbel, and he comments on the pointedness of Hebbel's investigations of male–female relationships, of the 'affinities of the lady with the bestial'.[14]

Klee's *Dance of Salome*, his *Pandora's Box* and his frequent fables of domestic plight may relate to his reading of Hebbel's *Herod and Mariamne*, of Wilde, Ibsen and Wedekind. Klee's diary itself could reflect the inspiration of Hebbel's critical scrutiny of his own work in *his* diary, which Klee admired.

At various points during Klee's life it seemed he would become actively involved in theatre design. In 1913 he was a member of an association of

avant-garde artists calling themselves Das Münchener Neue Künstler-theater.[15] The war intervened. After his war service, he wrote for release saying that he anticipated a position as teacher at an art school in Berlin, and as artistic adviser to a modern theatre in Munich.[16] Neither plan eventuated. Later at the Bauhaus, where he was to spend such productive teaching years, he was invited by the Dresden Opera to do the décor for Mozart's *Don Giovanni*, long one of his favourite works. Once again the plan came to nothing.[17]

Though not directly active in the theatre, Klee was, for the greater part of his life, closely associated with artists with an active and individual interest in the stage. Around 1911 his friends in Munich, Kandinsky, Schönberg and Hugo Ball, were engaged in a new form of allegorical and Expressionist musical drama preliminary to the Neue Künstlertheater.

At the outbreak of war, Hugo Ball went to Zürich and became a key performer at the Dada Cabaret Voltaire. The *Gesamtkunstwerk* recommended by Ball and Kandinsky for the Munich theatre was achieved in the Dada soirées, tossed off in a spirit of challenge and invention.[18] The cabaret was the ideal venue for artists preoccupied with performance and with finding an immediate public for their art. Indeed the literary cabaret was central for the entire formation of German Expressionism,[19] and moulded the music of Schönberg, who composed his revolutionary material amid the circle of Der Blaue Reiter and the Neue Künstlertheater.

Kandinsky was very much the father-figure of this Munich painter–theatre circle. In his seminal *Concerning the Spiritual in Art*, published in 1912, he wrote on the theatre as well as painting. Klee noted while reading it: 'the boldest [of his circle] is Kandinsky who tried to act by means of the word' (905).[20] To the *Blaue Reiter Almanac* Kandinsky contributed an involved and somewhat confused essay called 'On Stage Composition', and the draft of a play called *Der Gelbe Klang* (The Yellow Sound).[21]

Much of this stage theory is elusive and 'Kandinskian', but it is an important document of a painter's interest in the stage. It also had an affinity with (and probably influenced) the stage compositions of Schönberg, especially *Die Glückliche Hand* (The Lucky Hand). Schönberg's work, thickly symbolic and expressive of the 'inner spirit', used many of the effects recommended by Kandinsky, such as 'colour–light'.[22]

Hugo Ball also wanted a dance-like theatre of colour and light. 'From 1910 to 1914', he said, 'everything revolved around the theatre for me: people, love, morality . . .'.[23] He wanted the theatre freed from the strictures of the naturalistic stage: the false perspectives and the coulisses. He referred to the 'reform in the air'; admired Wedekind, Stanislavski in Moscow and Reinhardt

in Berlin. He wanted the sun and moon to 'run across the stage and proclaim their sublime wisdom'.[24]

Simultaneously in Berlin and Hamburg the Sturm Künstlertheater was being directed by Lothar Schreyer, with the similar aim of producing the total work of art which Schreyer called the *Einheitskunstwerk*.[25] Again Klee was in indirect contact, well aware of Sturm activities. He was a contributor to *Der Sturm* magazine and the *Bilderbuch* (Picture Book).[26] Schreyer's Sturm productions included some of the key works of early Expressionism: plays by Kokoschka, a pantomime, *Die Totem des Fiamettas* (Fiamettas' Totem), Kandinsky's *Der Gelbe Klang*, and the dramas of August Stramm. Schreyer produced, too, his own archetypal pantomimes *Kindsterben* (Child Death) and *Der Tod* (Death), with much use of mask and dance.[27]

The Bauhaus stage renewed the concerns of the Munich artists, the Zürich Dadaists and the Sturm. The director was first Lothar Schreyer, then Oskar Schlemmer. Both were concerned with the creation of a theatre of dance, light and colour. Walter Gropius as director of the Bauhaus gave the theatre importance in Bauhaus activities, both as a course of instruction and as an architectural problem.[28] The Bauhaus itself stood for synthesis: for the *Einheitswerk* of the performing and decorative arts. The 'total stage' was to embrace all aspects of spectacles; it was to return theatre to its ancient function of ritual; it was to feature the marionette and the informal entertainments of vaudeville, circus and cabaret.[29]

From 1921 Klee taught at the Bauhaus. He lived next door to Kandinsky, and witnessed the events of the Bauhaus theatre. He, too, gave to his simulated figures the artificial and theatrical guises of stage performers, the shape of the puppet and its manipulative strings, and the facial covering of the mask. Most of Klee's figurative drawings and paintings, and, indeed, many of his nature paintings, have a sense of the exposé upon the stage, and of the rising of the curtain. Figures – and even plants and flowers in 'nature's theatre' – are presented frieze-like or frontally, often in a spotlight, as if on a stage. And the personae are of the theatre: clowns, acrobats, equilibrists and harlequins, ballet dancers and characters from opera, like Fiordiligi.

Klee periodically returned to the theme of the new drama which he had witnessed in his twenties, to the bestial and instinctual nature of sex, which he often depicted as a juggling act: the fragility of balance epitomized by circus performers is paralleled by every human act of role-playing. Of course, such preoccupations are not the exclusive legacy of the dramatists. Artists like Munch, Beardsley, Franz von Stuck, Gustav Klimt and other Symbolists were similarly preoccupied.[30] In the Munich and Vienna of the Jugendstil period we find the themes of many of Klee's very twentieth-century paintings.

He offers us a visual prognosis of our current vogue for 'sexual politics', and anticipates much of current psychology's interest in human behaviour as role-playing.

Klee's interest in exposing hidden aspects of character was early attested by his exploration of the masked face, one face on top of another, posing the question of which is the truer. He was interested in the emergence of the face growing out of a web of lines, with distortions to indicate aberrations of character. He uses some of the methods of physiognomic study and caricature, but the range of his masks is often close to the experimental theatre of his own time – to the Blaue Reiter circle, Futurist, Dada and Expressionist theatre, and above all, in the twenties, to the Bauhaus.

For Klee the years of the thirties, when he was dismissed from teaching in 1933 and was without citizenship in his native Berne – for the Swiss authorities considered his residence in Germany had been too lengthy – were marked with a dual sense of both his own illness and the illness of Europe.[31] His work expressed both a sense of threat and a new intensity in nature studies. The flowers and the parks were portrayed with broad and glowing colour, and greater scale and texture of surface. The characteristically fine line became broadly black and ragged, a slab of paint rather than a line. It is in these textured and boldly-coloured works that Klee's inspiration for the Abstract Expressionist movement may be glimpsed.[32]

Yet his work retains an aim of specific and often cruel comment, explicated through the titles. Whimsy and humour are only surface effects. The creative order of nature and its reliable re-blossoming give a sense of stability and of lyricism, but at the other extreme the looping drawings, people fragmented and disembodied, and the palette of red and black, threaten instability and collapse.

The meditations on creativity, the theory of logical picture-making, the paintings of nature's purgative and non-human radiance, are but one side of Klee's art. Always in close proximity is that witty and yet searing view of mankind tottering fraily across the earth. Klee's pictures are evidence of his fine consciousness of the equilibrist act of life.

1 From Comedian to Comedy

In 1906 Klee exhibited ten etchings in the Munich Secession. He sent them up from Berne with instructions to his fiancée to have them framed in a single frame, 'otherwise the jurors might pick the collection apart' (764). It was also a saving on transportation. The etchings received very little attention, which did not surprise Klee. He had rejected their elaborate style and saw them as a completed first phase. Already he had set for himself the task of altering and simplifying his work. He was moving away from their self-conscious thematic preoccupations and was in search of a simple modern style.

Again the diary, and Klee's letters to his prospective wife Lily, give a full background.[1] Around 1901 Klee was reading Aristophanes and noted: 'Read early comic playwrights. . . . *The Birds* is quite delightful' (343). A few lines later: 'Long live Aristophanes;' some pages later: 'That Aristophanes! I wish I too might write a good comedy.' In 1902 he was travelling in Italy and was again reading Aristophanes. In the following year he returned to Berne and commenced his first *Comedian* etchings. They are provincial works, produced in a provincial centre. They are contrived, self-conscious, and set in fussy borders. They would be but a coda to the *fin de siècle* if it were not for the concern they show with the human condition.

The etchings were inspired by Klee's reading of Aristophanes, though not all of them can be directly linked to the plays. The mixture of fable and real life, the love of disguise and the association of the human with the animal and insect worlds, had a great appeal for him. From childhood he had loved spectacle and theatrical events. Comedy and satire were the literary forms to which he was drawn, and his inventiveness in these fields, not altogether common in the visual arts, is one of his unique offerings to modern art.

In the first ten years of his career Klee was almost exclusively concerned with the figure. Not until 1909 did he do a series of landscape drawings of Berne and the surrounding country which are the first concerted studies of nature in his oeuvre.[2] The preoccupation with nature seen close up came later, in the Bauhaus years when Klee's whole teaching theory cohered in the idea of developing linear elements as an analogy to the growth and unfolding of nature.

In accordance with academic practice, his first studies of the figure were drawn from life. Klee joined the private academy of Knirr in Munich in 1898 and worked there for two years.[3] Despite masters like Rodin whom Klee was to discover independently, figure drawing had come to be regarded as a dull academic process. Klee's early studies were academic and anatomical, but with an added bite. There are sharp pencil studies of parts of the body which examine the muscular structure, but give an added twist, as in the nude back view sprouting an animal tail.

Klee never produced a classical study of beauty. The genesis of a satirical attitude is first suggested in the diary in an account of his reactions to the ugliness of the model he was forced to draw. He writes of his recoil from the model: 'the ugly woman with the flabby flesh, bloated breasts, disgusting pubic hair – I am now forced to draw her with a sharp pencil' (65). An early anatomical drawing of an arm exaggerates the sinews and veins beyond the thin scraggy flesh. Diary comments increasingly show his awareness of deviations from the norm of the classical, so that it almost becomes a mission to exaggerate and deform. He was quite sure, in 1901, that he was 'on the side of satire' (294), and later confidently observed that 'dissertations could be written about the significance of the ugliness of my figures!' (618).

The idea that ugliness was a servant of beauty was a popular notion at the time. Arthur Symons, for example, had observed in 1898 of Beardsley that his 'sacrifice . . . [was] really the sacrifice to eternal beauty and only seemingly to the powers of evil . . . because he loved beauty [its] degradation obsesses him'.[4] The human figure, as caricatured by Beardsley and Klee, was further attacked as a viable subject by German artists during these years. Franz Marc, Klee's later associate, had said, 'very early in life I found man ugly: the animal seemed to me more beautiful and cleaner'.[5] Hugo Ball, that central figure in Dada Zürich, whom Klee came to know in Munich, wrote in 1917: 'The human figure is progressively disappearing from pictorial art, and no object is present except in fragmentary form. This is one more proof that the human form has become ugly and outworn and the things which surround us become objects of repulsion.'[6]

On his Italian journey of 1902, Klee found himself torn between a love of classical art and his estimate of himself as counter-classical, already a 'baroque' artist. In being drawn to the classical world he was also forced to reject it more thoroughly. He acknowledged its intoxication: 'I own a series of the most beautiful photographs of ancient statuary. I never tire of spreading them before me. It purifies me of certain desires' (340). 'My hatred for the Baroque after Michelangelo might be explained by the fact that I myself notice how much I have been caught by the Baroque until now. . . . I feel

drawn back to the noble style without being convinced that I shall ever get along with it' (290). But his own service to the classical world is clarified more and more as a rejection: 'the service of beauty through drawing her enemies'.

While in Italy, he studied anatomy with medical students. He was still intent on mastering the figure, but he observed with distaste: 'I am going to draw nudes along with the provincial painters, from a horrible model dragged in from the hills' (453).

It was not, however, the life class or the example of the past, but the lesson of the present which influenced Klee to find a way on from the distaste for realism. In Rome he saw Rodin's drawings of the nude. They impressed him with their economy of style and with what he saw as the caricature and exaggeration of their conception.[7] 'Above all Rodin's caricatures of nudes! Caricatures! A genre unknown before him. The greatest I have seen were among them, a stupendously gifted man. Contours are drawn with a few lines of the pencil' (413).

A further counterbalance to the classical tradition came through the Art Nouveau work of Beardsley. Klee saw his work in the Munich print museum during 1904 and observed that 'his style is influenced by the Japanese and is thought-provoking' (578). He himself later became more particularly interested in the Japanese linear style, and so placed himself among those artists of the previous fifty years who had found lessons in abstraction in Japanese graphic art.[8] He was contemplating a new sparse style even while he was working on the intricate etchings. In other words, during their very execution Klee was constantly appraising his works, and looking for a more economical form of expression.

Skirting naturalism, digging beneath the surface, he wrestled first with a new presentation of the face. It had to be a mask; not the primitive mask which was to attract so many early twentieth-century masters, but the mask as an accoutrement of the theatre, accomplishing the theatrical task of clarifying character.[9] Like many other artists at the time searching for an *alter ego*, he assumed that he, the artist, wore the mask and participated in the actor's process of revelation. In 1908 he wrote, 'I am an actor in the middle of the circle' (806): one of the many comments that underline his sense of distance from the world of ordinary human endeavour. Like Mondrian and Kandinsky, and before them Gauguin and the Nabis, Paul Klee saw the artist's task as that of the prophet.[10]

Klee wanted to be detached, he strove for an uninvolved vision which he himself called 'cool romanticism' (951). He aspired to be 'an observer above the world' (713) and had earlier noted in one of his many character-assessment comments: 'Individuality is not an elementary sort of thing, but

an organism. Elementary things of different sorts co-exist in it, inseparably. If one tried to separate them, the components would die. *My self, for instance is a dramatic ensemble*' (638, my italics). The profile mask studies, which begin the suite of etchings, are visualizations, heavily symbolic, of the revelatory nature of the artistic act. The two faces one on top of the other imply that the top façade can be peeled back, with the artist's knowledge, to reveal the true face underneath. The mask is joined to the head so that it has grown to become part of the brain and skin, physically attached.

The *Comedians* are revelations of character, and they are the first of Klee's many physiognomic works, with features of exaggeration reminiscent of earlier physiognomic studies by Hogarth, Blake and William Horton.[11] They are also examples of his early preoccupations with the grotesque and with anti-classical effects. He renders them almost obsessively in a meticulous etched technique with much detail and modelling.

The first *Comedian* reveals his inner face as dark and brooding in contrast to the mask. The eye is hooded and overhung, the mouth sewn into the downward lines of the chin. The overlaid mask is open-eyed, with light skin, upturned mouth. It is a Dorian Gray change of face that charts the inexorable road to ugliness.

Klee's diary gives an account of this work, with a precise statement of his intention and of the underlying philosophy that determines the theme:

New engraving: The Comedian, First version. Grotesque mask on a grave, moral head. Accompanying the reading of Aristophanes' comedies. Unfortunately I could not resist the temptation to use the scenery of this grandiose theatre in an engraving. . . . The mask as the work of art; behind it, the man. (517)

In this commentary Klee makes one of the first statements related to his famous 1918 'Creative Credo' that 'art does not render the visible, rather it makes visible'.[12] It was in tune with his reading of Oscar Wilde and his approving quotation of Wilde's 'all art is at once surface and symbol'. For Klee in 1903 'the lines of the mask are roads to the analysis of the work of art' (618). It not only reveals character in man, but it is the very character of art. Klee approaches his inner vision through study of anatomy and of physiognomy in order to understand the point of distortion. He was later to say that physiognomy showed the connection of vision with 'the cerebral functions of feeling'.[13]

A variation on the same face is the second *Comedian* – a satyr-like mask sprouting two ears, close to the world of the animal to which Klee will return. It is an inscrutable half-smiling mask, again attached to an under-face which has a grimacing mouth and upturned eye.

1

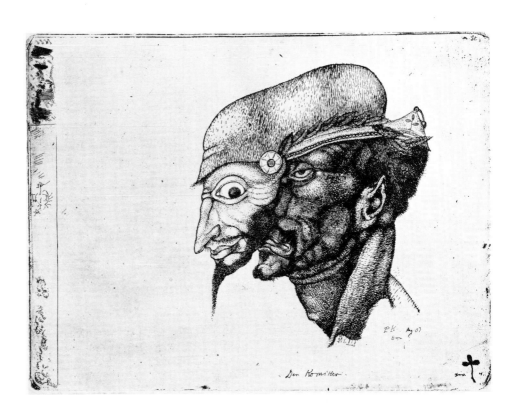

1 *Comedian*, 1903

2 *Comedian*, 1904

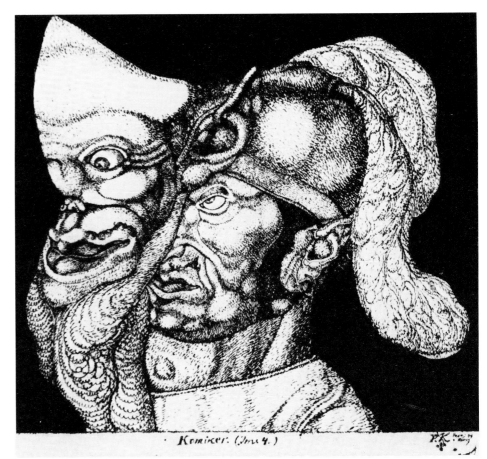

The second *Comedian* bares his teeth and turns his mask mouth upwards; the mouth underneath turns down. The third *Comedian*, of 1904, appears with the lower face stern, as if the calm upper face were a visor to be lifted. This dissembler wears an extravagantly plumed hat which gives him an aristocratic and proud silhouette against a dark and emphatic aquatinted ground. The mask is deformed, the nose squashed, but the eerie voluptuous lips are smiling. As with the early faces, the fine lines of the head are shadowed in many brief strokes that spiral into a nasty skin-like beard.

2

Although Klee's inspiration was Aristophanes, the visual form of the etched masks does not suggest the Greek theatrical mask. Klee's masks were simplified and firm in contour, unambiguously tragic or comic: his return to Greece is in spirit rather than form.[14] His visual presentation is closer to the skin-merging masks of Goya, who had seen that the mask could become a physiognomic study. Goya also used it (as Klee would later) in scenes of carnival and burlesque to suggest disguise and social role-playing. In 1905 Klee wrote, 'I turn my eyes towards Spain where Goyas grow' (602). One thinks of Goya's 'beauty, reason and caricature', the satires of Spanish courtship, the floating ladies with butterfly heads, the animal features taking over the bestial humans, and the basic intent to create satirical scenes and allude to the moral through titles.[15] Klee turned also to the literature of Spain. It is not surprising that *Don Quixote* was his favourite novel, and that he had read Calderón's *The Marvellous Magician* and *The Alcalde of Zalamea* (561). No doubt he was also familiar with Calderón's *The Grand Theatre of the Universe*, one of the classical statements of the ancient theatrical metaphor of the world as a stage: the *theatrum mundi*.[16]

Klee considered *Perseus* (*Wit has Triumphed over Misfortune*), of December 1904, to be a sequel to the *Comedians*. There are two heads – Perseus, full face, and the Gorgon, with the profile revealing the nose squashed into the cheekbones. The diary comment fully documents the work:

3

This new Perseus has dealt the sad dull monster Misfortune the death blow by cutting off its head. This action is reflected by the physiognomy of the man whose face functions as a mirror of the scene. The underlying marks of pain become mixed with laughter, which finally retains the upper hand. Viewed from one angle, unmixed suffering is carried *ad absurdum* in the Gorgon's head added on the side. The expression is stupid, rather, the head robbed of its nobility and of its crown of snakes except for some ridiculous vestiges. (582)

Perseus is still very much in the late nineteenth-century tradition of grisly and exotic heads, which seek to turn the viewer to stone. Franz von Stuck, Klee's teacher, had earlier produced his Medusa head with its exotic wig of snakes.[17] By focusing on Perseus rather than the Medusa, Klee may have believed that

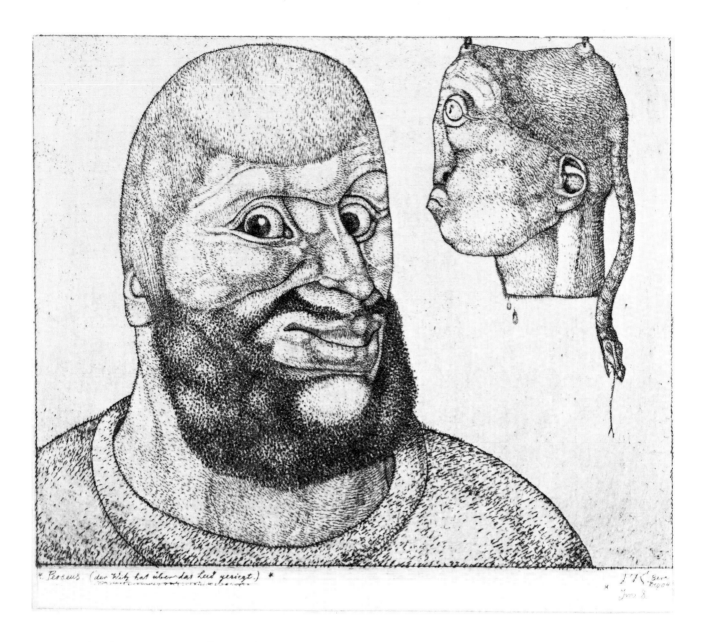

Perseus (der Witz hat über das Leid gesiegt.)

3 *Perseus (Wit has Triumphed over Misfortune),* 1904

he was freeing himself from heavy grotesque effects: his search now is for 'the dominance of laughter'. But this is not yet to be achieved, for exaggeration, deformation and caricature are vicious visual tools, with magic power to distort. Perseus, usually handsome, is given the face of a Gorgon, and the etcher's needle bites at the skin of his face; the Perseus beard and shaven head register barbed punches from the burin.

The primitive mask – African or Oceanic – so inspiring for French artists like Picasso and Derain around this time, is relatively unimportant to Klee, although he had drawn primitive totems as early as 1896.[18] Later, in his work during the Bauhaus years, the geometricized features of the primitive mask do suggest themselves, but in the early oeuvre the influence of primitive art is

remote. *Threatening Head* (March 1905) is the closest Klee comes to a negroid head, but equally it might appear like the masks worn by the devil in medieval miracle plays.[19] The head is fully frontal, and burdened above in a Goya-like manner with a little antlered rodent: 'Some hopelessly destructive thought or other, a sharply negative little demon above a hopelessly resigned face' (603).[20] It is not unlike later works that disclose a mental image inside the head, with the brain transparent and set with birds or genitalia. *Threatening Head* is the first intimation of the peeling-off of the entire scalp, rather than merely the face, to reveal secret thoughts.

The final head from the early works announces Klee's typical characterization of woman, a *fin de siècle* inheritance that shows her as a brute of insidious and destructive charm. *Charm (Womanly Grace)* (July–November

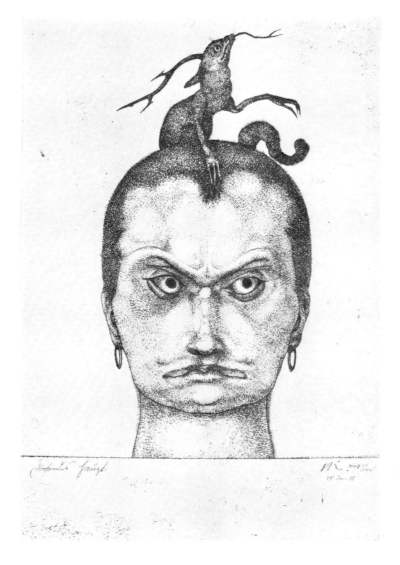

4 *Threatening Head*, 1905

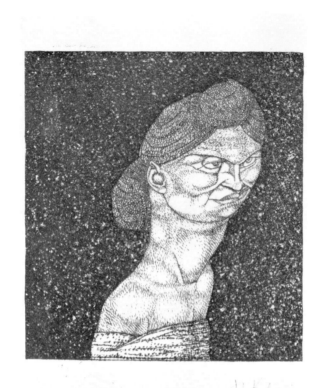

5 *Charm (Womanly Grace)*, 1904

(charme (weibl. Anmut))

1904) is a three-quarter bust against a heavy Goyaesque aquatint: a thoroughly unattractive creature with lopsided mouth, surely the result of the perpetually inveigling process of her smile. Its caricatural point is similar to that of the *Virgin in a Tree* of the previous year, and to the work which immediately follows: *Woman and Animal* (November 1904). Performing against a sombre aquatint is the woman, a creature with legs ingrown into horrible and convoluted pulp. She stretches her quasi-elegant tapered hand, holding a flower to the ear of the deer-like creature that follows her, aspiring to the delights indicated by her other hand. The woman is clearly the aggressor: a creation of a bachelor artist.[21] In general the etchings are in the company of those graphic comments in erotic vein by Max Klinger, Félicien Rops and Alfred Kubin. Klee's interest in Rops was specific enough for him to list, in 1906, works of Rops that he admired (708).[22] But Klee's themes range beyond their eroticism and sexual aggression.

Hofstätter, in the only detailed study of the caricatural intent of these early works, has emphasized that a recoil from and a criticism of bourgeois habits, particularly of bourgeois sexual behaviour, are a common spring for the satire of the late nineteenth century. A similar impulse – easily documented in

6 *Virgin in a Tree*, 1903

7 *Woman and Animal*, 1904

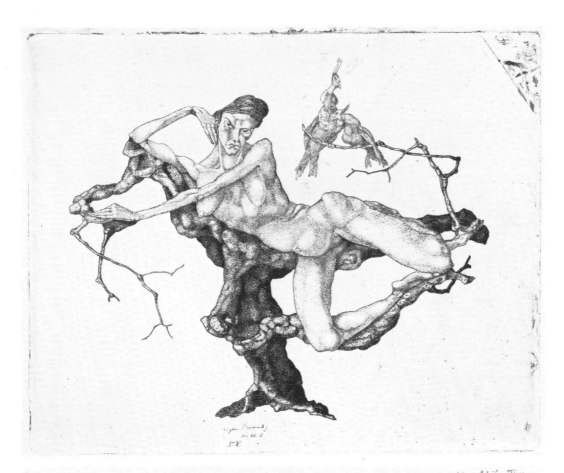

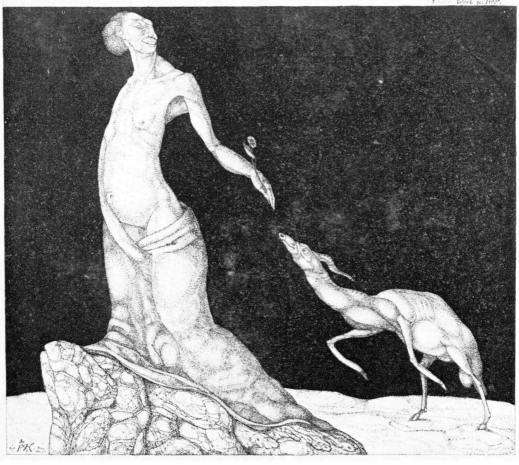

Klee's diary – lies behind these works.[23] The sinking flesh of the virgin in her tree and the woman leading the animal is also dragged over the bones of the male actors, but they are allowed, or are preconditioned to expect, more heroic things.

In two works Klee satirizes rank and sycophancy: *Two Men Meeting, Each Presuming the Other to be of Higher Rank* and *Man Bowing before a Crown* (December 1904). *The Aged Phoenix*, the five-hundred-year-old figure with Aristophanean bird trappings, Klee stated to be the direct result of a further inroad into the exchange of roles of man and animal. He was reading Ovid's *Metamorphoses* 'in an old bilingual edition from the German Artists' Library in Rome' (601).

The last etching was *The Hero with One Wing* (January 1905), the proudest of the early figures, glued to his plot of earth. He is waiting, with severe mien, for his hand which is in a sling to become a second wing and allow him flight. He is like the hoop-la Aristophanean bird who is a pathetic but almost successful translation of human into winged being. Klee saw him as

A tragicomic hero, perhaps a Don Quixote of ancient times. The man, born with only one wing, in contrast with divine creatures, makes incessant efforts to fly. In doing so, he breaks his arms and legs, but persists under the banner of his idea. The contrast between his statue-like, solemn attitude and his already ruined state needs especially to be captured, as an emblem of the tragicomic. (585)

8 *Two Men Meeting, Each Presuming the Other to be of Higher Rank*, 1903

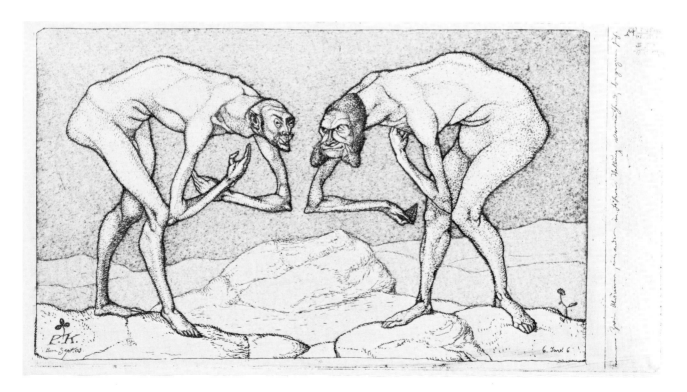

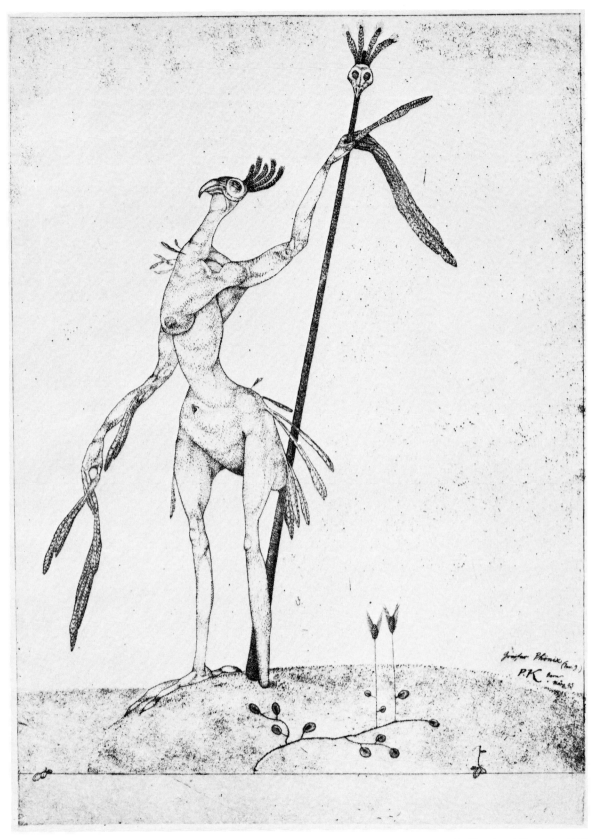

9 *The Aged Phoenix*, 1905

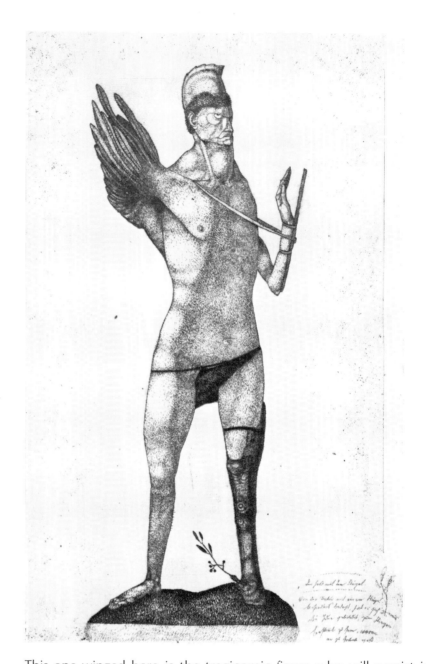

10 *The Hero with One Wing,*
1905

XI

This one-winged hero is the tragicomic figure who will persist in different forms as the major protagonist in many a Klee work, living out the essential allegory of man's aspiration and his tenuous balance on earth. He is the model for the later *Equilibrist,* of 1923, when all remnants of classical dignity will be stripped from him, and his fragility and his inevitable fall will be spelt out in his very delineation.

In June 1905, Klee wrote that he was relatively satisfied with the etchings, 'but I cannot go on in this way' (632). From as early as 1900 it was clear to him that a detailed and intricate style was alien to his true direction. He appears to have been heavily influenced by the economies of the German satiric style, as

seen in the journals – so characteristic of Munich – like *Simplicissimus* and *Jugend*, and perhaps by the memory of that famous graphic critic of the middle class, Wilhelm Busch.[24]

Klee actually submitted drawings to *Simplicissimus* in 1906, though they were not published, and even earlier he had been ambitious in that direction:

From time to time I collapsed completely into modesty, wished to produce illustrations for humour magazines. Later I might still find time to illustrate my own thoughts. The results of such modesty were more or less sophisticated technical-graphical experiments. (105)

This statement precedes Klee's first thin-line transparent drawings – the graphic style that would form the basis of his mature style – by some two years. 'Modesty' and 'humour' were to determine the development of his figurative style. Linear scaffolds, worked out on separate sheets prior to full paintings, belie the notion of Klee's working process as one of quaint involuntary improvization. Even with the most sophisticated of his colour works of the 1920s the mapping-out process was done in drawings.

One of Klee's key figure paintings of the 1920s is called *Comedy*. This is a measured parade of strange creatures, upright and apparently human, but with bird, animal and plant parts as well. It is a metamorphosis that one might call Aristophanean. The 'chorus' enters with great formality and parades across the stage. The players wear phallic costumes and some of them are disguised in animal masks.[25] VIII

Around 1918 Klee had painted various 'bird dramas': landscapes with mountains and fir trees seen very far away in bird's-eye view.[26] But *Comedy* returns emphatically to earth, to make more direct comment on the *comédie humaine* and to show how the traps and snares of the bird world also await humans.

The title of the painting is ironical, the content is explicitly sexual; the figures are ordinary 'girls', women rendered small and childlike, and through this childishness removed from the direct bitterness of tragedy. Three drawings – all studies of the promenading girls, and relating directly to the painting – make the meaning clear. *Concerning the Fate of Two Girls* (1921) has a time-sequence across the page, a dramatic action revealed through the repetition of figures who are linked by a 'psychological line'. All pictures must in fact be 'replete with spiritual and physiognomic nuances which run the whole range from tragedy to comedy', as Klee said in his Jena Lecture 'On Modern Art'.[27] Klee observes the fate of his figures in time: the width of the sheet of paper is a condensed dramatic scale displaying the whole comic and catastrophic direction of their lives.

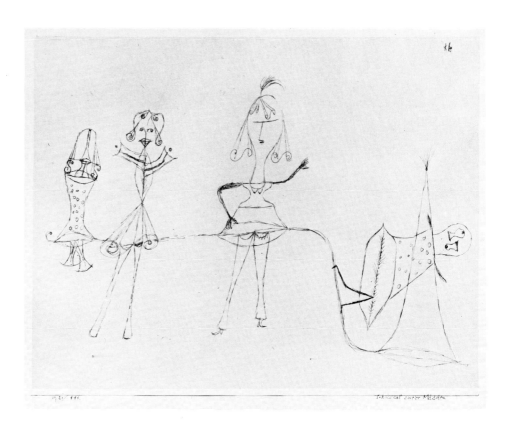

11 *Concerning the Fate of Two Girls*, 1921

These girls in the grip of fate are vulnerable figures with insignificant eyes and carefully embroidered hair (made of treble clefs – curls that came naturally to Klee the musician), and they stand with gesticulating, welcoming arms and transparent, high-lifted skirts, displaying themselves before their audience. On the right of one figure her 'fate' is drawn as a line from the base of her skirt. It sharply declines to bear the weight of another toppled figure, the same girl later in the time-sequence. One upward-turned skirt is in fact a giant vaginal symbol of lips marked with a fine hairline. The left-hand girl is not engaged in such extravagant display, and her fate is not yet at such a cataclysmic point. She enters disadvantaged, faceless and armless, and is given, in her second appearance, limbs that are still atrophied, permitting less possibility of alluring action, so she is spared the specific fate of her friend.

The final painting, *Comedy*, is less direct, but the point is similar. It is a more numerous Aristophanean chorus, a kind of *Lysistrata* enacted by birds and left-over humans. A little to right of centre is a blind phallus figure with a curved head and a long shaft body on small legs. On the left the fated two girls reappear with vaginal armour. An actor from the bird world, half-male, half-female, tramples a smaller vaginal-skirted creature. The right-hand figures are totems: all are combinations of opaque draped skirts and eyes

26

masked by 'sunglasses', hybrids with parts joined on upside down so that the sexual organs function as blind hunting heads.

Two much earlier works with similar titles precede *Comedy*. One of the rare paintings done in the period of the etchings is *Comedy, Two Figures, One Adult, One Child* of 1905. It is an allegory of youth and adulthood, of the adult's power to move and the strictures to which the child is subject. It might be a kind of visual equivalent of Wedekind's *Frühlingserwachen* (Spring Awakening). The female figure trips, large-hipped and gaunt, with a flower in her hand, but the child's movement is blocked by a high skirt. It tries to branch out, to assert itself, with a Redon-like aureole around its head and a flower in its hand. In 1920 came *End of the Last Act of a Drama*, with human actors not yet animalized and without the clearly bestial figures of the next year's *Comedy*, but with the plot and the strata of action already there. The woman is clearly the victim – a reversal of her role in the early etchings. Stretched across the ground as if on a rack, she is the support for a promenade of dapper males and a cat, all taking a walk across her, underneath two seeing-eyeball suns.

12 *End of the Last Act of a Drama*, 1920

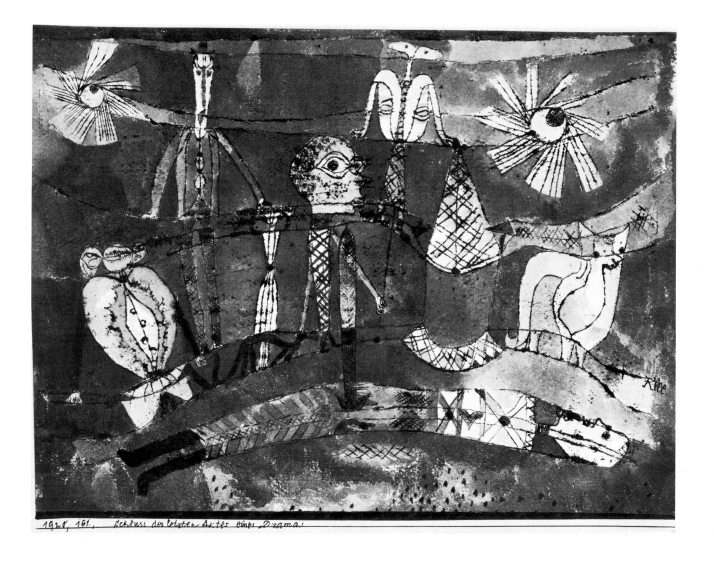

More and more, historians recognize the impact of the *fin de siècle* period on the themes and forms of diverse modes of modern art.[28] Constant in Klee's work is the theme of degenerate human types on the brink of tragedy, and the key figure is often the woman. She is the traditional vortex of the moral calamity, in Gustav Klimt's *Tragedy* of 1890 and the *Sin* of Franz von Stuck, as much at home in Munich as in Vienna. Both male and female are victims in Klee's mature works of the twenties. In 1901 he had commented that 'sexual helplessness breeds monsters of perversion' (170), and grimly imagined 'a symposia of Amazons, and other horrible themes. A threefold cycle: Carmen–Gretchen–Isolde.' In 1903 he projected pictures called *Disgust* and *Shame* (480), and such post-Munch exercises as *The Dead Genius* and *Mama and Papa Lament over the Green Cadaverous Child* (507). His awareness of family and social strictures, of the sexual drive independent of emotional commitment, is an awareness won in part from the insights of the theatre from Hebbel to Wedekind.

Though Klee's own documentation of his literary preoccupations ceases, the theatrical influence is further confirmed by the interest of artists with whom Klee mixed in Munich and Weimar: artists who were involved in an 'anti-naturalistic' theatre which was in the process of rediscovering older devices of puppet, mask and mime. Klee evoked the artificialities of the stage when the stage itself was rediscovering its traditional artifices, and breaking away – like painting – from conventions of naturalism.

For Klee, the presentation of the figure now becomes less naturalistic and leaves the overt theatricality of *fin de siècle* allegory. The theatrical becomes a theatre, the melodrama turns to comedy, introspection becomes humorous satire. The curtain – a symbol of the artifice of both art and life – is introduced to further point to the revelatory uncoverings of the artist. It is the traditional frame for tabernacle and icon, a seal of religious mysteries, and it is redolent, of course, of the magic of the theatre.[29] It takes the stage with the actor in one of Klee's most intricate and virtuosic line drawings – *The Realm of the Curtain*, of 1925. The bowing figure has the same labyrinthine construction of fine parallel lines that builds the curtain into something glorious and baroque with as much life as has the actor. This small drawing is perhaps Klee's most engaging tribute to the theatre.

In the major paintings the moral point is seldom forgotten. The background of *Comedy*, for example, is not dissimilar to the plain backdrops of the Schlemmer Bauhaus productions – a foil for the stage figures, giving a simplicity and abstractness to the sets in the manner of such innovators of modern staging as Gordon Craig and Adolph Appia.[30] Klee's *Comedy* has a background of striated washes in a murky evil brown, with the darkest band

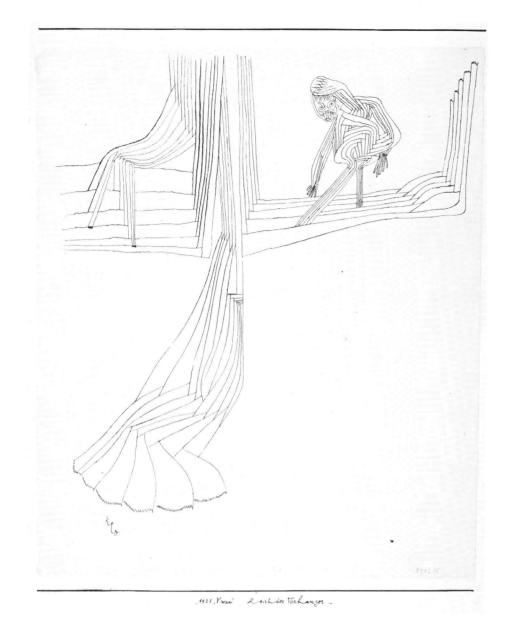

1925, Vwmi Reich des Vorhanges

13 *The Realm of the Curtain,*
1925

behind the heads of the figural frieze. The effect is a little reminiscent of the Goyaesque aquatints of the first etchings. It not only reflects the preferences of the avant-garde stage for a neutral setting, but symbolizes a moral opposition of the forces of darkness and light. As Klee wrote in his 1918 'Creative Credo': 'By including the concepts of good and evil a moral sphere is created,' and 'Art should be at home everywhere like a fairy tale: and it should know how to deal in good and evil, like the Almighty.'[31] His preoccupation with the exposure of ethical values is constant from early works until his death in 1940. The theme of exposé – of individual personality in the *Comedians*, of social situation in the etchings of men and women, their rank, sex and ambition – recurs throughout Klee's oeuvre.

2 The Mask Face

When producing the elaborate etchings of 1903–5, Klee was watching for 'the underlying marks of pain [to] become mixed with laughter' (582). But the etchings, as he recognized, are grotesque and repellent.[1] The form is too harsh; the comic is crippled by the weight of the grotesque, and the tension cannot dissolve.

Klee set himself the task of mastering a light graphic style. He experimented in various ways, observing through the wrong end of a telescope and drawing through field glasses, using a pantograph.[2] The reduced style which he so deliberately sought, even while working on the etchings, is seen in pen drawings of 1905 and 1906. *Soothsayers Conversing* (1906) retains the squashed Aristophanean profile with bared teeth and flattened nose, but it is clear in outline, without the complex burin work and detail of the etchings. Klee's 'reduction of means', as he himself called it, had of necessity to be accompanied by a simplification of facial expression. In his rather sparse and exploratory production between 1906 and 1910, he experimented with a basic schema for the head, which he rendered very quickly in ink on wet paper. The forms were indistinct, absorbed into the wetness. They were accompanied by precise verbal descriptions, such as

14 *Form in Light, Experiment in Colour, Very Blurred*, 1910

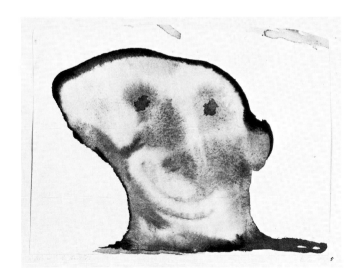

1906/33 Auguren im Gespräch

15 *Soothsayers Conversing,*
1906

Male Head, Youthful with Blue Eyes, and *Form in Light, Experiment in Colour, Very Blurred,* both of 1910.

Slightly earlier pen studies of the figure also show a severely reduced schema for representing the full form: an automatic pen line jerked around the subject in a highly nervous, very light outline. A sketchbook sheet of drawings of children (1908) employs this line to draw heads, dresses and legs in a single childish outline. It is an early instance of Klee drawing children in their own manner, and it points to one of his most obvious interests – reaching the innocence of children's art in both their style and their perception.[3]

16

Klee's interest was shared by others at the time. The *Blaue Reiter Almanac,* collected in 1911 by Wassily Kandinsky and Franz Marc, gave considerable weight to the value of children's art for the artist.[4] Reproductions of children's drawings appear opposite Bavarian folk paintings on glass and old German woodcuts, with theatre masks and shadow puppets and other evidences of the wide-ranging taste of the modern artist, seeking to slough off the tradition of formal naturalism in Western art. Klee preserved his own childhood drawings carefully, and he himself obviously desired, as he put it, 'to know nothing of Europe', to shed his formal academic training and revert to the

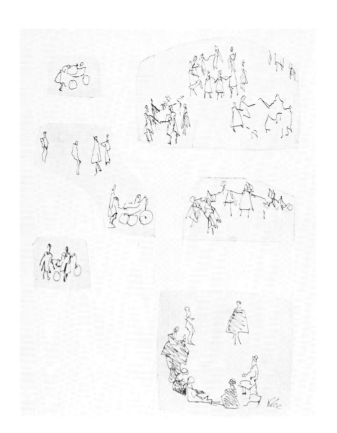

16 Sketches showing children playing out of doors, 1908

pure style of his first phase. He commented at the time of a Blaue Reiter exhibition: 'Do not laugh, reader: Children have artistic ability, and there is wisdom in their having it. The more helpless they are, the more instructive are the examples they furnish us; and they must be preserved free of corruption from an early age' (905).

Much, then, of the weight of Europe's rejection of naturalism underlies the interest of Klee and his friends in child art. Klee's apprenticeship as an artist was lengthy and self-imposed: on the one hand it was directed towards the ease of configuration of the child, and, on the other, to the direct expressive line of some modern masters. The example of the East, and of Japanese art in particular, was as important as that of the West.

Klee had continually alluded to the problem of line in his art in diary entries. In 1906 he observed that 'a work of art goes beyond naturalism the instant the line enters in as an independent pictorial element as in Van Gogh's drawings and paintings and in Ensor's graphics. In Ensor's graphic compositions the juxtaposition of the line is noteworthy' (842). It is, however, not only the linear means but also the subject of mask and carnival in Ensor's work that must have exercised a fascination for Klee. For Ensor was acutely aware of the allegorical nature of carnival disguises. His mother kept a shop which sold carnival masks for the famous Ostend fair, and for Ensor, who lived eccentrically among them, they must have symbolized a certain period

of annual farcical gaiety. He became so identified with his mask theme that he was caricatured in his studio crammed with masks.[5]

Ensor's work was widely known in Germany. Alfred Kubin, who had developed a jagged graphic style and had an extensive collection of Ensor etchings, was Klee's friend and supporter. Klee later sent Ensor examples of his work. 'In the rubbish of the studio after Ensor's death were two etchings by Klee (*Tragedy on Stilts* and *Street Urchins*). Klee must certainly have given them to the artist whose reputation for closeness was famous and deserved.'[6]

Ensor painted himself as a mask – with the face of Rubens – among masks, and a number of his works, most notably his large painting *Christ's Entry into Brussels*, show religion as a carnival. In his fine etching of a cathedral the very building shows signs of degeneration, as if it were unable to contain the crowd milling around it. In 1910, in a series of landscape drawings of Berne and Munich, Klee was to draw the Berne cathedral in a similar process of disintegration, although without the crowd.[7] He suggests a symbolic hysteria through the eaten and infirm outlines of the church itself. Interested in the incisive quality of Ensor's line, Klee took confidence in rendering his own line with more frailty and nervous twitch, allowing it to bite finely at the outline of the object. Ensor's dances of death, his carnival *memento mori*, are reflected perhaps in Klee's *Two Spinsters, Nude with Crests* of 1908, the year he commented on his interest in Ensor's line. The faces are grotesque masks,

17 *Two Spinsters, Nude with Crests*, 1908

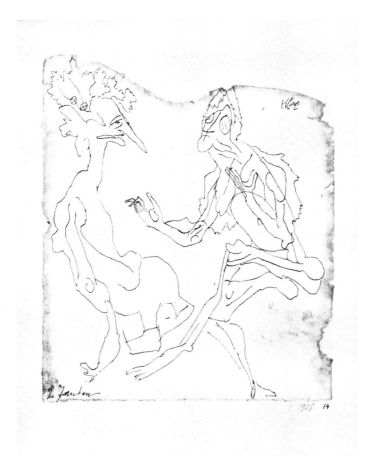

rendered in caricature style. The women have hanging chins and punchinello noses; they are prancing around; the woman on the right dances as a skeleton.

Emil Nolde, friend of both Klee and Ensor, gave to the mask a prime place in his body of work.[8] In 1909 he visited Ensor in his mask studio. After this visit, masks appear frequently in Nolde's work – among the earliest is the 1911 *Still Life with Masks*. Nolde, however, does not remain within the theatrical and carnival mask tradition, although his interest in the theatre was considerable and he records many theatre visits during his Berlin period.[9] But, in tune with the early twentieth-century interest, he looks eagerly at the masks of primitive civilizations. In 1911 he began to draw in ethnological museums, and in 1914 he made a voyage to German New Guinea. For Nolde the mask is a memento of an exotic civilization, a still life object, a collector's piece to be hung on the wall, like the Cubist musical instrument. He joins in the general Die Brücke fervour for the primitive, although he was early schooled in the grotesque faces of the Western decorative tradition, as can be seen in his early mask drawings which were done in St Gallen in Switzerland.[10] In many of his religious paintings the face is given brutal changes of projection, a high angularity, gaping mouth and wide eyes; *The Last Supper* of 1909 recalls the stark, close-packed faces in Ensor's *Christ's Entry into Brussels*, with those ambivalent qualities derived from the mask – vital, clown-like, yet frozen as if in death.

Klee's self-portraits, executed in his 'formative years' from 1900 to 1919, show the artist himself trying on the mask.[11] The first portraits are relatively naturalistic: artist with head in hand, the eyes strong and staring. A 1909 portrait, like other head drawings in that year, is a looser experiment on coloured sheets in pen and wash, accompanied by the customary description: *Self Portrait, Full Face, Head in Hand*. In the same year comes an even more loosely formed sketch in ink and coloured chalk. The artist sits at work beside a window, looking out at the external world. He leans away from the opening, and shares the dark brown colour of the inside world. *Youthful Self-Portrait* of 1910 is rendered as a ghost-like image by pale line, faint ink and a touch of shading: it comes closer to the unnerving confrontation with the frontal head. By 1911, naturalistic outline and proportion are regularly bent and distorted, the props of the external world eradicated: the face becomes a mask. The confident distancing of naturalism is well in evidence in the 1919 *Artist Meditating*. The body is shrunken, head and eyes are enlarged, and the artist's creative hand is stretched out, enlarged like a giant's in a close-up distortion. In that same year, *Lost in Thought–Self-Portrait–Portrait of an Expressionist* appears as the culmination of the self-portraits: an un-

19

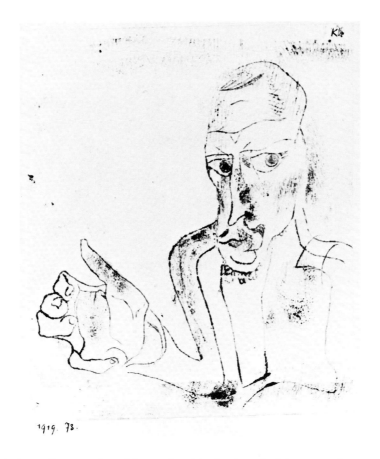

1919 73

18 *Artist Meditating*, 1919

ambiguously mask face, flattened and frontal, with the head oblong, and no form behind.

Many years earlier, in 1905, Klee had experimented with drawing his own face: 'Represent yourself without mirrors and without the kind of *a posteriori* conclusions that you get from mirrors. Exactly as you see yourself, therefore without a head, which you do not see' (664). A day or two later, he thought: 'If I had to paint a perfectly truthful self-portrait I would show a shell and inside it would have to be made clear to everyone – I sit like a kernel in a nut. This work might also be named: allegory of incrustation' (675). *Lost in Thought* resembles drawing experiments in perception executed when the eyes are half closed and the head is turned sideways. The subject's impression of his face is that it is looking forward, but it is flattened.[12] The eyes in this rendering are closed and the eyelids seam across the face. The eyes metaphorically turn inward; they are no longer peering like those in the eager young artist of 1909. Without needing two faces as in the *Comedians*, Klee has shown that the outer face is a covering for unknown thought. A pressure that is almost psychotic seems to force the retreat, as if the donning of the mask were necessary for the exercise of the artist's magical powers.[13] Indeed the

19 *Lost in Thought – Self-Portrait – Portrait of an Expressionist*, 1919

lithograph was made, as we will see, in a period when Klee was frequently portraying magicians. The depicting of the eyes joined to the frown gives much of the sense of extreme thought-pressure in the face, and Klee may well have drawn on the conventional schizophrenic tendency to focus on the eyes, for he had a specific interest in the art of the insane.[14] But he was also moved to express the romantic notion of the artist set apart. As early as 1901 he aspired 'to seek God among the stars' (176), and made a very confident prognosis: 'I am God. So much of the divine is heaped within me that I cannot die' (155).

His progression from 1901 to this portrait of 1919 had been modest and disciplined, but now he had confidently achieved the Symbolist's dream: in the words of Mallarmé, 'the spectacle of the inner world'.[15]

The fascination with the mask came about in both the theatre and the visual arts because of an increasingly felt need, particularly focused in the Symbolist era, to make clear the difference between the world of art and the world of natural appearances. The ordinary man does not know what he wears; actor or artist must tell him. Actor and artist don the mask deliberately and wear it with hieratic pride.

The mask also gives free rein to the tradition of the grotesque, and so expresses a marked pattern of taste in early twentieth-century art. A Munich friend whom Klee first met in 1911, Wilhelm Michel,[16] published a book called *Das Teuflische und Groteske in der Kunst* (The Diabolical and the Grotesque in Art), which draws its illustration from Goya, Ensor and Redon, and from primitive and Eastern art. The illustrative range is not unlike that of the *Blaue Reiter Almanac*. The mask and the tradition of the grotesque are linked by works drawn from all phases of the history of art, and are interpreted by Michel against a background of certain nineteenth-century literature which inspired modern fantastic art. Hoffmann and Poe are discussed at length, and Michel comments on Hoffmann's expression of pure fear in the classical tale of the automaton, *Der Sandmann*.[17]

As Michel describes it, the mask is a key symbol of a disguise which appears to eavesdrop on the soul.[18] It indicates the presence of an unknown spirit, but it is a false presentation simulating a reality that does not really exist. Michel acknowledges the charm of the mask, but observes how clearly that charm can turn to horror. One of its functions is to conceal the despair of life and also to disguise, as Klee had found, the connections between the inner life and its outward expression. As an example of the contemporary art in the grotesque mode, Michel reproduced Klee's early etching, *The Hero with One Wing* — one of the first of Klee's works to be reproduced. But the anthology also seems to offer an inspiration for an important later work, testifying once again to Klee's continued fascination with the mask and the continuity of his themes and forms over many years. Michel reproduced Hokusai's *Lantern Spectre*, one of the woodcut series for *A Hundred Tales*. It

10

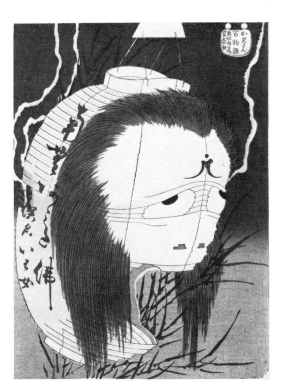

20 Katsushika Hokusai, *Lantern Spectre* from *A Hundred Tales*

37

appears to have a direct relation to one of Klee's finest mask paintings from the Bauhaus years: his *Actor's Mask* of 1924. This is not, of course, a literal borrowing. The turned face of the Hokusai Klee rendered frontally; the eyes of the mask are closed in the inward-turning manner of his self-portrait of 1919, *Lost in Thought*. The spectre's spikey hair becomes a sharp childish haircut, surmounted by a peaked hat, and the cracks of the Hokusai face weave across the eyes and mouth of the Klee face, creasing it into antiquity. Hokusai's graphic design is recast by Klee in complementaries of green and rusty red, against a background raised like armour with nails of paint. For Klee it is the child actor with proud mien who sees within, and can direct the magic theatre: the child is already cast in the role of the adult.

We have already noted that Klee sensed the Japanese influence in the works of Beardsley which he admired in 1905. Early on he experimented with some of the conventions of the Japanese, as in his 1906 *Masculine Head, Gypsy Type* which relates, in feature and outline, to those of Kuniyoshi in his *Kusunoki* at Shijo-mawate.[19]

21 *Masculine Head, Gypsy Type*, 1906

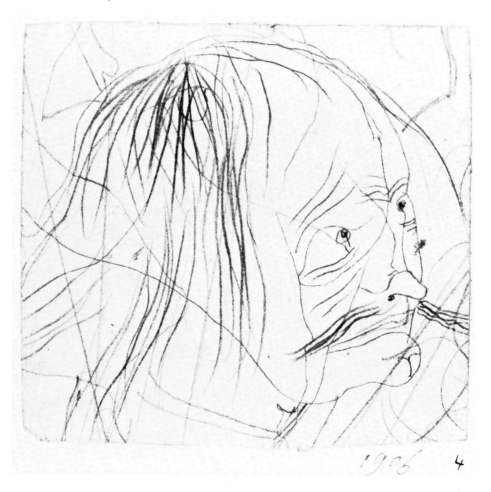

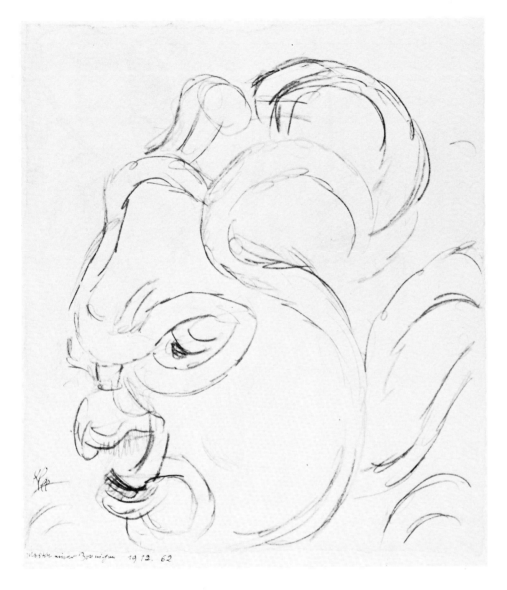

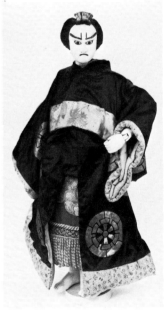

Further evidence of Klee's quotation from the Japanese appears in the 1912 *Mask of an Angry Woman*, and the similar *Broad Female Head* of the same year, which take a form like that of the male puppet heads of Bunraku theatre.[20] These puppets, some five inches high, are tiny essays in a long tradition of oriental art. They appear to be at once formal and traditional, and exaggerated and grotesque.

The distinctive Japanese bearing of Klee's *Actor* seems not to have impressed previous commentators on Klee's art who have seen him in relation to the School of Paris and to Die Brücke primitivism. Alfred Barr insists that the *Actor* reminds him of Melanesian ceremonial masks.[21] But Klee avoids the harshness of the art of primitive peoples, and draws rather on

22 *Mask of an Angry Woman*, 1912

23 Wrestler puppet from the Japanese Bunraku theatre

sophisticated forms, particularly those of Eastern theatre – oriental conventions which were, indeed, of marked interest to his contemporaries in theatre, like Meyerhold and Brecht, and Eisenstein in film.[22]

Certainly Klee would be aware of the enthusiasm for the primitive mask, and aware of the excitement generated by the ethnological departments opening in the museums.[23] He would have known the collections in Berne, Basle and Munich. The pronounced interest in ornamentation in his work undeniably has associations with primitive geometries.

The masks of Oceanic art reproduced in Wilhelm Hausenstein's 1923 publication, *Barbaren und Klassiker* (Barbarians and Classicists) – a book which would have been interesting to Klee, since Hausenstein had written on Klee himself – suggest patterns akin to Klee's painted faces, especially those of later years.[24] A New Guinea dance mask has an uneven pointed outline, round button eyes and an uneven mouth. Its surface is patterned like crazy paving, reminiscent of Klee's way with faces. Ingenuous lopsidedness and stitched features are seen in other masks reproduced by Hausenstein, almost all of them drawn from the ethnographical collections of German museums, in particular the Munich Museum of Folk Art. Klee's *Rough-hewn Head* of 1935 recalls the vertical planes of a primitive mask reproduced in an even more famous contemporary publication, Ozenfant's *Foundations of Modern Art*, which Klee may have known in its 1931 German translation.[25]

These primitive masks are but formal triggers to Klee. They enrich the vocabulary of the basic, schematic face, but they are not as important as the philosophy of the mask as a manifestation of the *teatrum mundi*. Huizinga's classic study, *Homo Ludens*, best explains the fascination of all masks:

Think of the peculiar charm that the mask as an *objet d'art* has for the modern mind. People nowadays try to feel the essence of savage life . . . Modern man is very sensitive to the far off and strange. Nothing helps him so much in his understanding of savage society as his feeling for masks and disguise. While ethnology has demonstrated their enormous social importance, they arouse in the educated layman and art lover an immediate aesthetic emotion compounded of beauty, fright and mystery. . . . The sight of the masked figure, as a purely aesthetic experience carries us beyond 'ordinary life' into a world where something other than daylight reigns; it carries us back to the world of the savage, the child, and the poet, which is the world of play.[26]

This world of *Homo Ludens* is very dear to Klee, and it can be seen to embrace the world of the theatre as well as that of the savage: the sources of the mask fuse.

From the circle of Klee's Munich friends came a further published testimony of the fascination with the mask. August Macke contributed an essay, 'Masks', to the *Blaue Reiter Almanac*. The almanac's illustrations are of

dazzling and original range, and among them are many different theatre and primitive masks.[27] Kandinsky's essay 'On Stage Composition' is illustrated with a Chinese theatrical mask from the Berne Historical Museum – an illustration that may have been suggested by Klee. Macke's essay is illustrated with photographs of a stonemason's carved portrait with the eyebrows drawn together in a double curve, with dance masks from South America, and other works drawn from the Munich Ethnological Museum.

The content of Macke's essay, however, is metaphysical rather than ethnological. Written in exalted Blaue Reiter prose, it seeks to remind the reader of his obligation to seek for the expression of inner thought. Macke makes no distinction between primitive and theatrical masks. The stylized face, whatever its origin, symbolizes through its direct expression the externalization of the artist's inner life in the work of art. His chant-like list includes the masks and stages of the Japanese and the Greeks; he sings of the world gallery of non-naturalistic art (extolled more academically in the contemporary 'will to form' treatises by Riegl and Worringer),[28] and prompts the artist to compose with similar 'strong forms', and to recognize the valid diversity of all forms of expression:

The cast bronzes of the negroes from Benin in West Africa (discovered in 1889), the idols from the Easter Islands in the remotest Pacific, the cape of the chieftain from Alaska, and the wooden masks from New Caledonia speak the same powerful language as the chimeras of Notre-Dame and the tombstones in Frankfurt cathedral.[29]

Before coming to Munich, Macke was active in the theatre: in 1907 he had been the scenic director of the Schauspielhaus at Düsseldorf.[30] He also shared Klee's interest in physiognomy. In an excited letter to Gabriele Münter, written in 1911, he was full of schemes which he wanted to develop for the *Almanac*.[31] A number of his articles showed his interest in the artifices of the Eastern and the Western stage: he wanted to write on the masks and puppet plays of the Greeks, the Japanese and the Siamese. But the wide symbolic range of the mask must have been so attractive to Macke that he dropped his other projects. Presumably he could have used any of these subjects to demonstrate his main point: that the art form contains the inner life. For Macke, as for Klee, the mask is capable of demonstrating the spiritual task of art as an outward symbol of an inner life. As Klee said in his most direct early statement about the mask: 'the mask represents art, and behind it hides man' (618).

In verbal form it is, however, the poet Rainer Maria Rilke – a friend of Klee's – who captures the poetic image of the mask.[32] At some stages he was in contact with Klee, who wrote in 1912, after he had returned from a visit to

Tunisia, that 'the subtle Rilke must tell us something about Tunis' (965).[33] In 1919, after Klee returned to Munich from army service in Gersthofen, he shared an apartment with Rilke. Although Klee expressed his admiration for the poet he did, in 1915, see himself set on a different road. His diary records:

I had sent Rilke a small selection (of my water-colours) which the poet personally brought back to me. His visit gave me really great pleasure. A picturesque, limping lady came with him. I at once read passages of the *Buch der Bilder*, and of *Die Aufzeichnungen des Malte Laurids Brigge*. His sensibility is very close to mine, except that I now press on toward the centre, whereas his preparation tends to be skin deep. He is still an impressionist, while I have only memories left in this area. He paid less attention to the graphic work, where I have advanced farthest, than to the domain of colour, which is still in the process of maturing. (959)

Rather might Rilke be called, at this stage, a late Symbolist. *The Notebooks of Malte Laurids Brigge*, which Klee hastened to read, might be viewed as the record of the search of the protagonist–author for his identity. It is a process involving the casting off of one mask and the assuming of another. The mask is the leitmotif of the narrative:

The mouleur, whose shop I pass every day, has hung two masks beside his door. The face of the young drowned woman, a cast of which was taken in the morgue because it was beautiful, because it smiled deceptively, as though it knew. And beneath it, *his* face, which did know.[34]

At one point the poet physically puts on the masks; he is fascinated by the disguise and undergoes a sensation of physical cohesion of his face with the mask face. He writes:

I have never seen masks before, but I understood at once what masks ought to be. . . . The face I fastened on had a singularly hollow smell; it lay tight over my own face, but I was able to see through it comfortably, and not until the mask sat firm did I detect all sorts of materials which I wound about my head like a turban, in such a way that the edge of the mask which reached downward into an immense yellow cloak, was almost entirely hidden on top and at the sides. At length, when I could do no more, I considered myself sufficiently disguised.[35]

Rilke's major poetic cycles, the *Sonnets to Orpheus* and the *Duino Elegies*, are concerned with the nature of the poet's Orphic inspiration, the Dionysian dance, the exposé of the theatrical act of life.[36] In the fourth book of the *Duino Elegies* the major protagonists of the moral and the spiritual are united:

Engel und Puppe: dann ist endlich Schauspiel.[37]

The inanimate symbols of life – mask, puppet and doll – and the symbol of sky and spirit, the angel, are linked together, and the half-filled mask rejected for its imperfect simulation of imperfect life.

Returning to Klee, around 1912 we can observe the mask, frontal, newly simplified, established in his work as the dominant way of representing the face. It emerges from the slight doodles of heads done in 1909 and 1910. Significantly, the first new mask is given to the traditional pierrot, youthful and innocent, wearing that clown sadness that he had been given in nineteenth-century representations.[38] He is the first of the circus figures, and his company in the early paintings of the twentieth century is extensive. He is of course a major figure in the early work of Picasso, and a preoccupation of the poets of Picasso's circle. Theodore Reff has observed that for Picasso 'the costumed entertainers who already appear among his subjects as early as 1900 are the first manifestations of that love of the theatrical in all its guises which was later to find such varied expression in his life as well as his art.'[39]

It has also been observed that the sadness given to the clown since Watteau's *Gilles* identifies him with the alienated artist. Set apart from his audience, he is forced to assume merriment. An emotional equilibrium between comedy and tragedy preoccupied Klee while he was producing the first exercises in the grotesque, for he was even then aware of his preference for the 'dominance of laughter'. Finally he found a style of linear innocence that might for him approach the quality he so admired in Mozart's work: his balance between terror and beauty.[40] Klee's awareness of dualism – of the extremes between order and chaos, tragedy and comedy, the horizontal and the vertical – is central to his philosophy of art.

The *Head of a Young Pierrot* is lightly drawn and deliberately tentative, but already it suggests the solemn frontality of one of Klee's later, most hieratic and quizzical mask faces, the mature *Clown* of 1929. *Head of a Young Pierrot* reaffirms the sad reality behind the theatre appearance of the early *Comedians*. The 'happy' pierrot is in fact sad, but the new style confirms the disappearance of the 'ill will' of which Klee wrote early in his diary. Slight as this wash drawing is, it is one of the first approaches to the touch of grace which will be characteristic of Klee's later work.

Other small works of this year – the year of the adoption of clown, acrobat and marionette in the full-figure studies – confirm the importance of the mask face. *Pangloss-type Mask* refers to Voltaire's *Candide*, which Klee had illustrated for publication in the previous year. Pangloss was the determined-to-be-happy philosopher who trapped himself in his happy mask. He confessed that he had suffered dreadfully; but having once maintained that all things went wonderfully well, he still kept firm to his hypothesis, though it was quite opposed to his real feelings. Like the young Pierrot, Pangloss, the happy philosopher, is finally forced to submit to the grimace.

V

55

24

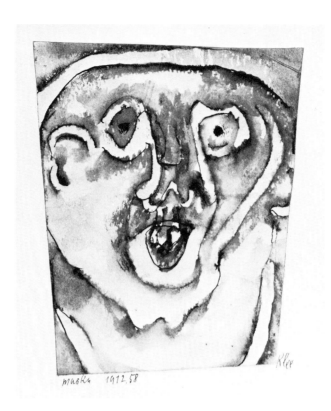

24 *Pangloss-type Mask*, 1912

In tiny graphic works of 1913, the face is circular and simply outlined, following the schema of the *Head of a Young Pierrot*. Klee called these heads *Constructions*, and drew them with something of the crudity of the carnival mask. They also imply that this basic head is a general picture of man as clown.[41] The faces grin; a grimace supersedes the smile in such trinities of heads as *Construction with Three Heads*, *Three Heads*, and *Cry of Fright*, with its array of wide-toothed little mortals encumbered by the weight of their ungainly round skulls.

These modest pen drawings, together with a similar pair of wash sketches, are ugly heads, angular and inflexible, but they are only marginally grotesque. Klee has moved from the realm of caricature to a more beguiling and sympathetic rendering of the human face. The mask still exposes the fate of suffering which Klee sees as man's inescapable heritage, but now it is distanced because the rendering is more artificial: the light style renders it approachable. Furthermore, the mask itself has come to symbolize the very revelatory nature of art. As early as 1901, Klee saw the possibilities of a new art of portraiture:

Thoughts about the art of portraiture. Some will not recognize the truthfulness of my mirror. Let them remember that I am not here to reflect the surface (this can be done by a photographic plate), but must penetrate inside. My mirror probes down to the heart. I write words on the forehead and around the corners of the mouth. My human faces are truer than real ones. (136)

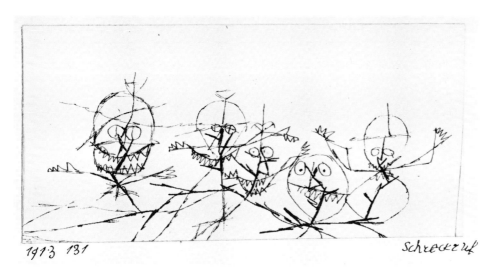

25 Cry of Fright, 1913

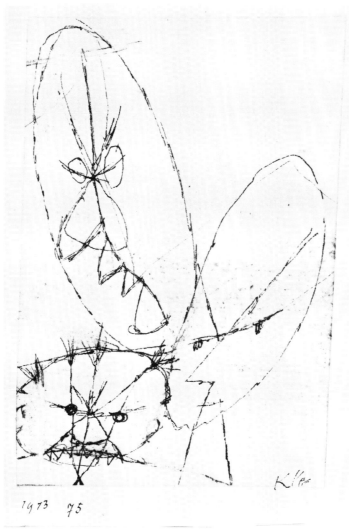

26 Construction with Three
Heads, 1913

3 Acrobat, Dancer and Clown

In 1911, Klee – still seeing himself principally as a graphic artist – executed twenty-six drawings as illustrations to Voltaire's *Candide*. Publication was delayed until after the war.[1] As early as 1906 he had noted in his diary: 'I read a unique book: *Candide* by Voltaire. Three exclamation points' (743). In 1909: '*Candide* with its condensed riches provides innumerable stimuli for illustration'. It is clear from his following comment that Klee recognized in the style of Voltaire the quality that he himself sought, 'that of exquisitely spare and exact expression' (865).

The illustrations mark a consolidation of one of the many different figure styles created in previous years: the style that Klee himself described as his 'swarming scribbles' (899). The characters are naked and transparent, minute and spindly as if seen from a distance. They are akin to the small-scale figures of Segantini and Kubin.[2] They exist in a very bare world, as victims of the thin lines which draw them.

The change of scale, already anticipated in Klee's early drawings of children in their own style, is of immense importance. Like the adoption of the basic schematic head, it signifies Klee's permanent adoption of a scale of modesty. The characters are involved in the enactment of the plot; as yet the scenarios belong to another author, but Klee will soon feel confident enough to invent his own.

The Candidean figures make plunging gestures with long thin arms waving out into the empty space.[3] They sway precariously on long legs with very tiny feet only just on the ground. The ground is scribbled around their feet – a minimal setting; mostly they gesticulate against vacant space. Only essential props are provided: a table, a settee, a horse. In the illustration for chapter 22, *Light Would Kill Her*, the curtain – later to become Klee's favourite framing device – makes its first appearance. It is related that Candide is in Paris and is called by a trickster to the sickbed of his beloved Cunégonde. It is the disguised con-man he finds, and 'she' must remain shrouded by the bed-curtains while the devoted Candide fills her hand with diamonds.

In 1911 Klee was already thinking of 'harmonizing' his 'swarming scribbles with firmly restraining linear boundaries' (899). He soon arrived at a consistent

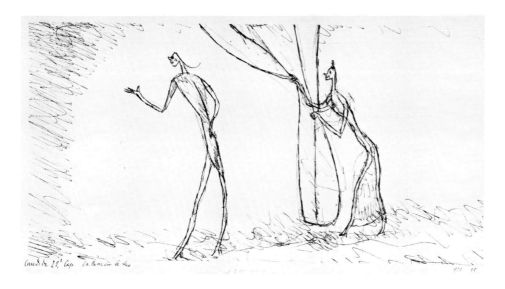

27 *Light Would Kill Her*,
drawn in 1911 for *Candide*

presentation of the figure: still small in scale, clear and almost straight-lined in outline. The new mannikin displays his inevitable human weakness both in his form and in the irony of his situation; he is a puppet figure in a play. Among the types in the drawings that follow are the performers of the circus and the *commedia dell'arte*: those professional humorists and entertainers who symbolize the artist's concern with comic release and light satire.[4]

Although they might appear slight in Klee's overall body of work, the circus drawings from the years 1912 to 1919 are of crucial importance to the themes and forms of the figure in his mature style. Acrobats anticipating the famous *Equilibrist* of the Bauhaus period perform on increasingly elaborate constructions of lines, intricate but ultimately irrational, for no support is provided for the key struts. The protagonists are marionette figures, always elaborately jointed, sometimes with their strings attached. Their strings imply either that there is a relaxation or an evasion of personal responsibility, or that their actions are circumscribed and they are without free will. Fragile of line, sometimes with the strings hanging slack, they are little beings to be viewed with kindness. After 1912, Klee's figures always have something of the marionette in their bearing, halfway between the ingenuous and the streamlined.

Harlequinade of 1912 is one of the first of the drawings with marionette figures. The characters are clearly intended as puppet actors, with strings working their triangular joints. They flee, in their pointed hats, from an undisclosed centre of calamity to the left of the drawing. Flight, catastrophe, calamity: these will be the factors commonly activating Klee's figure works. The small race will partly camouflage their own tragedy with the

XI

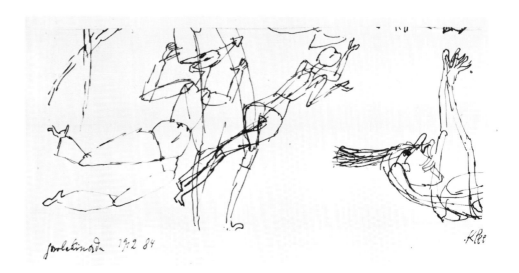

28 *Harlequinade,* 1912

29 *Human Weakness,* 1913

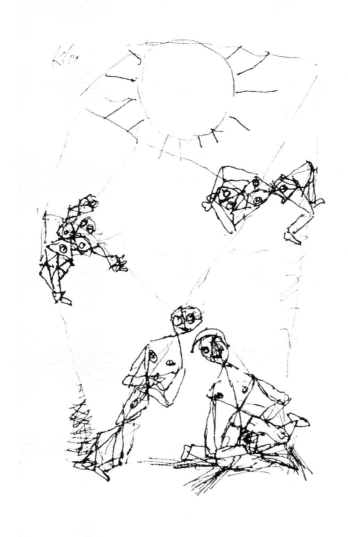

awkwardness of their movements and the simple appearance they have been given.

Such situations and dilemmas are the themes of numerous small drawings and lithographs. In *Human Weakness* of 1913, the figures are as puppets without control of their destiny, their limbs are awkward with a lack of grace and they lack command of speed and therefore topple. Always transparent, they are drawn without roundness. Their heads are semicircular, they have big eyes, they lean at angles and collapse at their joints. The smaller climb upon the larger, escaping from the ground-line. Above them shines an all-seeing sun with childish rays; underneath they are as Lilliputians. A lightly-drawn line of strings connects them both to each other and to an unseen manipulator: invisible Fate. In their inflexible joints, their lack of bulk, their transparent forms and tentative silhouettes is implied the necessity for an operator to tighten their strings. They are the first of Klee's most representative type of protagonist. Not only are they delineated in his new linear mode, but they embody his philosophy.

The variety of body images Klee has used up to this time – anatomical studies, the detailed etchings, the thinnest tentative linear studies, the Candide figures, the marionettes – gives visual confirmation to the idea expressed in the medical field by Dr Paul Schilder: 'The image of the body is not a static phenomenon from a physiological point of view. It is acquired, built-up and gets its structure by a continual contact with the world.'[5] Klee's protagonists, through their form, demonstrate recalcitrance in their contact with the world. The hardness of the body indicates a moral and psychological inflexibility.

Alternative forms for the figure seem less important to Klee than the straight-jointed inflexible dolls which are physical representations of habits of mind. But there are other figures that relate to the more fluid Candide figures: figures that have curvacious bodies, though they enact similar burlesques. *St George*, a lithograph of 1912, has the traditional knight on horseback, but the dragon is in fact the princess, larger and more dangerous than knight and horse and speared by the knight through the genitals. It is a specifically sexual drama, with the overlapping of figures and lines making clear display of the sexual thrust. The figures are nude, the male castrated. 30

Klee also draws ribbon-like figures, more agile in their caterpillar-like forms, always shown in action and denouement, as in the lithograph *The Higher Spirit in Mourning over the Lower*. It is another foreshadowing of the Tate Gallery *Comedy*: a line joins the figures and traps them together; the elbows of some figures are bound into the shoulder of another, and the line passes from the shoulder of one to the lower body of others. In *The Last Stage of Don* 31

VIII

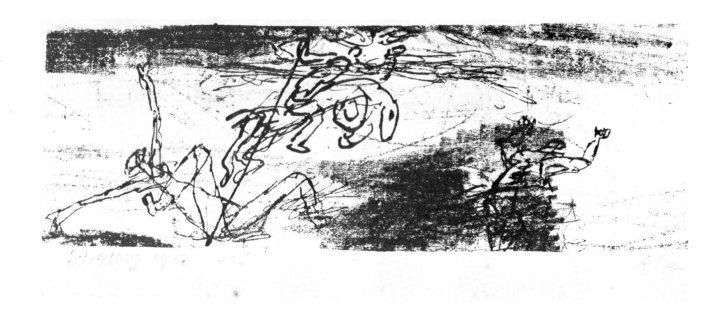

Juan's Infatuation – presumably the Don has reached a point of philanderous exhaustion – the action line joins the falling figure of the woman to his flying spurs and haphazard gestures. Again the latticework links the genital areas to make the sexuality explicit.

Klee's little dramas are examples of the inherent helplessness of the human race, unambiguously spelt out in the lithograph *Collapsing Flight* with its three figures, one with shoulders extended like a crucifix, tripping over one another. Their immobilized legs, dragging behind in long shafts, also appear like crucifixes.

Much of this satirical impetus surely springs from Klee's youthful anti-bourgeois view of society, which was already explicit in early diary entries.[7] His home city of Berne clearly prompted some of these Punch and Judy allegories in which policemen in neat uniforms flee the scene. They race across the picture in *The Fleeing Policemen*, and, in another exposé of the hand of the law, one succumbs quite readily to the female in *Temptation of a Policeman*.

In a diary of 1913 Klee speculated on such Guignol events, seeing an idyllic picture of Berne having the following things:

1 The *Zytgloggegügel* [clock cock], which sings 'Call you, my fa . . .'.

2 A drunken foursome of singers who serenade this bird.

3 Two polyps (policemen; cops) in rubber shoes pondering whether they will triumph over the four or succumb in the end.

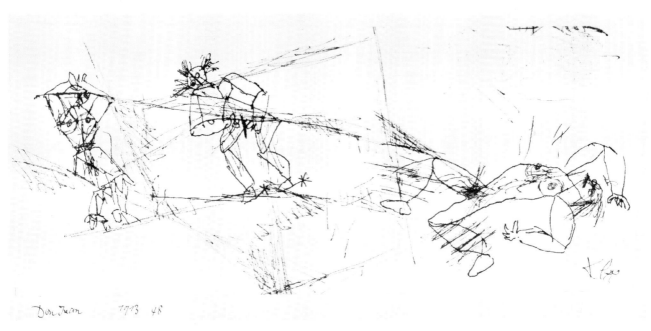

Don Juan 1913 48

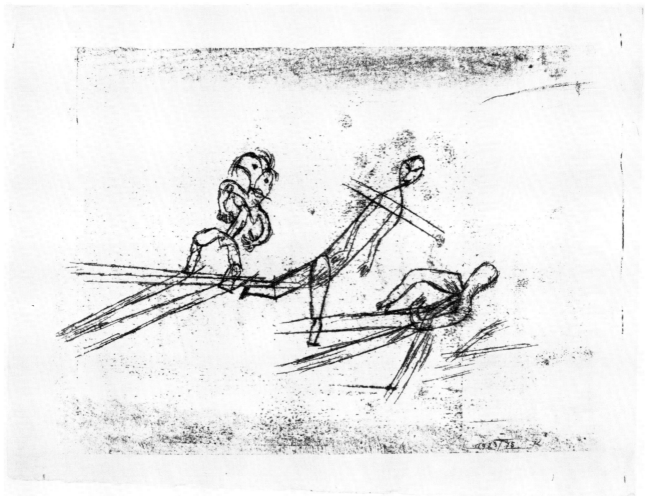

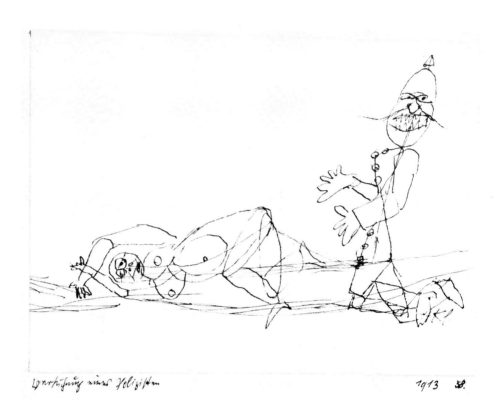

34 *Temptation of a*
Policeman, 1913

Lynchifierung eines Polizisten 1913 38.

4 The arcades of Bern, which arch over the scene (double over with amusement).

'A stroke of lightning in the night; the day screams sharply in its sleep. Faster, Mr Canine, you'll be late for Frau Gfeller's dinner date – where you're invited to a full plate.' Suchlike things I am now able to express with a certain precision, and this by line alone, line as absolute spirituality, without analytic accessories, simply taken for granted. (920)

It is significant that Klee links these small dramas of the absurd with their elliptical action to 'spirituality' rendered through precise lines.[6] Although he experienced colour and a new confidence in the use of paint during his Tunisian trip in 1914, he acknowledged his most advanced work to be in the graphic field, and we have seen that he was disappointed when Rilke was more interested in the paintings than the graphic work.

These works involve movement through time. They depict action and its consequence, and ask to be 'read' as a progression. They can be seen in relation to one of the most important elements of Klee's later Bauhaus theory: that of movement in a work of art. Klee wanted each picture to be seen as 'genesis'; ideally the viewer should take a chair, sit down, and identify with the construction in time of the art work.[8] Like the human dramas, his nature pictures set up the plants like characters and frame them in curtains. Such pictures depend on an appreciation of movement and growth.

But movement in the pre-Bauhaus years is revealed through the psychological actions of the human being, and here again we must turn to the background of the theatre and literature in order to understand fully the theory of the movement of the marionette which was current at that time.

The classical statement on the puppet figure, often linked in general terms with Klee, is the nineteenth-century essay by Heinrich von Kleist, *Über das Marionettentheater* (On the Puppet Theatre), wherein the puppet is a figure of superior grace, a classical figure from which human imperfections can be banished.[9] Its control is passed to a superior manipulator who offers a new liberation and release from mundane gravity. The puppet can gain perfect movement and balance. But Kleist's ideal puppets have taut strings, whereas for Klee they are slack. Klee's puppets will not easily be granted liberation and grace.

And E. T. A. Hoffmann, whom Klee was reading in 1906 (750), invented his mechanical automata and concerned himself with the conflict between the animate and the inanimate. The doll and the automaton are granted life, for they can move, but they have only partial life and are slightly grotesque in their simulation. Everything participates in the clockwork structure of the universe, and man within that system is of necessity himself an automaton.[10]

Later on Schlemmer, as director of the Bauhaus stage, was to invoke both Kleist and his marionettes and E. T. A. Hoffmann. He would also have been aware of one of the most important stage directors of the first twenty years of this century, Edward Gordon Craig, who likewise espoused the cause of the marionette. Called 'perhaps puppetry's most articulate advocate',[11] Craig reintroduced for modern theatre the Kleistian concept of the director–manipulator, the man who holds together the total work of the stage. Craig's writings spread his ideas – particularly his essay on the 'Übermarionette' (super-marionette), which demanded 'that the actor must go and in his place comes the inanimate figure – the Übermarionette until he has won for himself a better name'.[12]

By seeking to distance the actor from the ordinary actions of human beings, Craig sought, as Bertolt Brecht would later by different means, an alienation which prevented the actor–audience identification response to the naturalistic theatre.[13] The play should become artificial, ritualized. As Craig wrote:

When one designs a puppet on paper, he draws a stiff and comic looking thing. . . . He must take gravity of face and calmness of body for blank stupidity and angular deformity. . . . With the return of the puppet it will be possible for the people to return to their ancient joys in ceremonies.[14]

Indeed, the early twentieth century is notable for its interest in the marionette. From Florence, Craig published a magazine called *The Mask*. His publication provides a small corpus of research articles on the history of the marionette, beginning in 1908 with Adolf Furst's 'A Note on Marionettes' which documented the early appearance of puppets in allegorical plays. In the 1912/13 issue, Anatole France's essay on Signoret's marionettes was reprinted, and an essay by Arthur Symons on the Constanzi Theatre of Rome.[15] Following through several issues came the contributions of 'Yorrick' tracing the puppet metaphor from Plato and Aristotle to the current time.

The grotesque grin of the puppet had already fascinated the Nabi artists of late nineteenth-century France, and they were further inspired by Alfred Jarry's notorious *Ubu Roi*, which was conceived and enacted as a puppet play.[16] Arthur Symons saw its revealing new primitivism: 'Ubu Roi is the brutality out of which we have achieved civilisation, and those painted, massacring puppets the destroying elements which are as old as the world, and which we can never chase out of the system of natural things.'[17]

Most advocates of the puppet were aware of its two faces: its primitive spirit and its potential for grace. For Bernard Shaw 'the puppet is the actor in its most primitive form'[18] that harks back to the functional doll figures described by Frazer in his *Golden Bough*, where the primitive mannikin is created to give substantiality to the soul.[19]

Klee's interest in the marionette was not merely theoretical and literary in its sources. He often went with Kandinsky to the Paul Brann puppet theatre in Munich – one of the most famous in Europe, which opened in 1906 with productions from literature and opera.[20] Brann's productions had an Expressionist character: they included *Dr Faustus, Don Juan, Big Klaus and Little Klaus* and works by Maeterlinck, Goethe, Gluck, Mozart, Pergolesi and Offenbach.[21] Paul Brann has, with this spectacular repertoire, been named as one of the new artists of the *Gesamtkunstwerk*: 'On his immature stage appears a harmonious unity of all arts, much more convincing than in the regular theatres: naive, dramatic work and pleasant settings are here triumphant, precisely because lifelikness is not demanded from his stringed marionettes.'[22]

Indeed, many of Klee's opera paintings with their mannikin figures suggest a marionette stage. Klee's image of the puppet and Kandinsky's emphasis in his essay of 1911 on stage composition espousing 'an harmonious unity of all the arts' must in part spring from the interest aroused by regular attendance at the Paul Brann theatre.[23]

Futurist and Dadaist theatre loved the artificialities of mask and automata. In the Futurist theatre manifesto (which was circulated in Craig's magazine

The Mask) they spoke of their new kind of theatre, a *teatro del varietà*[24] which was to mirror the democracy and vitality of cities and bring the people's theatre of circus and cabaret back into the realm of formal theatre. In the year when Klee produced his first graphic marionette, Marinetti, that ringleader Futurist, constructed a wooden mannikin as his self-portrait: a stiff and comic looking thing resembling the crude puppet described by Gordon Craig.[25]

No less a witness than Igor Stravinsky, staying in Switzerland during the war years and travelling at weekends to Milan, 'the Futurists' headquarters', gives a fascinating account of the shifts of scale and orientation experienced by the marionette spectator:

The most memorable event in all my years of friendship with the Futurists was a performance we saw together at the Milan puppet theatre of *The Chinese Pirates*, a 'drama in three acts'. It was in fact one of the most impressive theatrical experiences of my life. The theatre itself was puppet-sized. An invisible orchestra, clarinet, piano, violin, bass, played an overture and bits of incidental music. There were tiny windows on either side of the tiny stage. In the last act we heard singing and were terrified to see that it came from giants standing behind these windows; they were normal-statured human singers, of course, but we were accustomed to the puppet scale.[26]

At this time Stravinsky was composing his allegorical musical plays *Renard* and *The Soldier's Tale* (the latter certainly a work which Klee knew).[27] It has been suggested that an experience of the marionette theatre affected the music:

. . . the same idea . . . man is a toy in the hands of impenetrable, cruel and amoral forces; and . . . life is a kind of mechanism of destiny wherein free will plays no part.
 It is interesting to note how often in his theatre work Stravinsky represents his dramatis personae either as puppets or animals, without free will.[28]

In 1916, Stravinsky's composition *Fireworks* was given a stage performance by the futurist Balla, who designed it with colour–light and a fantasy of abstract shapes.[29] Distorted perspectives and phantom architecture were invented by Depero for his Futurist marionette ballet, *Balli Plastici*, which was performed in Rome in 1918.[30]

Apart from the Futurists, the most considerable Italian artist at this time, Giorgio de Chirico, set the mannikin as the central human form in his painting. In 1914 the artificial figure, stuffed, seamed and streamlined, enters his painting as a vacated and cryptic human shell. The source of De Chirico's interest in this type of figure is again specifically theatrical, for his brother, Alberto Savinio, had earlier used this marionette type in a play which he published in Apollinaire's magazine, *Les Soirées de Paris*.[31]

In Klee's own Switzerland, Dada-land, puppetry developed into something of a tradition in the war years, and was practised by painters and key figures in the avant-garde theatre. Klee was a soldier in Gersthofen, and was not a member of a Dada group, but he was certainly acclaimed as a master in Zürich: 'Klee's work seemed to open the way to the Elysian fields we saw stretched out before us.'[32] He was included in the exhibitions and was a subject of the lectures. So also was Kandinsky, whose *Gesamtkunstwerk* was of acknowledged importance for Hugo Ball's cabaret. Ball himself lectured on Kandinsky: 'Yesterday my lecture on Kandinsky: I have realized a pet plan of mine. Total art: pictures, music, dances, verses – we have it now.'[33] Klee wrote an ironical dialogue in his 1908 diary: ' "Teacher, may I play a little mu-mu-music besides??" "Versatility in the arts? By all means, you must, you may! Versatility in the arts is good, provided it does not lead to works of integrated art" ' (810).

In Zürich the marionette theatre formed an annexe to the Kunstgewerbemuseum for the first Swiss Werkbund exhibition, and Sophia Täuber-Arp presented her puppets from Gozzi's play, *Le Roi Cerf* (King Stag). Each was a turned wooden figure, individually conceived, performing against a background of tonal squares typical of Täuber-Arp's early abstract paintings.[34] At the same Werkbund, Carl Fischer and Otto Morach presented puppet programmes, marionette operas of Pergolesi, Mozart and Donizetti, in a repertoire that was similar to that of the Paul Brann theatre in Munich.

At the famous Cabaret Voltaire evenings there was a spontaeous use of masks and many resulting antics, as recounted by Hugo Ball:

Janco had made a number of masks for the new show, which bear the marks of something more than talent. They recall the Japanese or Ancient Greek theatre, and yet they are wholly modern. They are designed to make effect at a distance, and in the relatively small space of the cabaret the result is astonishing.
We were all there when Janco arrived with the masks, and each of us put one on. The effect was strange. Not only did each mask seem to demand the appropriate costume; it also called for a quite specific set of gestures, melodramatic and even close to madness.... The dynamism of the masks was irresistible. In one moment we became aware of the great importance of such masks in mime and drama. The masks simply demanded that their wearers should start up a tragico-absurd dance.[35]

After Janco's revelation of the power of the mask, Dada performances of masked dances were frequent: Tzara's almanac records two evenings in April 1917 when Apollinaire and Kandinsky were present. Negro music and dancing were combined with the mask performances.[36]

In 1917 Kokoschka's *Sphinx and Strawman* was given its première by the Zürich Dadaists. Originally written for the Sturm Theatre in Vienna in 1909, it

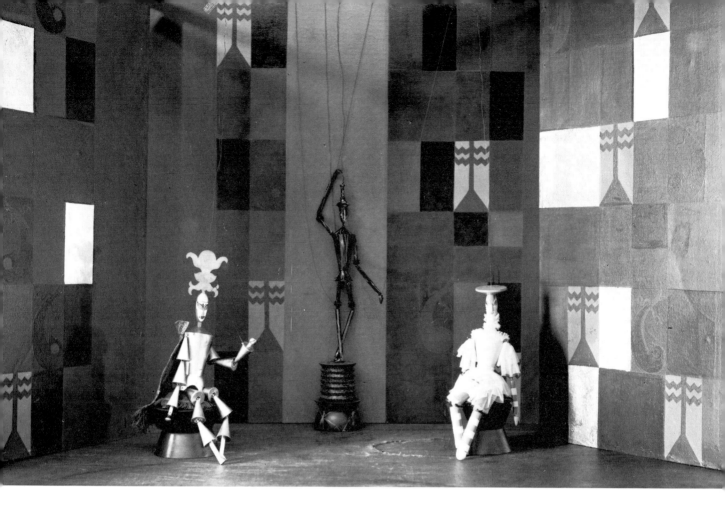

35 Sophia Täuber-Arp,
marionettes for *Le Roi Cerf*,
1918

was a play on that preoccupation of *fin de siècle* Vienna, *les femmes possédées*. It was subtitled 'a play for automatons'.[37] The actors appeared in mask for 'a grotesque setting'; the gentlemen wore top hats; they had mask heads with holes as mouthpieces.[37] After it, Tzara observed that:

This performance decided the role of our theatre, which will entrust the stage direction to the subtle invention of explosive wind, the scenario in the audience, visible direction, grotesque props: the Dadaist theatre. Above all, masks and revolver effects, the effigy of the director. Bravo! & Boom Boom![38]

After the second 1917 cabaret evening in April, there was a new dance with 'six dazzling masks'. With this performance Tzara was content that 'the final victory of Dada was complete': a victory for play, improvisation and mask.

Kokoschka is of great interest, since in his early years he was closer to the active theatre than any other German artist. Although there is no record of significant contact between him and Klee, Klee would certainly have known of his activity as a Sturm artist. Although Kokoschka is in fact claimed as one of the first of the German Expressionist dramatists,[39] his crucial experiments

with an anti-naturalistic, symbolical theatre seem to have very little interaction with his painting, which contains nothing of the 'theatrical aesthetic' so decisively operative in Klee's work.

The thematic preoccupations of Kokoschka in his plays have been described as the deadly struggle of man and woman, a legacy from Strindberg and Wedekind.[40] As in Klee's works of this same period there is an 'obsession with sex', a preoccupation with a *théâtre des femmes*, as Klee described it (170), in which a situation is developed by nameless male and female characters into struggle and flight.[41]

Kokoschka's ideas have an affinity with the theatrical theory of Kandinsky, for his concept of the stage moves towards a 'theatre of silence', of minimal dialogue and ritualistic action. While still a student Kokoschka constructed shadow-play puppets made of copper foil and painted. His figures *Stag* and *Musician* of 1907[42] show a similarity with Javanese puppet figures which were widely collected at the time as part of the contemporary cult of the oriental. And Kokoschka was in the centre of the cabaret movement, working his jointed puppets for the opening programme of the newly formed Fledermaus Cabaret.[43]

Klee's sympathy for the alternative theatre and for the circus, his own wish to achieve a light style that carried a sense of improvisation and play, fed – if indirectly – on the same sources as the Futurist, Dada and Sturm theatres of the war years, with their underlying protest and consciousness of the collapsing national and class structures of Europe at war.

Indeed the circus game is not so removed from the war game, for both play off the weak against the strong. The puppet metaphor is one of the most prominent in political cartooning, and Klee would have been familiar with representations such as those in *Simplicissimus*.[44] George Grosz was to use the metaphor in his etchings many times.[45]

For Klee the importance of the theme of the puppet–acrobat is suggested in his selection of a folio of drawings – all with circus themes – for the Expressionist publication *Sturmbilderbuch III* in 1918. In *Acrobats* the figures are themselves their apparatus; they are transparent mannikins sharing body-lines which also map out their descent. The fall is ungraceful, for the jointed mannikin limbs are capable of only two-way action. The acrobat reverses the normal positions of the body, he stands on his hands, he demonstrates his flexibility and his sense of balance. He has been called 'a living symbol of inversion or reversal',[46] an upsetter and a reverser of the established order. Half professional, half inept, Klee's acrobats work against gravity and are unsuccessful, for they plunge downwards with arms twisted behind, unable to brace the body against the fall. As in a much later Klee

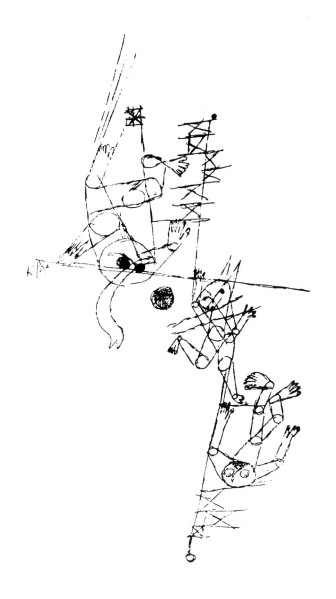

1914.113. Akrobaten

36 Acrobats, 1914

drawing of 1930, *Refuge*, these figures swim in air or water to escape injury or drowning.[47]

A drawing for the *Sturmbilderbuch* folio, dated 1916, *Acrobats and Jugglers*, 37 more than hints at an allegory of mental balance. It is one of Klee's first experiments with the fusion and breakdown of a single body. Two heads share a body, one emerging from a scaffolding which simultaneously forms the ground-line for a juggler figure perched on a doubtful framework in perilous relation to a figure below. The deliberately tentative line carries the tension of balance into the smallest details of the drawing.

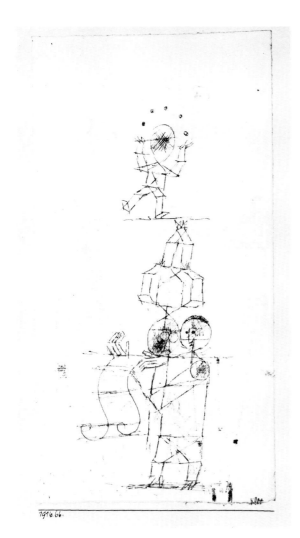

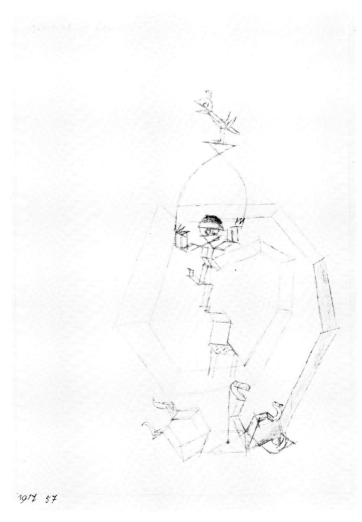

7916.66.

1917 57

37 *Acrobats and Jugglers,*
1916

38 *Miserable Circus,* 1917

A related drawing of the previous year, *Head Jugglers,* shows this same fascination with displacement of the body: acrobats are separated from their heads, which they hold in their hands; one sits with his head on his lap. On a thick line stands another figure doing a handstand, his circular head as large as his body. A companion figure with body intricately expanded loses his smaller head in the dark shading of his waist.

In 1917, the same acrobatic theme and the style of the publicized drawings is used in *Miserable Circus.* The ring is flattened on to the paper; a figure is drawn as if constructed in folded paper. Like an umbilical cord the arena unwinds from the human body and circles tentatively around the performer. The juggler is poised on one leg on the back of the chair which is also folded transparently, elaborately constructed, yet in impossible balance. The little man supports himself; on top of his head is a cryptic, hunted bird.

Klee's sense of the expressiveness of the human body came to him early but matured slowly in his art. When in Italy in 1902 he went to see the dancer

Sado Jaco, and commented in his diary on her mixture of 'grotesque humor' and 'acrobatic skill' (403). This reaction is a basic one: awareness of physical expression and disgust related to the delight in breaking through the borderlines of the body, overcoming the rigidity of the body image, dissolving and weakening its outlines.[48]

Klee's experiments with physical alterations are expressed by his use of circus figures, straining to destroy physical limitations, awkward, grotesque and rigid in performance. He gives visual form to the idea of tension and elasticity by the choice of circus and the form of his puppet-like clowns. He hits on the very images that Henri Bergson needed to explain his idea of the comic in his essay *On Laughter*, where rigidity makes way for laughter: 'This rigidity may be manifested, when the time comes, by puppet-like movements, and then it will provoke laughter; but, before that, it has already alienated our sympathy: how can we put ourselves in tune with a soul which is not in tune with itself.'[49] Bergson is also fond of the idea of mechanical action which is stilted and therefore humorous. Klee's circus works exploit the confusion between the apparatus and its user: 'What incites laughter is the momentary transformation of a person into a thing', continues Bergson. The transformation of human into puppet also provokes this effect. Klee's own identification with the acrobatic dilemma is revealed in a diary comment:

A flying man! I force the third dimension into the flat plane . . . I dream of myself. I dream that I become my model. Projected self. Upon wakening, I realize the truth of it. I lie in a complicated position, but flat, attached to the linen surface. I am my style. (425)

The flattened way of drawing, then, demonstrates an involvement and an empathy that goes further than the mere use of circus iconography. Picasso's circus works have been seen to symbolize the discipline and skill of the artist.[50] Painter inspired poet: Rainer Maria Rilke wrote of Picasso's circus world in the fifth book of the *Duino Elegies*. It has been observed that the acrobat is not only the subject of the verse, but part of its deliberate gymnastics: 'There is an acrobatic element in Rilke's poetry itself which tinges its greatness with the hue of the abstruse.'[51] Klee's experiments with the abstruseness and ambiguity of line are a similar acrobatic performance, as yet only tentatively mounted. And if wit is evidence of a dramatic way of thought, then circus and drama subjects are a part of the theatrical turn of Klee's mind.[52]

The acrobat and equilibrist from the circus are partnered on the stage by the stars of the *commedia dell'arte*, the harlequin and pierrot. Although Klee

painted his first pierrot mask in 1912, he never uses the harlequin figure with the tenacity of Picasso or Rouault. The figure of folly and calamity is one of the important theatre symbols in his work: the historical *commedia* figures appear beside the masked heads, the marionettes and the acrobats.

It has been realized that Picasso's early absorption with the figure of the harlequin indicates his urge to identify with an 'outsider' symbol, almost like a reincarnation of the wandering *saltimbanques* of Daumier.[53] Likewise Rouault's clown is seen as his *Doppelgänger*.[54] Marcel Proust is connected with a classic *alter ego* anecdote. He was asked at a Parisian salon to play Pierrot in Gaston's one-act play *Columbine*: 'You're just right for the part, you're so pale and your eyes are so big . . .'. His biographer remarks that 'Proust refused to act on the stage a character he was already playing in life.'[55] One might recall Verdi's *Rigoletto*, with the central figure trapped, both emotionally and socially, in his role as court buffoon:

> *O rabbia! esser buffone!*
> *Non dover, non poter altro che ridere!*
> *Il retaggio d'ogni uom m'è tolto:*
> *il pianto!*[56]

We have already seen that pantomime symbolism was conspicuous in the late nineteenth century: that the pierrot is among the disguises of Gauguin and even Cézanne, and has been emphasized as a key figure by the commentators Meyer Schapiro and Hans Hofstätter. He stands as evidence of the artist's self-conscious preoccupation with art for art's sake. Arthur Symons claimed the pierrot figure for the nineteenth century as 'one of the types of the century', and we must likewise claim the inheritance well into our own.[57]

The pierrot not only appealed to the visual artists, but also to musicians and choreographers, who returned the *commedia dell'arte* to the centre of their stage. In 1911 the international wizard Diaghilev presented his *Petrouchka* at the Théâtre du Châtelet in Paris as a manifestation of the new total art work created by himself, Stravinsky, Benois and Nijinsky. Inspired by Benois's memories of the Russian puppet plays of his childhood, it is a ballet of blackamoors and dolls brought to life. Benois drew on traditional Russian costumes; Stravinsky incorporated folk tunes and popular accordian songs of the period. The music and its visual presentation, now a classic of the ballet repertoire, were heralded as new. In Prince Lieven's words: 'The whole character of the dancing, the poses of the figures, the angular movements and gestures, the doll-like immobility of facial expression, the strange jerkiness of the positions, were not normal ballet and had never been seen before.' It

was Nijinsky's star role. Lieven continues: 'From the first moment of his appearance on the stage one felt that he was neither doll nor man, but a strange and terrifying mixture of both . . .'[58]

The Petrouchka puppet is an awkward dancer, and the novelty of his demeanour has been seen as a significant element in the development of modern dance. Suzanne Langer contrasts the abrupt movement of Petrouchka with the liquidity of the free dance: 'Petrouchka the marionette motif in all its varieties and deviates . . . the mystic force that works by remote control, establishing its own subsidiary centres in the bodies of the dancers.'[59]

In tune with their time, Diaghilev's artists remained loyal to the harlequin. Stravinsky and Picasso returned him to the centre of the stage for *Pulcinello*.[60] Picasso did a large number of drawings and paintings of pierrots and harlequins from 1917. Stravinsky used the *commedia dell'arte* figure in his 1921 comic opera, *The Buffoon*.[61] In German opera, Strauss and Hofmannsthal introduced the *commedia* to their 1912 *Ariadne on Naxos*, juxtaposing it with *opera seria*.[62] In 1913 Schönberg, at this time a heavy-handed painter of ghoulish masks and a member of the Blaue Reiter circle, used the traditional figure in his *Pierrot Lunaire*.[63] Pierrot becomes a key Expressionist figure type, the embodiment of madness, alienation. The dark falls of the female voice express the same anguish of spirit as in Schönberg's slightly earlier musical drama *Erwartung* (Expectation): a daemonic female monologue. In *Pierrot Lunaire* an ostensibly comic figure voices the anguish. Klee saw the first performance: 'Even Schönberg is being performed, the mad melodrama, *Pierrot Lunaire*. Burst, you Philistine, methinks your hour has struck!' (916). He sensed its revolutionary qualities to be far in advance of the Russian Ballet. A year later he saw the Russian Ballet company in Munich and contributed a critique to the Swiss journal, *Die Alpen*:

Several guest performances by the Imperial Russian Ballets, with Nijinsky and Karsavina as soloists, bring an unusual novelty into the routine of opera. I am not saying new life, for what is involved here is an old, probably dying art. Times long since vanished survive in it.

The occasional incursion of modern elements does not alter this state of affairs. And one can look with emotion on what is disappearing, never to return. Particularly outstanding is Nijinsky, who dances in the air and on the ground simultaneously. My memory conjures him up in the moment he leaps and in the exquisite turnings of his young, powerful body. (916)

In his view of the Russian Ballet as conservative Klee shared the opinion of theatrical figures like Gordon Craig, who commented in the same year: '. . . Nature has a Rhythm. The Russian Ballet knows nothing of that Rhythm. . . . The Russian Ballet belongs to the Theatre of Yesterday.'[64] And John Balance,

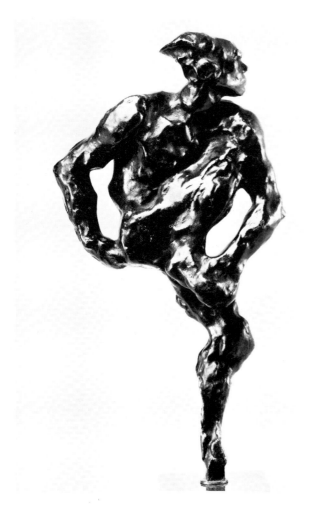

39 Auguste Rodin, bronze of *Nijinsky*, 1912

40 *Nude Sketch, with Raised Right Leg*, 1912

in a vein similar to Klee's, wrote in *The Mask :* 'It is nothing new. It is old French Ballet warmed up. As a work of art the Russian Ballet is a myth, and as a work of originality it is a fraud.'[65]

But if the ballet may have appeared an unrenovated art, the famous leap of Nijinsky symbolized a new acrobatic and modern freedom of the body. His circus lineage contributed to his prowess; his acrobatic skill and his personification of the Petrouchka endeared him to artists. The airborne dancer is almost as significant as the acrobat; he is a subject and a form at the heart of new art experiments: acrobat and dancer were taken seriously for both their artistry and their dynamics. The Futurist Severini, in Paris in 1912, used the music-hall dancer as his main kinetic motif.[66] In the twenties, Alexander Calder – mobile-maker-in-chief – made his circus in wire, and then a prototype mobile in suspended wire of the dancer–singer Josephine Baker.[67] Picasso, Matisse, Schlemmer, the Delaunays, Kandinsky, Miró, Rodin, Klee, were artists who experimented with new forms of the figure and were all, at some stage, enthralled audiences of circus and dance.[68] Indeed dance and circus appear as the *sine qua non* of the new body image.

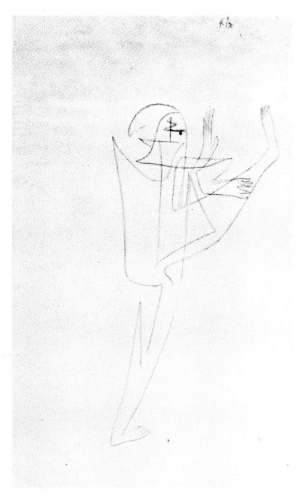

41 *Dancing Exercise*, 1928

In 1912 Nijinsky posed for Rodin, and the famous bronze sculpture of the dancer, acrobatic in its straining pose, has been called 'the nearest to an abstracted essence of a figure in movement'.[69] In the same year Klee drew a figure in contorted pose: the small sketch, *Nude Sketch, with Raised Right Leg,* has a remarkable similarity to the Rodin bronze, exaggerating even further the stretching form of the Rodin work. The leg is raised to its limits, the thigh strengthened in muscle, the head and arm compressed into an oval subservient to the action line of the leg. Much later, in 1928, Klee did a variant in almost the same position, in an ink drawing called *Dancing Exercise*, which is drawn with a stiffening of the earlier curves, changing from the sinuous to the regulated, from Jugendstil fluidity to Bauhaus discipline. The figure, still nude like Rodin's Nijinsky, is now constructed with straight lines, forming the body of intricate planes and extending legs and arms into tight small hands and feet.

Klee's eye for movement and his sense of the tension of gravity in the dance are detailed in early diary accounts of dance performances he attended. Four of them were written during the Italian tour of 1902, and the

fifth is the account of the Russian Ballet in Munich in 1913. He comments on the pose, line and acrobatic skill and the veracity of the performance. In Rome, for example, he saw 'La Belle Otéro', Spanish singer and dancer, a 'genuine representative of La Belle Epoque' who had made her reputation in Paris.[70] He wrote in detail of her performance:

... After the first part of the dance she rests. And then mysteriously, as it were autonomously, a leg appears clothed in a whole new world of colors. An unsurpassably perfect leg. It has not yet abandoned its relaxed pose, when, alas, the dance begins again, even more intensely. The pleasure becomes so strange that one is no longer conscious of it as such.

Apart from what is after all of an orgiastic character, the artist can learn much here. Of course, there would need to be still another dancer if one is not only to feel the law of movement, but also to understand it. The point at issue is perhaps only the complication of linear relations that subsist between bodies at rest. This topic for the time being constitutes my real field of research. (362)

This is Klee's most important comment on the dance, for here he connects his own visual researches with the laws of movement demonstrated through the dance. The kernel of his Bauhaus teachings on 'the phenomenon of the moving point' begins to take shape; likewise the symbolic demonstration of the dance as 'departure from earth'. Gravity early acquired a symbolic meaning for him. He was later to write: 'Gravitation and momentum add up to earthly cosmic tension,' and 'The purest form of movement, the cosmic form, arises from the elimination of gravity, of our bond with earth.'[71] Here he speaks with the appreciation of a Heinrich von Kleist.

On the Italian journey he also noted having spent the evening watching Cléo de Mérode, 'probably the most beautiful woman alive' (380). Her international repertoire of dance included Cambodian, Greek, and period French — the usual music-hall mélange of the time. Klee demonstrates his readiness to join the coterie audience that cultivated Eastern and Western, primitive and modern, and to find subtleties in such mixed fare. But he was also ready to be critical of such imported feats if they interrupted the 'peculiar logic' of Mérode's body and 'the beauty and wisdom of the organism as the whole'. Some ten years before he was to utilize such interruptions and abruptions in his graphic work, he wrote:

This has to be looked at with precision: here the main lines are not enough, and no substitute of a pathetic sort is available (she seems asexual). The substance of the dance is in the soft-lined evolutions of the body. No soul, no temperament, only absolute beauty. She is the same in the Spanish dance as in the gavotte of Louis XVI. Next to the gavotte, the Greek dance (Tanagra) suited her best. An Asiatic dance was not convincing. (380)

A few days later he saw the Spanish dancer Guerrero. Again his comment is serious and critical and his eye seeks out the contours of the dance: 'Technically speaking, the upper part of the body lacks mobility, it remains too stiff amidst the otherwise free flow of lines; the dance, as a result, sometimes gives the impression of skipping. The rhythm of the feet is particularly good' (385).

In view of the enthusiasm of artists like Toulouse-Lautrec and Mallarmé, Klee's main experience of the dance might well have been through the famous Loïe Fuller – queen of the Art Nouveau dance – whom he saw in May 1902.[72] But she was 'purely technical, purely decorative', and he was much more enchanted by the accompanying Japanese artist, Sado Jaco:

Sado Jaco doesn't stand out from her troupe like a diva; instead, it is the style of the company as a whole that makes a phenomenal impression.

A kind of primitive consciousness pervades the whole thing, both the plays and the art of performing them. The poses develop in abrupt movements and remain fixed for long moments. (403)

Klee's liking for the Eastern theatre is confirmed in a later comment of 1904, after a performance of Chinese acrobats at the Deutsches Theater in Munich: 'Real Asians are better than English aesthetes tired of Europe' (578) – an echo of Rodin's reactions to the Cambodian dancers as reported by Hugo von Hofmannsthal: 'The movements of these women when they dance are right. The movements of the European dancers are false.'[73]

Despite Klee's interest in the dance and his careful documentation of effective movement, his early art, concerned as it is with Symbolist themes of mask and persona, does not reflect his concern with movement and fluidity. A few fragmentary sketches suggest only the vaguest beginnings: in retrospect we see the long maturation of some of the themes. The first dance study – simply called *Nude* – is dated 1905: a nude figure is bent over in violent action, and a sequence of positions of limbs is drawn lightly behind the darker complex outline. The combination of the movements of the dance in time, even in such a slight sketch, is prophetic. In 1908 Rodin attempted a clumsy two-part repetition of dance movements in bronze, and he had used a multiple outline earlier in drawing,[74] but it was not until 1911 that confident stroboscopic effect became a basic feature of Futurist painting and found its greatest notoriety in Duchamp's *Nude Descending a Staircase* in 1912.[75]

Around 1907 and 1908 other fragmentary Klee sketches show dancers, not as movement studies, but as further expressions of his caricatural approach to human activity. The dance is used to highlight the most farcical

42

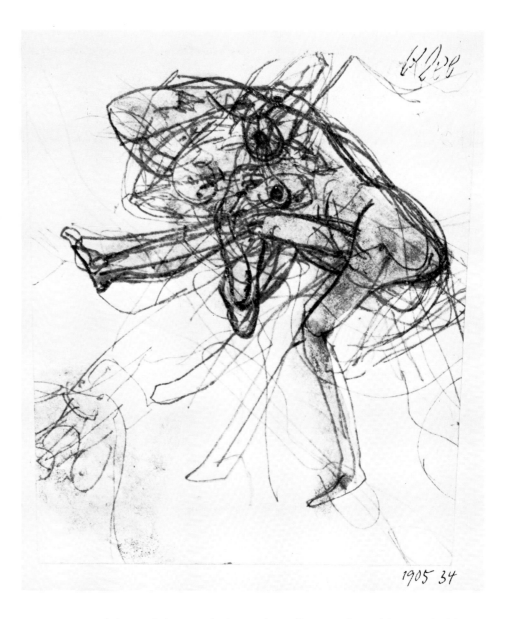

1905 34

42 *Nude*, 1905

movements of decrepit human beings, absurdly capering with arms held out,
awry and with kicking legs, like the *Two Spinsters, Nude with Crests*.

17

One of the small sketches of 1907, a pungent *Nude, Dancing Venus*, points
to the future. It exaggerates the thrust of the dance into a sexual caricature,
anticipating one of the important themes of Klee's later work, the potency of
Venus. The dance, as Klee was so aware on his Italian trip, frees the body; its
liberation is both emotional and psychological. The dance of the Venus
carries a satanic attraction: its elegant sinuous line, its diaphonous Art
Nouveau draperies are at the service of the dance of death.[76] It is a theme and
an emphasis to which Klee will return. Above all, the serpentine dance
belongs to Salome, who worked for destruction through the seduction of the
veil. Loïe Fuller's seven veils could be seen as a modern embodiment of the

43 *Nude, Dancing Venus*, 1907

ancient dance of death, another aspect of the *fin de siècle* themes of Beardsley, Wilde, and Gustave Moreau, of the skeletal dancers of James Ensor, and the various versions of Munch's lethargic and deadly *Dance of Life*.[77] And the mask was assumed as part of the lethal disguise. The puppet, too, was a grotesque dancing participant, as in James Ensor's ballet creation, ostensibly devoted to *La Gamme d'Amour*.

In his earlier work, Klee had indulged in caricatural expression, in themes of sexual and social perversion and decadence. He continues these Symbolist preoccupations through the introduction of another spectacle figure from the *fin de siècle*: Salome.[78] She is epitomized above all as the *dame sans merci*, ugly rather than voluptuous, lacking the innocence that Picasso had given to her in his etching of 1905. For Klee in 1920 – just prior to the Bauhaus

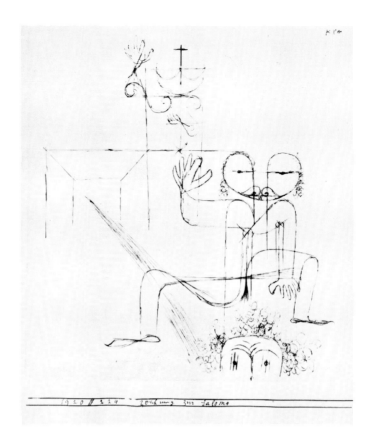

44 *Drawing for Salome*, 1920

appointment – Salome is endowed with something of the grotesque humour and acrobatic skill he admired in Sado Jaco's 1902 performance. In *Drawing for Salome* she is the gauche puppet: flat, almost like a shadow puppet, with splayed legs. She is manipulated by visible strings above the head of the Baptist, but he – the victim – is also drawn in above the dancer and pulls her strings, so that she becomes both seducer and victim, the *femme enfant* as well as the agent of the tragedy. In *Dance of the Veils* she prances again, childishly, and with some awkwardness, with fingers stretching the famous veil into a grin across her face so that it becomes, like the early masks, the actual skin. Though delineated in Klee's mature graphic style, she has that air of grotesque fascination which she gained in her nineteenth-century literary incarnations in the plays of Hebbel and Oscar Wilde – plays which Klee had read and seen on stage. We recall that dedication of the original Wilde edition of *Salome* given to Aubrey Beardsley: 'For Aubrey, for the only artist who, beside myself, knows what the dance of the seven veils is, and can see that invisible dance.'[79] Klee might have qualified as an initiate.

The marionette figure is not admitted only to the theatre and circus world. For Klee, its significance is much wider, and it makes an assured appearance in his second published set of book illustrations, those for Corrinth's *Potsdamer Platz*, drawn in 1918 and 1919.[80] The formula for frailty, perfected

45 Franz von Stuck, *Salome,*
1906: the *fin de siècle*
evocation of the *femme fatale*

46 *Dance of the Veils,* 1920

47 *Oh, you are so strong!,*
drawn in 1919 as an
illustration to *Potsdamer Platz*

27

36, 37

in the *Candide* illustrations and then extended in repertoire and firmness of touch in the *Sturmbilderbuch* drawings, can be transferred to any human plot.

The devices that appeared in the *Candide* pages included the acute stretching and elongation of the body, expressing its reaching-beyond-itself in desire or in pain. The transference, dilation or X-ray presentation of the heart and of the genitalia expose the sexual drive of the protagonists. The fusion of bodies, overlapping and merging, is the cipher denoting destruction of individual autonomy by society, sex or parenthood.

Klee's dramatic view of the world was not merely fed by the contemporary fringe theatre and his early reading, or with the leftovers of a Symbolist age, but was – as his diary reveals – close to his own way of seeing. It is a mixture of irony and humour, with a characteristic smile at the antics of the bourgeois and an underlying sense of pain at the strictures that distort patterns of behaviour. As early as 1905 Klee recommended that the satirized subject be close to the artist: 'One does not lash what lies at a distance. The foibles that we ridicule must at least be a little our own. Only then will the work be part of our own flesh. The garden must be weeded' (681). Did Klee, six years before the *Candide* illustrations, intend an echo of Voltaire's *Il faut cultiver notre jardin,* the words which conclude *Candide*?

4 The Bauhaus Stage

After 1917 Klee no longer worked predominantly with graphic techniques. Yet the work coming before the public was still graphic: the *Candide* illustrations and *Potsdamer Platz* were yet to appear, and, in 1917, the *Sturmbilderbuch* acrobats had just been published. The writers of the first monographs on Klee, H. von Wedderkop and Leopold Zahn, however, saw him as primarily a painter, with a corpus of paintings produced between 1914 and 1920, the publication date of their books.[1] The emphasis had shifted since 1912, when Hans Bloesch wrote of Klee as 'a modern graphic artist'.[2] Even in 1918 the poet Theodor Däubler thought of Klee – with great admiration – as a graphic artist who had reached a 'superior simplicity through his hair-line stroke'.[3] But Däubler, like all the observers of Klee then and since, saw the beginnings of his painting career in Tunisia in 1914.

Klee's watercolours, particularly those produced in 1917 and painted on such unorthodox grounds as cheesecloth, create a world of landscape with predominantly lyrical qualities. They are geometrically composed, bordering on the abstract. Caricature and the human figure play no part. Klee had learnt a gentle geometry from Delaunay and Blaue Reiter friends like August Macke, so influenced by Orphic Cubism.[4] Made aware of the intrinsic harmony of the colour spectrum, Klee worked in the colour range of the primary colours, the secondaries and the neutrals – black, white, grey – balanced together in harmonious watercolour squares.

In such works as *Pious Northern Landscape*,[5] of 1917, he repeats a strip of colour as if it were the element of a fugal composition, evocative perhaps of the country and inspiration of J. S. Bach. It is the repeated forms and the spectrum of transparent colours that give to these works their rhythm and musicality. Against the awkward human fall from grace as delineated in the drawings, there comes the certainty of that grace, not granted to humans, but celebrated in nature. Some of the paintings give nature herself the stage. *Nature Theatre* of 1914 is among the earliest of the painted landscapes. It is a Swiss landscape with fir trees and mountains, presented in a genial *Märchen*-like style – Alpine, but with no hint of Romantic chasms. Quaint, yet ancient

48 *Nature Theatre*, 1914

and archetypal, the trees and mountains are presented as if beneath a curtain: even nature must be revealed and must take her bow.

The *Märchen* stage set reappears in the works of the Bauhaus years which have specific theatre titles. *Stage Landscape*[6] of 1922 is framed in a cobweb-fine curtain, and the set is of diaphanous small houses with steps. In its gossamer lightness it is like other landscapes, not so specifically stage-titled or curtained, such as *Hermitage* of 1918 which features Klee's recurring cosmic fate signs, a dark sun above a dark cross. *Hermitage* is another northern landscape with Gothic overtones, hinting at the presence of an unseen recluse who seeks wisdom through the contemplation of the cross and through isolation in his nature theatre. Despite its very different style and mood, and a simplicity akin to folk art, its overtones are of Friedrich's *Cross at Rügen* and his winter landscapes. In Klee's small landscapes, the northern Romantic tradition is gently ushered into modern art.[7]

After 1920 the nature theatre appears only rarely, but actors, clowns and objects framed between curtains appear frequently. In this year Klee was called to the Bauhaus, where he was in close contact with Schlemmer, Schreyer and Kandinsky, all of whom had an active interest in theatre. In May 1922, at the Bauhaus festival, a few of the Zürich Dadaists – Doesberg, Arp,

Richter and Schwitters – were at Weimar to deliver a funeral oration over the ashes of Dada, but already the phoenix had risen in the Bauhaus school of theatre design.[8] Lothar Schreyer, the first master of the stage, was then developing the theatrical experiments of his Sturm Theatre in Berlin. He sought a total theatre, a theatre of artifice and mask. The use of masks was conspicuous in his own plays:

Some masks, such as *Der Tod* in *Kindsterben*, were over life-size; the masks in *Sünde* were up to three metres high, and they were moved from inside by their wearers. For *Kindsterben* we succeeded also in building up colour-form figures which in a way were crystallized power centres of the play. Each of these figures became a non-representational plastic coloured work of art. The work on the masks was always a new job to us, a compensation for the extremely difficult development of the *Klangsprechen* [the sound speech] which demanded far greater concentration than other artistic work.[9]

For a Bauhaus class in stage theory Schlemmer (who took over after a rather disastrous Schreyer performance) developed exercises creating variations on the human face, subdivided and separated into geometric shapes so that the parts were varied, contrasted and clear. One mask had tonal strips arranged vertically, in another he arranged the strips horizontally, another was divided down the middle into dark and light halves, another

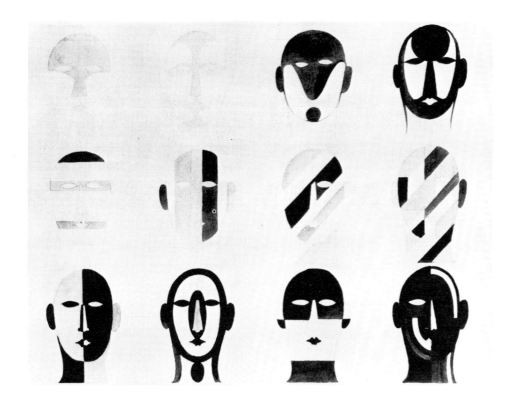

49 Oskar Schlemmer, drawings of variations on a mask for a Bauhaus class in stage theory, 1925

concentrated on the outline of a sphere head. The process was not unlike
Klee's measured division of the circle and the oval in his paintings *Senecio*
and *Clown*.

54
55

Schlemmer regarded the mask as one of the main instruments for
controlling expression on the stage: 'My experiments with masks have taught
me that a minimum of expression, even the suppression of any expression,
cannot prevent the mask being expressive with its fascination, its stereotype,
its inner being.'[10] But it is, too, a magical tool of transformation: 'The
transformation of the human body, its metamorphosis, is made possible by
the costume, the disguise. Costume and mask emphasize the body's identity
as they change it.'[11] Schlemmer aimed to make the human actor visible on
the stage as a design of clear parts in motion. The mask was an important part
of the regulated appearance of the figure.

Schlemmer also organized pantomime improvisations which must have
been somewhat reminiscent of those of the Cabaret Voltaire. The Bauhaus
students and staff made masks for their frequent festivals – Dada-like
creations, invented faces.[12] Klee enjoyed these events and appeared at a
party which had the theme 'Beards and Noses' with mutton-chops and at a
Kandinsky evening as a Turk.[13] For one of the official Bauhaus exhibitions he
embellished a lithographic postcard with a row of masks, and in 1926 he did a
pen drawing called *Mask Revue* with a line-up of heads made of whorls,
circles and squares, surely reminiscent of the Bauhaus events.[14]

Schlemmer, as we have seen, saw the mask as an instrument that would
not only promote a new non-naturalistic art, but would convey the artist's
sense of spontaneous play. As he put it in his 1926 diary: 'Human beings will
always love bright games, disguises, masquerades, dissimulation, artificiality,
as they will always love any festive, eye-catching, colourful reflections of
life.'[15]

In 1919, just prior to his call to the Bauhaus, Klee attacked once again the
problem of the representation of the face. While still rendering it in a
schematic, linear way, he made shading more prominent and exaggerated
features in a very deliberate way. In *Head with Moustache*, he practised a
gentle caricature. *Portrait of a Snub Nose* is a seamed and nasty face recalling
the ingrown masks of the early *Comedians*, but now Klee used a light style, a
frail line and a background of pastel blocks of wash: laughter, or at least a
smile, has the upper hand.

In the Bauhaus years various works appear with distinctively physiognomic
titles, like the shadowed ink drawing *Small Contribution to Physiognomy* of
1925, with a full face in bare outline, given small darting eyes, and a mouth in
darkness which cancels the ingenuousness of the features. *Demonstration of*

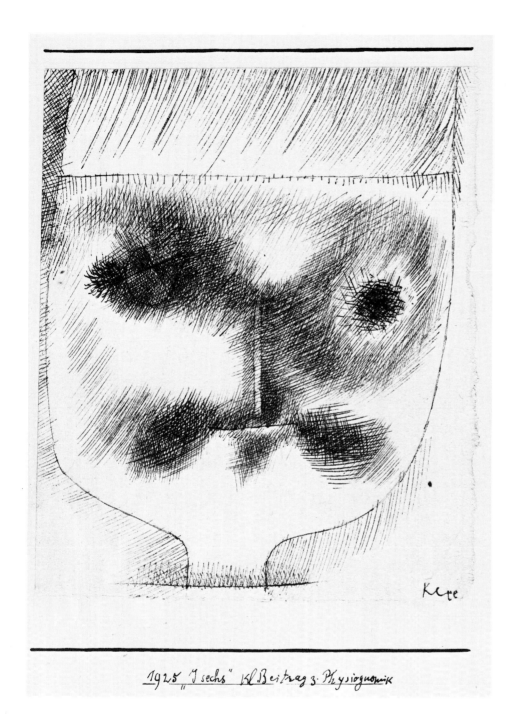

1925 "sechs" Kl Beitrag z. Physiognomik

50 *Small Contribution to Physiognomy*, 1925

Death of 1925 is a forecast of the end-of-life masks of the thirties, and uses a similar shadowed style that gives to the simple mask face, with its prominent triangular nose, a cross-hatching evoking the sinister. *Mystical Physiognomist* of 1924 is an inscrutable face with the clockwork eyes of the automaton set with turning arrows. It may be an ironic self-portrait: the vistas of the mind

are rendered as fragile climbing apparatus, reminiscent of the acrobat's equipment, implying the agility common to artist and gymnast. The head becomes transparent, and no longer does the thought need to be on top of it, as was the rodent of the early *Threatening Head*.

The face worn by its own tears appears in one of Klee's gentlest physiognomic masks: *Lomolarm* of 1923 (the title a play on the French *l'homme aux larmes*, the weeping man), with the eyes extended into rivers flowing over the nose and consuming it and becoming three long tear-ducts down the face. Their sad verticality is more prominent than the face's external boundaries.

These are masks of metamorphosis – man into tears, man into tree, man into flowers – a sequence of poetic faces produced in the twenties, like modern versions of the Ovid that Klee read in his youth. *Old Man Tree* of 1923 is a black line drawing of a complicated face, angular and vertical, in the process of emerging from a brown cross-hatched tree. In *Flower Face* of 1922, green unfolding shapes hint at the features. *Wintry Mask* of 1922 is in the sprayed technique of which Klee was fond at that time, a solemn white snowman face, a visual metaphor of a snowscape grafted on to a neck and suggestive of the chill of winter and of man rendered into the likeness of the seasons. Then there is the crueller metamorphosis of women into animals, like the elephant *Trunk Mask* of 1922, and the *Demoniac Lady* of 1937. Woman is, unhappily, rendered as a kind of deer, her hair done up in horns, her nose squeezed into a tiny neck, a great eye extending out and the neck growing into an animal's body.

Early on, Klee saw that the mask could be given to children, for it could be used to heighten their innocence and to forecast the sorrows of the adult world. In 1908 he used the new bare line to open out the features of *Child with Toy* into a big nose, a generous mouth and large sad eyes. Klee felt acutely the possibility of sorrow in a child's world: it is an index of his compassion that he saw that the child must manipulate the beguiling but dangerous pieces of the puppet theatre. *Child* of 1918 is already cast for the misadventures of the 1921 *Comedy*, as she carries the fateful symbols of eroticism. *Blue-Eyed Portrait* of 1919 has been given the despairing, fixed glance of the fated children, but the hairless head transforms the subject into a creature of indeterminate age, disconcerting with her asymmetrically dropped eyes. Children play a tragic role in Klee's oeuvre. The visual form and the title of *Child Consecrated to Woe* of 1923, with its hair woven of small diamonds, the nose of spiral lines, and the 'W' of *Weh* (woe) marking the forehead into a frown, are indications of his sense of the inevitability of circumscribed adulthood.

51 *Flower Face*, 1922

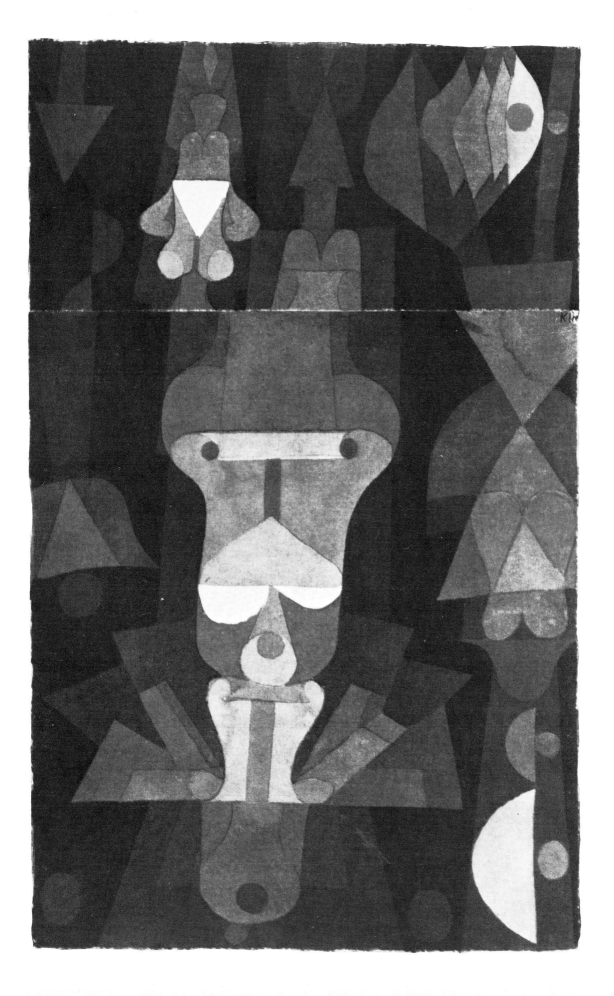

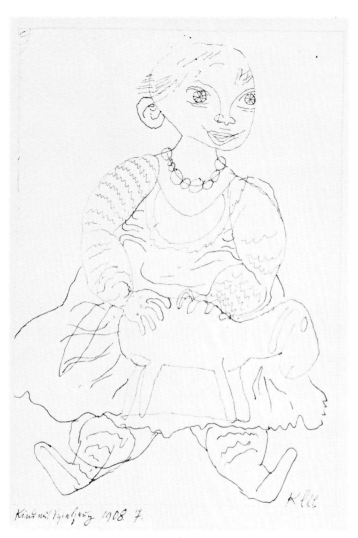

Kind mit Spielzeug 1908 7.

52 *Child with Toy*, 1908

1918 70

53 *Child*, 1918

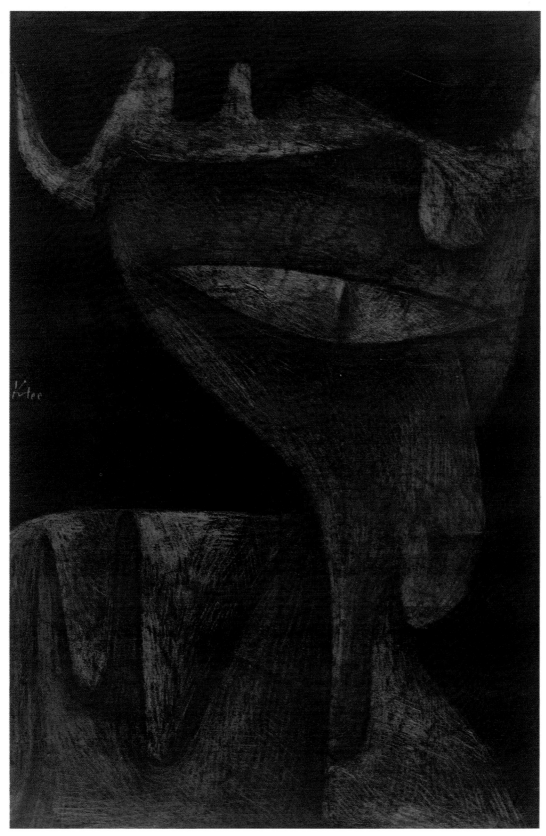

1 *Demoniac Lady*, 1937

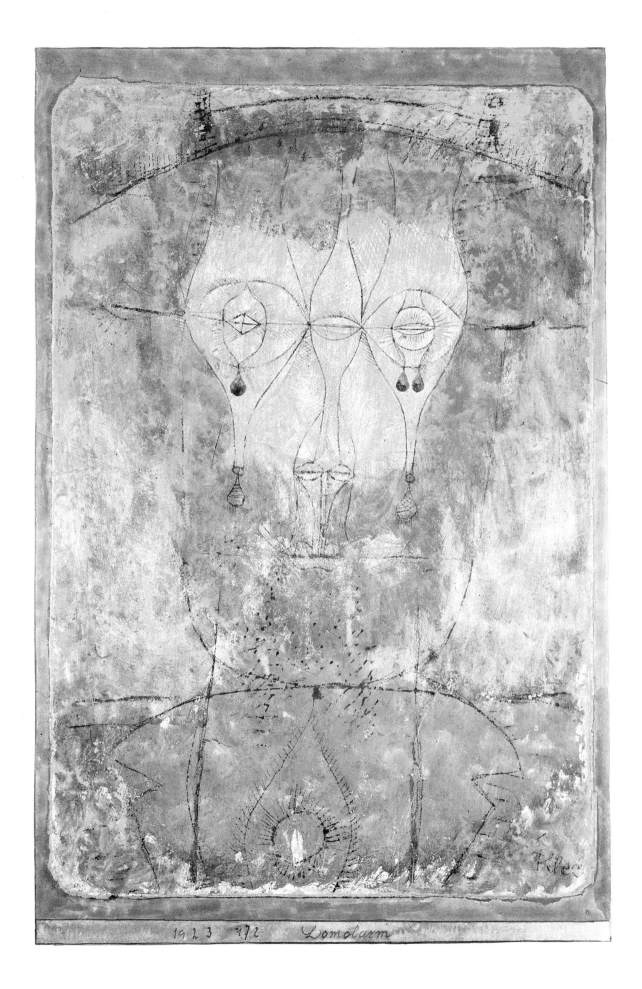

1923 172 *Lomolarm*

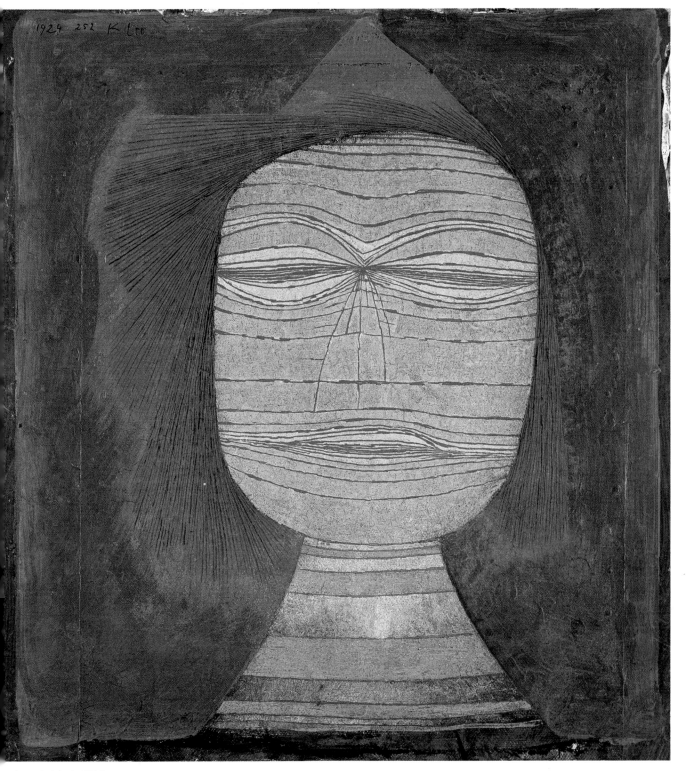

Actor's Mask, 1924

Lomolarm, 1923

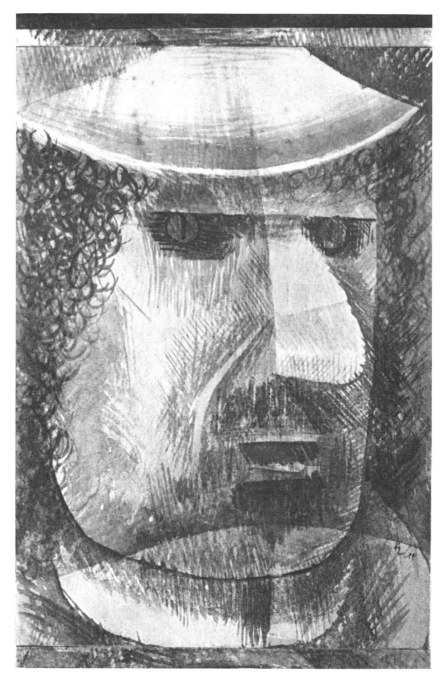

IV *Mask for Falstaff*, 1929

v *Head of a Young Pierrot*, 1912

VI *Don Chi*, 1934

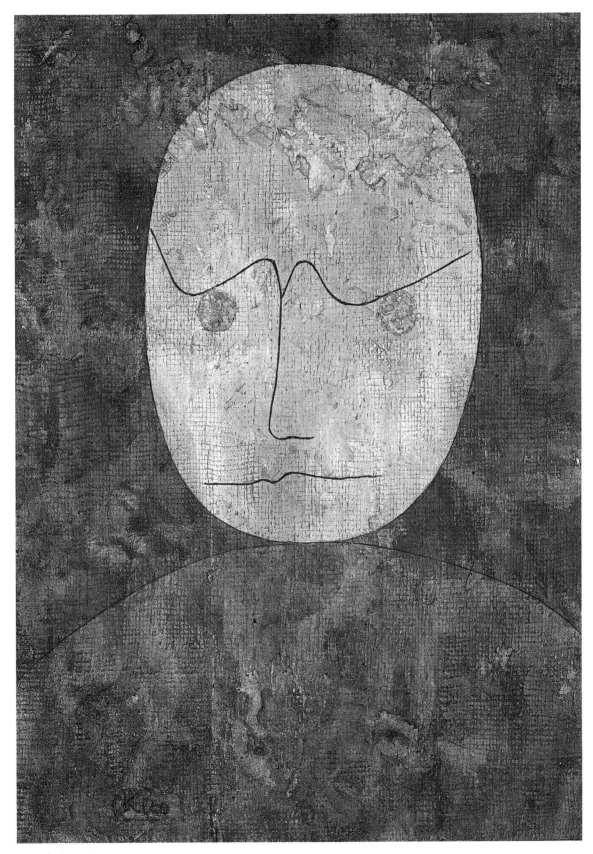

VII *Scholar*, 1933

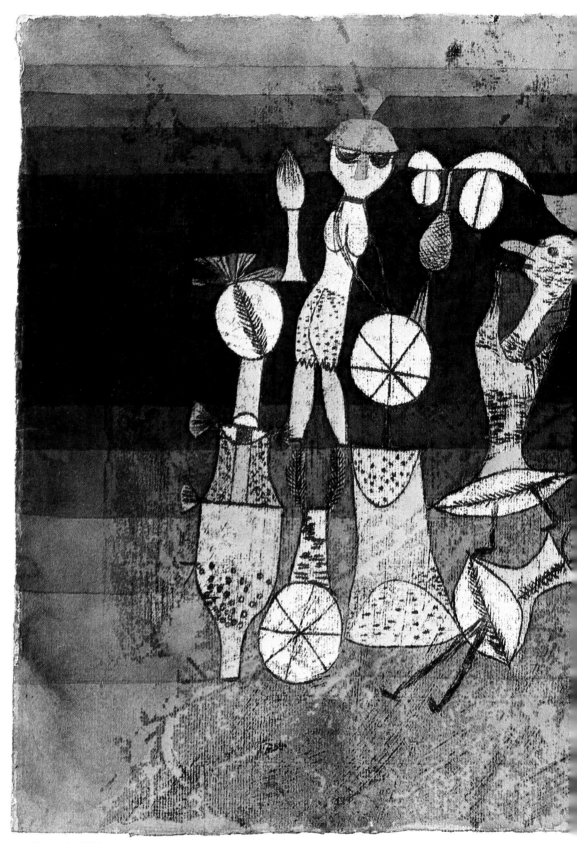

VIII *Comedy*, 1921

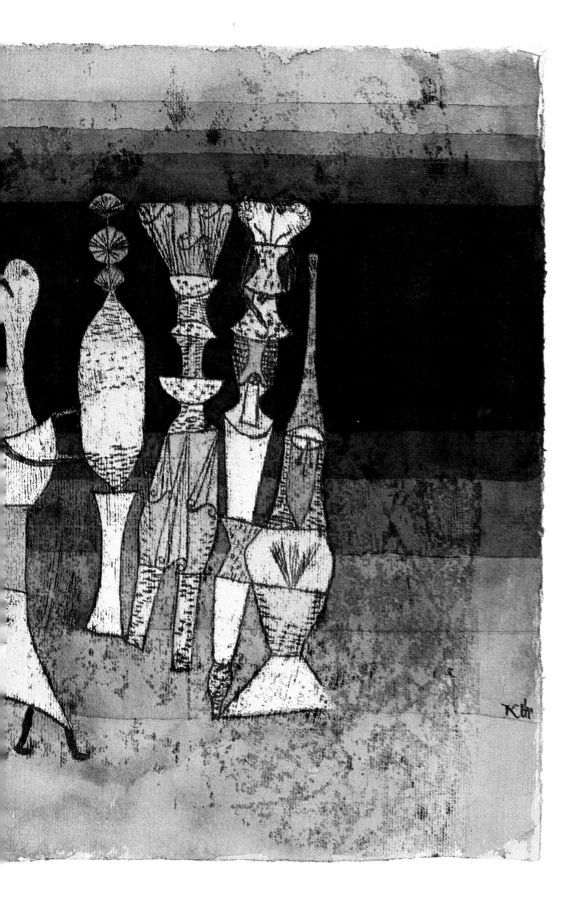

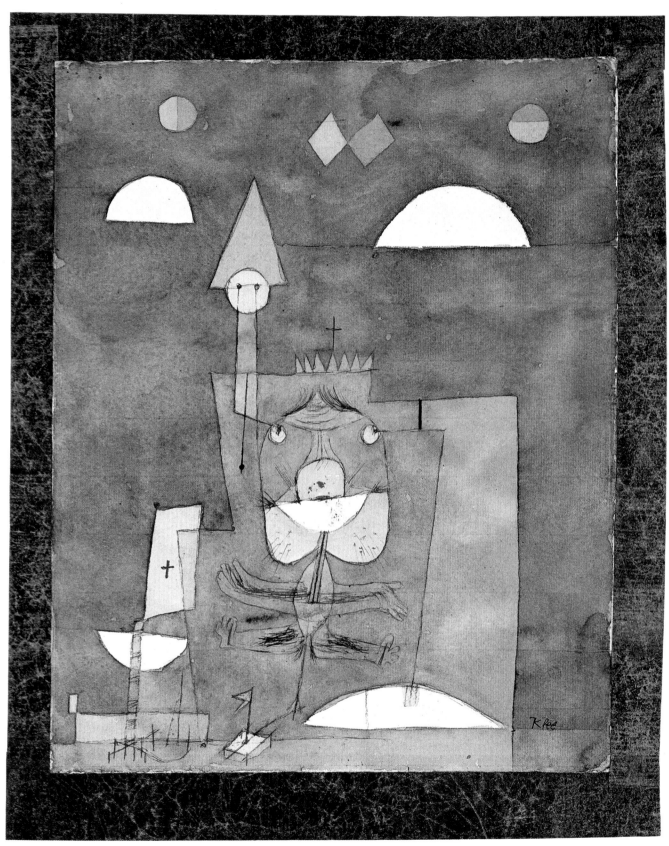

IX *The King of All the Insects,* 1922

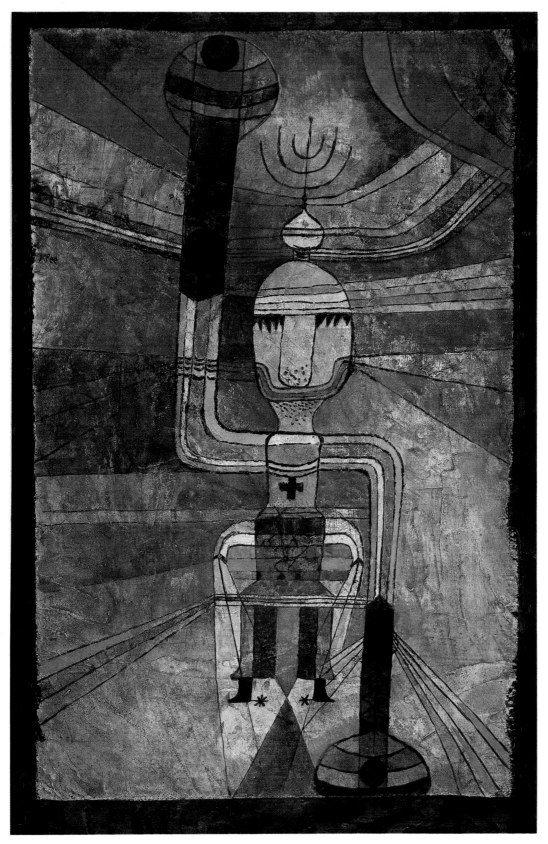

x *The Great Emperor Prepared for Battle,* 1921

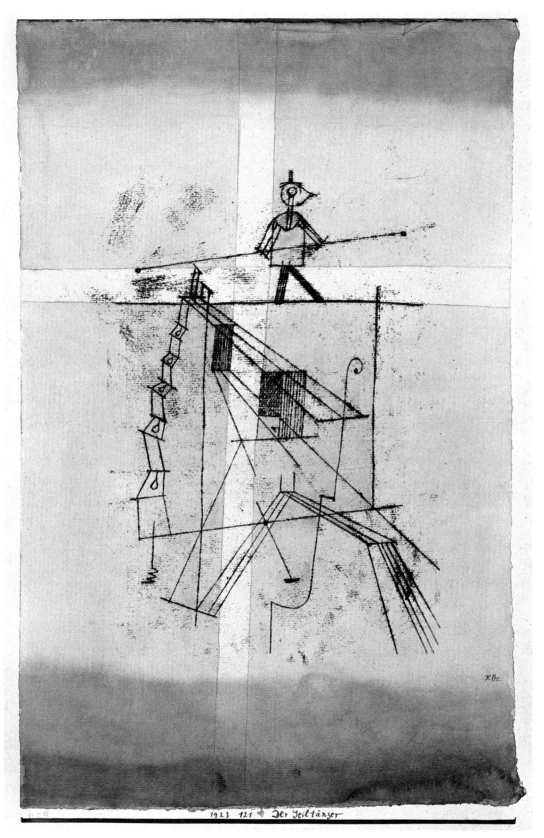

XI *Equilibrist,* 1923

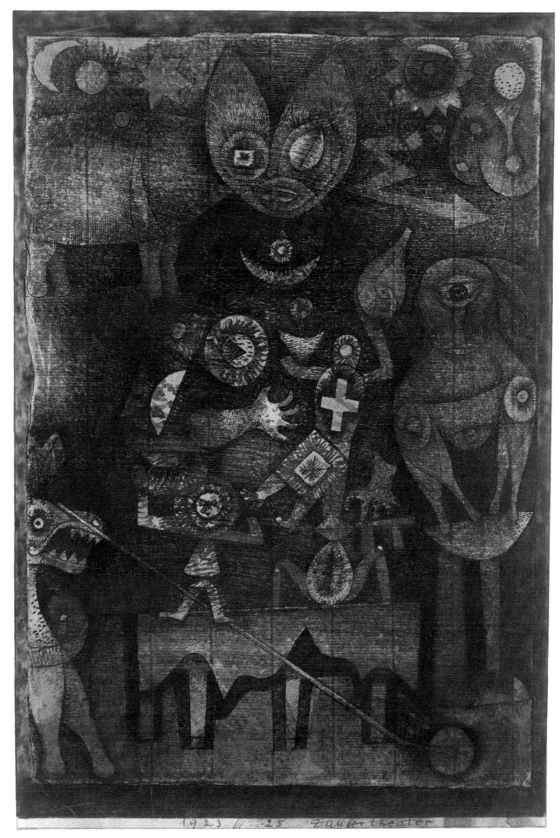

1 9 2 3 // .25 Zaubertheater

XII *Magic Theatre*, 1923

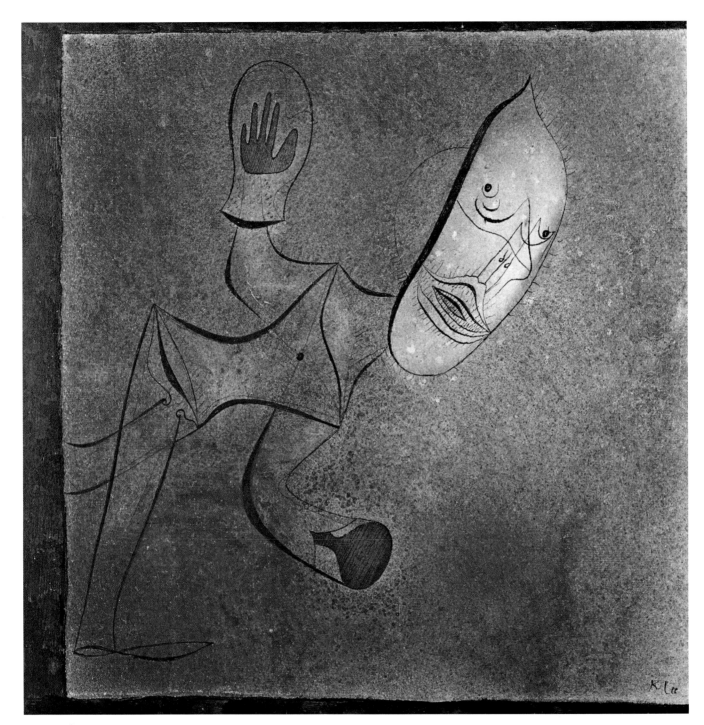

XIII *Brutal Pierrot,* 1927

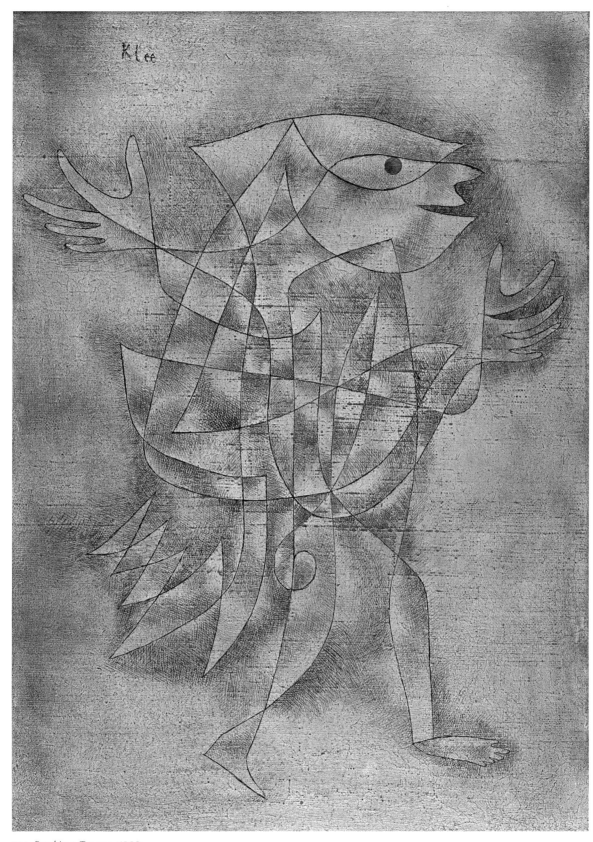

XIV *Fool in a Trance*, 1929

xv *Ceramic/Erotic/Religious*, 1921

Double transparent forms delineate *My Name is Parents' Image* of 1933: in a collage of two merged heads, the double dots of the parents' eyes impose their heredity on the child, while checkered shoulders hint at the harlequin.

The very formal hieratic painted masks of the twenties recall, perhaps, the tall masks of Schreyer and the geometries of Schlemmer. The colour squares are prominent, and make quite explicit the connotations of theatre. The face of *Senecio* of 1922 suggests to the viewer the process of creation, the juggling, almost abstract, of geometric pieces, of combinations of circles and their subdivisions. His forerunners are the 1912 *Head of a Young Pierrot,* and the circle doodles of heads from 1913. *Senecio* is a complete and confident circle; the left eye is mounted by a triangular eyebrow, the right eyebrow is curled. *Senecio* is a flower, but does not his name evoke that of the Roman playwright? This quizzical, modern Seneca may again stand for that idea of the world stage on which both humans and nature act out their lives. *Senecio*, the poisoned flower, and Seneca, the tragic dramatist, simultaneously inhabit this face which wears the multi-coloured costume of the harlequin.

54

V

Three of the masks of the twenties are proudly theatrical: the *Actor*, whom we have met through his oriental lineage, the *Clown*, and *Senecio*. These are portraits of artist–performers involved in the ritual of play. We have referred already to the role of play and spontaneity in Klee's theory of art. These faces can themselves be taken as symbols that continue the preoccupations of the early etchings, the artifices of art and the shifting relation between art, illusion and the world of play. It is the *Homo Ludens* again: these faces demonstrate the pervasiveness of play in the human condition and its essential role in the orientation of both child and adult.[16] Klee was strongly aware of the role of play in his working process, and sought to keep it evident in the finished work. He drew attention to the manipulative aspect of art-making, both in his technique and in his titles. And he sought, in these mature years, humour and wit in his forms and a correspondence of his forms with the titles.

III

55

Ernst Gombrich has written of Klee's description of the elements and process of painting, most clearly described in the Jena Lecture of 1924, as 'the modern painter's experience of the game'.[17] It is manifest as a willingness to work without a fixed goal and so to allow discovery and association in the process of work. Yet Klee is obviously interested in a precise range of themes both in nature and in the depiction of the human figure, and the spontaneity of the final result can be over-emphasized in an interpretation of his work. Yet it is obvious that he has long sought the spontaneous effect; he himself documents it. As early as 1908 he wrote in his diary of 'light and rational forms

54 *Senecio*, 1922

VII

. . . locked in combat; light sets them in motion, bends what is straight, makes parallels, ovals, inscribes circles at the intervals, makes the intervals active' (834). This 'combat' results in the subdividing of the circle and the zigzagging of the oval that he deploys in many later paintings, most notably in the masks: *Senecio* is the subdivision of the circle; the *Clown*, of the oval; and the oval is given a curved line for the frown in *Scholar*.

55 *Clown*, 1929

The *Scholar* may also, perhaps, be claimed to belong to the company of the theatrical dissemblers. Klee registered his comment – 'impish laughter at the learned apparatus of scholars and parsons'[18] – but gave a sad conscientiousness to his mask. In a drawing of the scholar the force emerges from a set of triangles, inflexibly constructed, with vertical planes furrowing into a long, frowning face. In the painting there is a swaying oval with a squiggle line waving across the egghead face to form the concentrating eyebrows.

In the theatre company there are, too, characters of stage and opera long IV loved by Klee. *Mask for Falstaff* of 1929 creates a face for that dual figure of tragedy and merriment, the jolly protagonist of *The Merry Wives of Windsor* who becomes the rejected and sad comedian of *Henry IV*. The inspiration may be Shakespeare or Verdi. He appears as another Pangloss whose assumed mask is at variance with his actual situation. Also at variance with his popular role as the successful philanderer is Don Giovanni, painted in 1934 on ragged VI hessian, his name shortened to *Don Chi*, his face a paper mask, thin and pathetic. It is as simple of feature as a New Guinea dance mask, an empty paper bag with a still elegant moustache inscribed above a spiral. A light tragedy: 'Mozart took refuge (without neglecting his inferno!) on the joyous side,' Klee had written earlier, thinking of *Don Giovanni* (950).

These masks, then, with their childlike directness, a basic schema which could almost be described as infantile, suggest a process of creation which has been at once dignified and light-hearted. Such works seem to be the products of scribble and play, and yet they register an adult fascination, carefully cultivated, with the head seen as a circle and the magic metamorphosis involved in naming a circle a head. And the personalities invested in the circles are those of theatre and the world of creation. This gallery of circles and ovals is a tribute to the theatre as an art of play and multifarious appearance, as painting itself was to Klee.

And as the head continues to be a signpost of physiognomy and artifice, rendered in the form of the mask, so the complete figure continues, during the Bauhaus years, to display the artifices and enact the allegories of the early puppet dramas. Klee himself made puppets, still preserved, for his son Felix, and we have many reminiscences of the puppet theatre which stood in the corner of his studio. Lyonel Feininger remembers:

Most beautiful of all were the masks and figures of the puppet theatre that Klee had made for Felix. Indescribably expressive, each single figure, even portraits of close friends aptly characterized and humorously caricatured. There was no end to the laughing and the enthusiasm when Felix gave a performance in his grotesque manner. Klee then sat somewhere in a corner, smoking his pipe and smiling in quiet enjoyment.[19]

A friend of Felix's recalls an impromptu performance:

He had built for his son Felix a puppet theatre, dark blue with red edges. The puppets,
mysterious beings made of plaster of Paris, painted in pastel tones, were part eerie,
tender, grotesque and witty. Among other things I still see before me that ghost
made out of an electric socket with nutshells for his eyes. One evening Klee was
playing alone in the neighbouring room – an old sarabande for violin. Suddenly Felix
disappeared behind the stage and improvised a dance with Death and his wife. This
was unforgettable.[20]

There was a whole gallery of characters: ghosts and monks, Eastern figures,
peasants, the figure of Death, and a self-portrait, all with simple folk-art
features, widely set eyes with careful eyelash stitching, emphatic separation
of eyelashes and eyebrows. Photographs of the puppet theatre show sets
with backdrops of flattened architecture, doors leading nowhere – miniature
paraphrases of an Expressionist stage, but without the trauma and the
claustrophobia. Klee's theatre sets are for children, as are some of his more
ingenuous paintings. Not all are clear allegory, but most carry the promise of
broken strings.

Puppets, not surprisingly, were cultivated at the Bauhaus. Not only did Felix
give his performances, but Schlemmer made puppets, and in 1924 Kurt
Schmidt made them with smooth, elegant joints rather reminiscent of the

Täuber-Arp creations.[21] For his production *The Adventures of the Little Hunchback* (a Klee-like title), he made the hunchback as a rounded pantalooned figure, the tailor's wife full-skirted with a circular head, the tailor a thin strip figure, the hangman like a child's Meccano man. Perhaps these figures show more variety of abstract invention than was offered by most artists at that time. Schmidt made them asymmetrical, with legs of different length yet with an overall balance. The straight pieces of wood are joined crossways, and arms are attached to ambiguous legs. In keeping with the general flavour of twenties' Bauhaus geometry, the figures have straight lines rather than curves; they are all flat.

The creations of Schlemmer and the Bauhaus puppeteers are of streamlined abstract human forms, small-scale evidence of a general rethinking of the presentation of the human figure. The renaissance of the figure anticipated by Schlemmer was to be initiated by these small artificial beings. He wrote: 'It is not a difficult step from the mask to the marionette and the puppet. The world of these artificial, moveable creatures is rediscovered and a renaissance of the puppet figure is introduced which can now become the field of experimentation of the stage . . .'.[22]

Even in the first phase of the Bauhaus stage, Lothar Schreyer, fresh from his Sturm Theatre experience in Berlin, had brought ideas of a new stage image of man: he had found this to be most appropriately the automaton figure. For

57 The tailor, the tailor's wife and the hunchback: Kurt Schmidt's puppets for *The Adventures of the Little Hunchback*, 1923

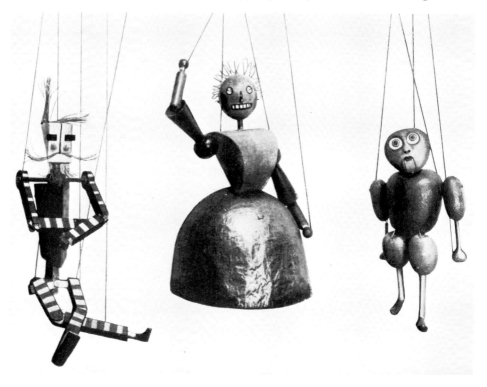

his Sturmbühne production of *Der Mensch* (Man), a post-Symbolist allegory, he introduced a figure of straight lines, jointed and flat[23] (and connected in its flatness and subdivision with a pair of his watercolours called *Marionette*[24]).

Schlemmer described the appearance of the marionette, streamlined and precision-built:

The functional laws of the human body in their relationship to space. These laws bring about a typification of the bodily forms; the egg shape of the head, the vase shape of the torso, the club shape of the arms and legs, the ball shape of the joints. Result: the marionette.[25]

As late as 1930 Schlemmer believed that a renewal of figurative art could come through appreciation of the puppet. In August 1930 he wrote a lament for the loss of direction in painting, seeing a destructive struggle for style occurring at that point in modern art. Paul Klee and Kandinsky he saw to have styles that were unassailable; they were 'islands' of their own. But he saw the general saviour as the puppet. It represented a necessary stylization and demonstrated a way to form that had been apparent in all great styles of painting. He recalled the puppet-like appearance of Seurat's figures, whose rounded form is clearly one of the sources of his own painted and sculpted figures, and is also so characteristic of his stage creations. The diary entry closes with an affirmation that the way to style lies through the puppet.[26]

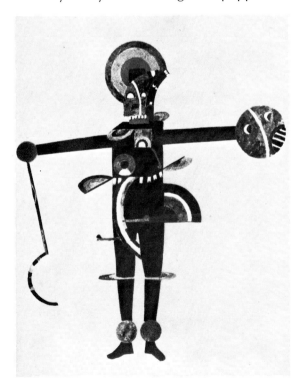

58 Lothar Schreyer, design for a figure for the stage production *Der Mensch*, 1921

59 *Performing Puppet*, 1923

Klee, of course, had long demonstrated that the puppet could provide not only a visual renewal of the human figure, but a means of comment. In 1923 he sketched a figure called *Performing Puppet*, like the *Candide* figures capable equally of dance or of collapse. The latter is more probable, for the figure is thin and spindly, imbued with all that earlier vulnerability; it leans with arms and hands awry, and the legs aggressively hinged to the body by a heavy-lined crosspiece. Kurt Schmidt's thin rod puppets produced for the Bauhaus stage about the same time are not unlike Klee's sketch.

Some of Klee's puppets become elaborate graphic patterns, like the *Costumed Puppets* of 1922, which make unambiguous reference to the theatrical tradition of the marionette. The sense of play and construction has built them with transparent curled legs and scroll-like treble clefs drawn into their joints, and provided fancy lids for their eyes. The marionette now operates even more clearly in its realm of delicate balance; its strings, whether actually drawn or implied, are strings of fate. The small lower figure stands on a ball and is connected by spring-like bracelets to the two large figures higher on the page. It is clear that the small figure is a victim of the actions of those who are taller and who dwarf it by their height. Such a figure, with its lightly disguised didactic point, gives opportunity for the build-up of linear forms: Klee's favourite 'development of a formal motif'. The element of

Kostumierte Puppen

60 *Costumed Puppets,* 1922

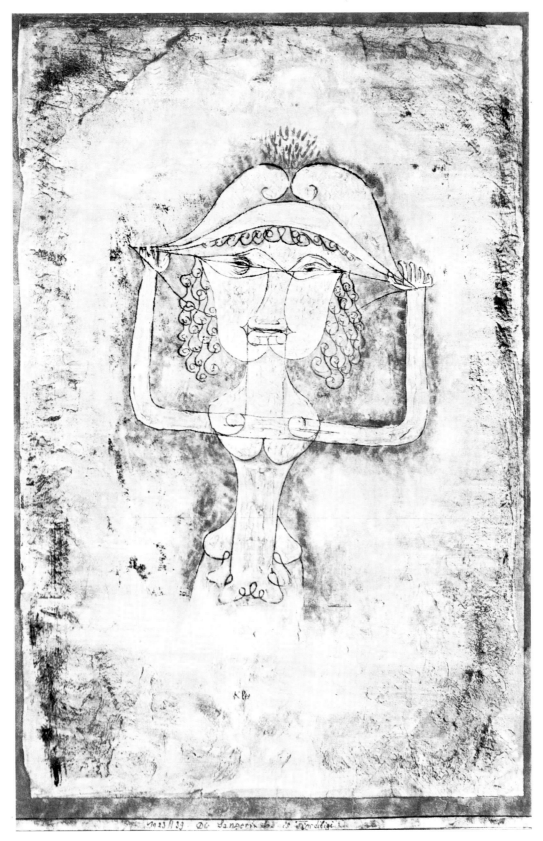

61 *The Singer L. as Fiordiligi,*
1923

chance and play helps the distancing, becomes part of the comedy, part of the release from too great a crescendo, an avoidance of tragedy. It is a merciful dehumanization that comes not to the artist of the grotesque, but to the artist who seeks comedy.

The puppet figure is not restricted to appearance in works with puppet titles. It makes an operatic appearance as a jointed shadow puppet in *The Singer L. as Fiordiligi*, where she is, of course, the heroine of Mozart's *Così fan Tutte*, seeking the best of all possible loves. She exists in both drawn and painted versions as quasi-elegant, a filigree figure with arms passing uninterrupted through her chest. Her mouth and nose extend into her breasts, and she has the flat ornamental rocking gait of the marionette.

From *The Marriage of Figaro* comes the representation of *Dr Bartolo* of 1921, a figure of straight lines and flat legs, three of them denoting a path of movement marked by arrows. Dr Bartolo is constructed in bands of horizontal lines which grow out into the suggestion of a room in one corner, form a musical staff of five lines around the figure's waist and at the same time become the boards of the stage he stands on. The figure is part of the music, the set and the stage.

The smallness of the scale of the puppet remains in keeping with Klee's small-scale painting. Other contemporary painters of the automaton – De Chirico, Léger and Picasso in the twenties – were fascinated by the logic of

62 *Dr Bartolo*, 1921

construction required for the automaton, but they were not involved with the Lilliputian connotations of the puppet. Their schematic figures are more monumental and related to a machine age.[27] For Klee, the smallness and fragility of the human figure is a critical part of its appearance and demeanour.

IX This may be best seen in a 1922 painting, *The King of All the Insects*. The king is cast as a see-through shadow puppet manipulated by a central stick and served by a set of fine nerve lines running through the centre of his body. He is limited in movement by the pinning of his arms and legs. He wears a small crown surmounted by a frail Latin cross – a Christ reduced to a microscopic kingship. Even smaller in scale, below the insect king, is a tentative diving-board apparatus which props up a large banner bearing a small cross. The Christ-king hangs above in his large heaven set with planets; his pipe extends upwards into a drainpipe antenna, an essential part of the automaton man who receives his gasoline from above. His reduction and alienation of scale make a clear satiric point. He extends the allegory of specifically political

X implication which Klee had painted in 1921 in *The Great Emperor Prepared for Battle*, an enactment of the war game of politics by another jointed and quasi-heroic little German mannikin, hung with his medals, brandishing club-like fists, directing his insect parade automatically, through closed eyes. His helmet is a prophetic warrior headdress – the seven-branched Jewish candelabrum. A curtain is opened above the emperor; the background is an extension of his own award-winning stripes. Again one might comment on the closeness of these ideas to contemporary caricature, in particular to the attacks on conventional religion made by George Grosz, which led to his trials for blasphemy in the twenties.[28]

In some of Klee's masterly perspective drawings of these early Bauhaus years the malleable body is shown acted upon by its environment, and human occupants of rooms are drawn into the lines of the perspective of walls and floors. *Perspective with Inhabitants* of 1923 is more than a didactic example for teaching general perspective.[29] Its space is symbolic, the ordinary living-room becoming a wind tunnel exerting such suction that the inhabitant cannot stand. The shadow puppet of 'thin and insubstantial nature' is flattened into his own floorboards as he tries to exist in this dangerous space.

XI Klee's best-known expression of the threat of gravity is his 1923 *Equilibrist*, too hastily seen as a competent, if comic, professional performer. The elaborate structure of thin and seemingly accurately placed wires and supports has no foundations: there is no ground-line, and the equilibrist with his single eye and his recalcitrant limbs is only a wooden balance figure, a toy.

63 *Perspective with Inhabitants*, 1921

A light shutter-like object, perhaps a symbol of inevitable fall, has tumbled down to reveal a tear at each of its accordion-like pleats. Wherever Klee erects a ladder there is implied a snake-like descent.[30] Like the famous trestle sets of the Russian and German stage in that decade, the very setting is symbolic of escalation and descent.[31]

The image of the equilibrist was used by Klee in a Bauhaus lesson in December 1921 to demonstrate the lesson of balance, so central to his art philosophy. 'We are speaking of a tightrope walker as the extreme example of a symbol of the balance of forces. He holds the force of gravity in balance (weight and counterweight). He is a pair of scales.'[32] There are as many as three versions of the 1923 *Equilibrist* – a drawing, a painting, and a lithograph of slightly different emphasis, which was published in *Kunst der Gegenwart*

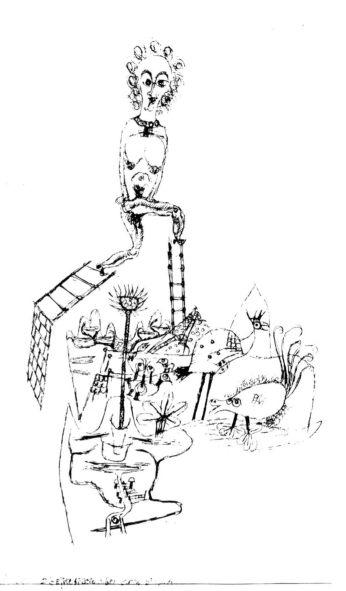

64 *The Equilibrist above the Swamp*, 1921

(Contemporary Art) in 1923. In the lithograph the figure is placed higher on the paper so that the acrobatic mechanism rests even more on 'air'. The figure and the wires are superimposed on a Latin cross, suggesting an act of balance that involves all Christendom. Like *The King of All the Insects* it hints at religious satire, returning to the elaborate constructions of pseudo-Gothic architecture which appeared in an earlier drawing of 1915, *Jerusalem my Highest Bliss*.

A work of 1921 makes the sinister implications of the tightrope walker quite clear, and specifically grotesque. *The Equilibrist above the Swamp* is a nude and graceless female. Her body with breasts and navel forms a lower frowning face. She steps brashly, with little control, from one ladder to another. Beneath her is a quagmire of ground-crawling birds, a collection of eyes, and a vindictive and phallic thistle.

Nietzsche's account of the tightrope walker in *Thus Spoke Zarathustra* seems not too distant, although the fatal imbalance, fall and inevitable dramatic death is distanced by Klee's scale and style. Zarathustra comes down from his mountain and encounters the tightrope walker falling to his death: 'He threw away his pole and fell, faster even than it, like a vortex of legs and arms.'[33]

Klee had often watched the performers, as we recall from a wry note in his diary:

The people of Berne are a bit slow; they probably think more than they say, or else they certainly would have shouted something up to 'Knie' on his high rope, as he was making the following home spun speech up there. 'The performance will last an hour and a half. For this hard period of work we are forced to demand a fee of at least twenty to thirty centimes.' 'Now up on the highest rope! For this, we must ask for an additional sum of ten to twenty centimes! I am sure none of you would do such risky work.' (German clowns are far from being this witty.) (772)

The clown has always been a feature of the travelling circus, but he is more than a folk figure. His popularity might even be said to have increased in the 1920s; he was certainly no retrospective hero of a faded Symbolist world. In modern guise, as Buster Keaton or Charlie Chaplin, he was among the stars of the new silver screen.[34]

The clown had great appeal for those artists who wished to inject the formal theatre with the vitality of the circus, such as Meyerhold, Wedekind, Kandinsky, the Futurists. Marinetti's theatre manifesto proclaimed that 'the theatre of variety offers the most hygienic of all performances owing to the dynamism of form and colour, simultaneous movement of jugglers, dancers, gymnasts, many-coloured riding troupes.'[35] In the 1920s both Schlemmer and Moholy-Nagy wanted to infuse the Bauhaus stage with the spontaneity and energy of the circus. The equilibrist performed his balancing feat, and Schlemmer himself performed as a musical clown with the traditional paraphernalia of fiddle, drum and floppy shoes. Moholy-Nagy used T-shirted equilibrists in his circus scene for *The Benevolent Gentleman*.[36] Alexander Schawinsky did his *Scene from a Circus* with cut-out animals and human actors dressed in cardboard.[37] The circus was often a theme for stage improvisations and Bauhaus dances.

The world of circus, variety and cabaret provided the essential element of folk theatre in Schlemmer's schema of total drama. The popular entertainments were to bring the acrobat, the gymnast and the equilibrist to the formal stage and liberate the comic forms of burlesque and grotesque. Moholy-Nagy's desire for what he called 'total stage action' was also to include circus and variety acts to give contrasted effects on the stage and to

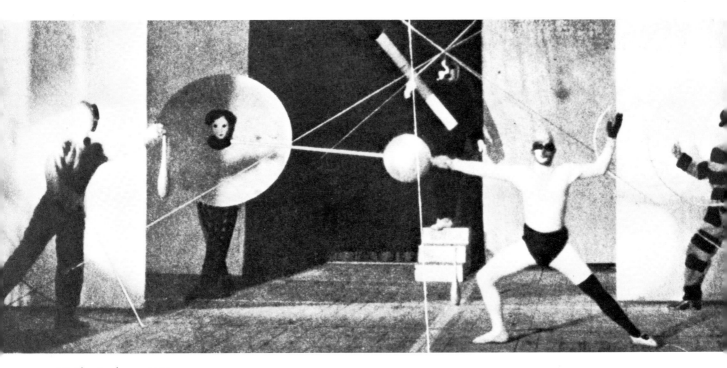

65 The Bauhaus stage
production *Equilibristics*

66 Andreas Weininger as a
musical clown in a Bauhaus
production

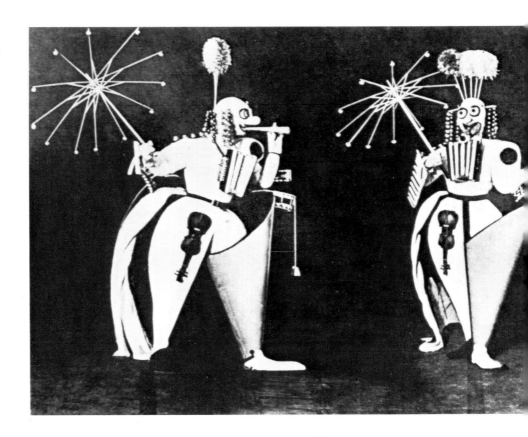

reinstate categories he named as the tragi-comic, the grotesque-serious, the trivial-monumental.[38] He regarded the popular theatre of circus, operetta, vaudeville and clowns as having achieved these desirable contrasts, eliminating the over-subjective. The social acceptance of the circus in all levels of society was one of the main reasons for its favour with the Bauhaus. The theatre of surprise, of improvisation, of fantasy and wit, had a wide appeal. As the psychologist is ready to admit, it returns us to our childhood.[39]

The charm and magic of the circus reappear in Klee's work, at times overriding the sense of the grotesque and the tragedy of the adult theatre. With the slender drawing line of the twenties he constructs the most magical *Big Top* in 1928, as a multi-peaked tent full of wonders, with banners and flaps and tiny people like ants beside it. *The Village Clown* of 1925 is a bit spiky and grotesque, but he is undeniably genial, a representative of a world highly accessible to children.

Klee also drew the 'theatre of surprises': of quick clown acts, dwarfs and stilt-walkers.[40] Such a sketch is *Grotesques from the Theatre*, with spindly figures stilt-walking, a dwarf in a top hat, a clown with a balloon. Or the 1923 drawing, *Again an Animal Performance*, with chess-type horses; or the geometric sketch of the figures of *Exotics' Theatre* (1922) promenading, posed before their audience, gesturing with arms which run by clockwork.

The *Magicians* also face their audience after the rising of the curtain, and perform acts carefully calculated to exploit the wonderment of the spectators – like the magician in the traditional funnel cap painted by Bosch many years earlier. Klee's *Mr Jules, the Art Magician* of 1920 can create whole landscapes behind his curtain. His colleagues, who frequently take the stage from 1918 to 1921, have funnel arms from which, presumably, all things can be extracted. The magician as depicted in these small, quizzical works would seem to be an embodiment of the artist–magician. Even when Klee paints a still life he gathers the objects and presents them under the revelatory curtain.

67

A revelation that might well have been made by magicians capable of summoning up objects and animals is found in the *Magic Theatre* of 1923. It reveals on its proscenium a strange world of symbols – arrows, bulls and crosses – in weird light. There are the performing animals in different sizes, again playing out their Aristophanean pantomime. The sun, the moon, the stars appear, symbols of a stretch of time. A strange and bulbous cat-like animal, with unnervingly different eyes, a bird figure with a single human eye and four legs, a totem on a stand, a donkey with sharp teeth: these are the personae of a disconcerting and cryptic drama. The animals are given no ground-line to stand on, but are gathered up and hung against a dark

XII

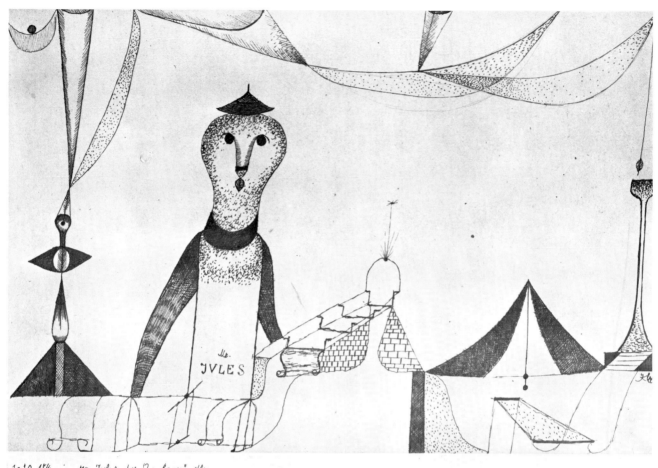

1920. 154. Mr. Jules, der Zauberkünstler

67 *Mr Jules, the Art Magician,*
1920

background. Smaller than the animals are two quaint clown-like figures, awkward, dancing in the centre of the picture. One has a Latin cross on his breast and holds a bulb with an eye on it; a baby's severed hand, illuminated, comes towards him. *Magic Theatre* is a cultish and ritualistic stage; perhaps it is a child's theatre, but its implications are sinister. Like the magic theatre of Hermann Hesse's *Steppenwolf*, it is clearly no paradise: 'all hell lies beneath its charming surface'.[41]

The magician could have pulled the *Doll Theatre* of 1923 out of his hat, or from his voluminous sleeve. It is superficially engaging in its childlike style of ingenuous colour and stripes. The central doll is geometrically shaped and jointed at the points; it wears a triangular skirt, carefully striped; its torso is heart-shaped, its head round with neat lips, round eyes, scribbled hair; its arms and legs are sticks. There is a child's sun in the sky – a disk with carefully drawn rays – and a primitive ground-line for the main figure. Another doll, not granted verticality, lies on the ground. There is a suspended bare window, an

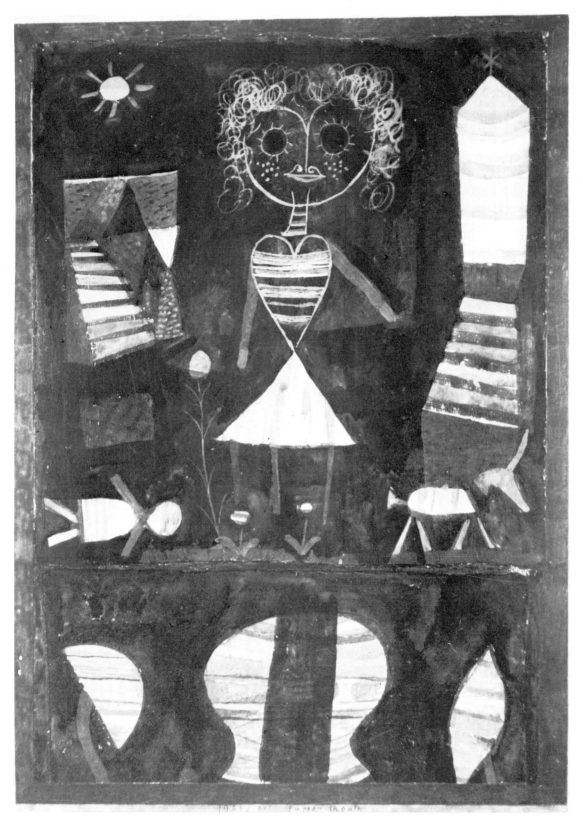

68 *Doll Theatre*, 1923

69 *Theatre of Animals,* 1921

Eeyore-like donkey, a house as elementary as a bathing box: all set down with no relation to each other, all striped. Such separation cannot be merely ingenuous, for it promises a more dangerous fragmentation. Below the main figure, large-standing and frontal, is a small proscenium where a striped head lies, cut in half. It is eyeless, and its facial features are eclipsed by the horizontal bands. The background is as dark as a child's blackboard, but its absence of light is a conscious choice of the artist and no mere forum for coloured chalks. An ominous darkness lies behind the stripes.

The child's theatre and the adult theatre play in the same arena. *Theatre of Animals* of 1921 suggests a world similar to that of Stravinsky's *Renard*, with allegorical animals performing on a trestled stage. Beneath its gaiety and gaucherie quiet voice is given to the childish and regressive in human behaviour.

Carnival Music of 1924 is among Klee's most detailed depictions of the circus world, here darkly shaded, with the result that the circus appears hermetic and primitive, like an alchemist's haunt. The performers are lined up in quizzical array before their tent, which is draped over them like a curtain. They have their trumpets, their jingle bells and their violin bows ready to *make Renard* music, conducted by the 'Homme de Pipetta' (identified as such on his top hat); all are manipulated by the figure on the right, a sort of

116

Red Indian Chief with fierce eyes. The performers are numbered, waiting for their sideshow to open, ordered from left to right with frieze-like exactitude. They are shadowed strongly from the footlights below as they stand in their gypsy high-heeled shoes.

Klee's paintings in the second half of the 1920s are less beguiling. There are more and more hints of threat contained in the dark colours and uneven lighting of the 'theatres'. The bodies are frequently dismembered: hands, legs, heads float in cruel separation. In 1925 the Bauhaus, after bitter and political dissolution in Weimar, was moved to Dessau. The theatre enjoyed some regard throughout Germany; the Bauhaus books and journals were in publication. But troubles in Bauhaus leadership were about to come to a head. In 1926 there was anger, discontent and the imminent resignation of Gropius in the air.[42]

In *Circus Drama* of 1926 the innocence of the circus is less in evidence and the pierrot becomes more and more grotesque and tinged with pathos. A mannikin clown with shambling arms runs from a horse; a gloomy isolated clown is relegated to a corner; an over-large clown face waves gloved hands.

70 *Carnival Music*, 1924

The clown is only partly a child's entertainer; he dons his mask face with adult solemnity for the *Clown* of 1929. In that painting he is a creature of some dignity, with a fascinating air of mystery and withdrawal even though he wears the crooked face of the buffoon. In 1937, almost a decade later, Klee again painted the clown – a child's figure, but retired and saddened. *The Clown in Bed*, with his head as round as a ping-pong ball, lies uneasily on a hard spiked pillow.

The Klee circus becomes a theatre of unambiguous disenchantment, with the clown sent to bed and the circus ring removed. *Drawing for Itinerant Circus* of 1937 shows the circles that draw the figures too wide, just managing to join up. The performing horse is on too sharp a decline, and the rider's arms fly into the air to indicate her horror. The 'grotesque' who proceeds her is run into the landscape background. He carries the burden of the hills on his head. The drawing relates to a later gouache and an oil painting of wandering circus people. They are as dispossessed as Picasso's *Saltimbanques* of 1905, or as Klee was, in the thirties, by his native country.

By tradition, the fate of the *commedia* figure is mishap. As in Klee's *Sturmbilderbuch* drawings published in 1918, the *commedia* collapse is

inevitable. In 1923 the fate of the *Equilibrist* of the same year is echoed by the *Harlequin on the Bridge*. Again the bridge is an elaborately constructed affair

71 *Harlequin on the Bridge,* 1923

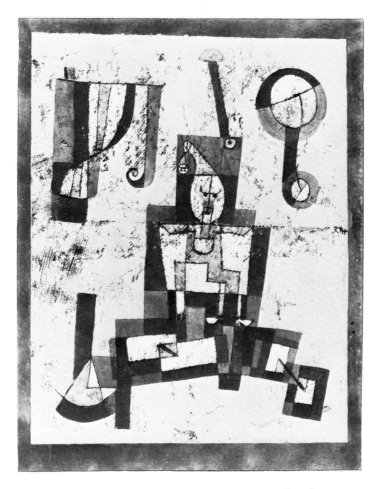

72 *Captive Pierrot*, 1923

of turned corners in intricate perspective, but without any true depth, a post-Alberti debunking of perspective by cancellation of any remaining rationale.[43] The vanishing point is turned away and the intricate structure rendered incapable of support. The bridge spans and hovers. Stretched over a vacuum it reappears as a symbol of suicide. The harlequin stands in the middle with his eyes schizophrenically concealed behind bands. He is impeded by the mannikin's body, hands loose and legs straddled, limited in possibilities of movement and decision. He is contained within a tight house, a mere aedicule only, and above him appear tentative stars: black indications of fate. He stands on the bridge which, despite its desperate turreting at the sides, cannot meet the supporting banks.

Captive Pierrot of 1923 again uses the traditional comic figure and plots his inevitable mishap. The solitary figure, centred on the watercolour page, is trapped in the watercolour washes. This captured pierrot is a jester, that traditional servant and *alter ego* of kings, here with his body slotted out of sequence, his legs sprouting hands. A frown replaces his traditional smile. The face is innocently circular, the lines of the mouth, the key to the physiognomy, continuing down to the shoulders. The emotion is extended

from the mouth to paralyse the entire torso. A curtained window, ochre-brown in transparent washes like the house, is detached and standing apart, so it gives no relief from the enclosure. The house itself rocks in the ochre void. Pierrot's props are as disembodied as he is himself. The jester's ball is out of his reach: he cannot escape his role, nor can he fulfil it.

The implications are of obstructed action and instability of support, whether bridge, horse or trapeze: all are inadequate props for acrobat, harlequin or equilibrist. Klee suggests the perpetual pierrot in us all, and increasingly he plays up his grotesque implications.[44]

XIII The ugly aspect of the pierrot – the hunchback Rigoletto – is highlighted in a work of 1927, *Brutal Pierrot*. The figure is sexually ambivalent, as androgynous in its way as its French Surrealist counterparts.[45] The mask mouth is a combination of mouth and moustache and is drawn around with short sharp spikes of hair, and the body of the pierrot is marked with the same kind of vaginal mouth. Klee creates the ancient harlequin, sent up from Hades, associated with death, and wearing his one-time hairy devil's mask.[46] If this pierrot tumbles on to the stage in comic action, then he comes not as a naïve innocent, but victimized and horrific in his fate. Klee, a lover of Charlie Chaplin comedy,[47] permits in his own work very little of the Chaplin ingenuousness; no quaintness of big shoes redeems the dirty brown figure, whose malformation is emphasized by his big hands, one masked by a mitten, the other absent – the cuff of his costume simply ends in a circle. Vicious changes have been wrought on the traditional comic figure, but they are already contained within the tradition, simultaneously grotesque and genial.[48]

In a similar plight is the figure with tasselled clown's hat whose legs give way in *The End of the Marionette* of 1927. His hands fly, but not to the ground to save him; legs entwine with no hope of reprieve, and the stippled careful background darkens most closely around him in the area of his imminent fall. He is a small figure in a large mottled space, denied even the small plot of

10 ground which Klee gave to his *Hero with One Wing* in 1905.

Charlie Chaplin, only momentarily despondent, was indestructible, but Klee's comedians, although presented in a seemingly light style, have lost any opportunity to recover. They exist in destructive perspective, or against darkening fields; some threat of serious collapse contradicts the comic feeling. Klee contrives a balance of the comic and the grotesque – deliberately: it is, as we have seen, the self-conscious programme of effect which he sought from his earliest years. But where the comic appears to dominate, it is, in fact, the grotesque which lingers. The American artist Robert Motherwell wrote that 'there is a point on the curve of anguish where one encounters the

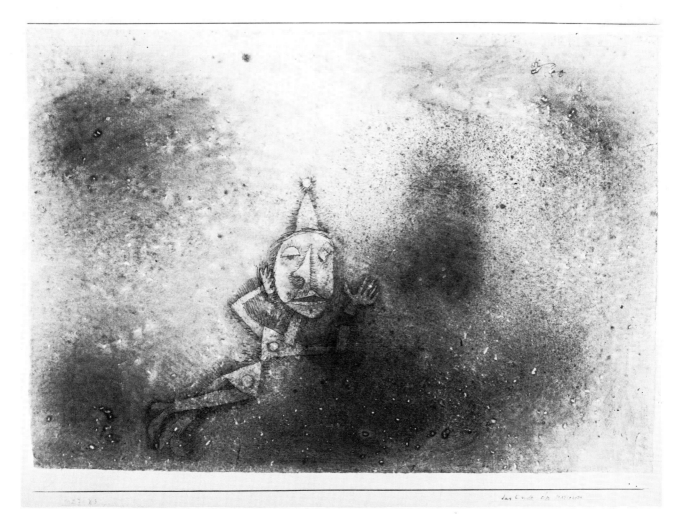

73 *The End of the Marionette,*
1927

comic. I think of Miró, of the late Paul Klee, of Charlie Chaplin, of what healthy human values their wit displays.'[49] Many years earlier, while producing his early set of etchings, Klee had observed:

Others have interpreted the *Comedian* long before me. Gogol, *Dead Souls*, I, Chapter 7 . . .'that there exists a kind of laughter which is worthy to be ranked with the higher lyric emotions and is infinitely different from the twitchings of a mean merrymaker.'
 He calls his novel 'a world of visible laughter and invisible tears'. (607)

 In the second half of the twenties, the engaging and naïve pierrot does appear, but he very soon becomes the fool, the madman. Perhaps the implication is that naïvety and lack of control sponsor derangement. Always engaged in movement and action (Moholy-Nagy has commented on the connection of the *commedia dell'arte* with improvisation, an important part of Bauhaus stage training),[50] the little fool totters in a trance. A cluster of *Fool*

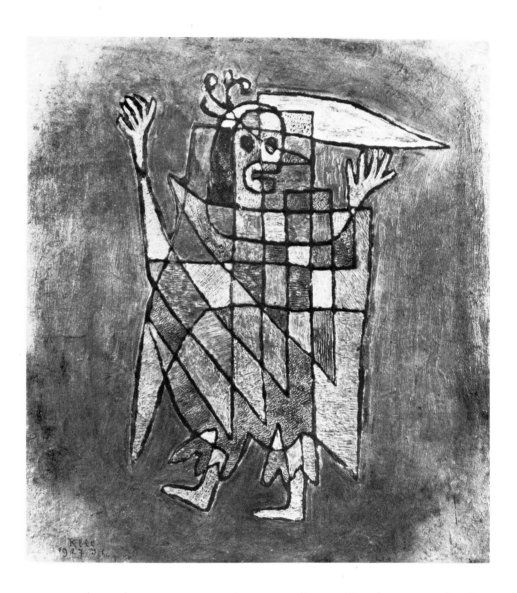

74 *Allegorical Figurine*, 1927

pictures appear between 1925 and 1926: works used by Klee on one level as teaching pictures to indicate patterns of movement and the modern device of simultaneity through the network of diamonds that form the harlequin costume. 'The jester', he remarked to his students, 'might be taken as an example of superimposed instant views of movement' :[51]

The combinations of the bodily, spatial and inward forms lead to synthesis, that is, an interpenetration of space, body and thing. The influence of the lines and planar forms suggests productive increase and decrease, outer and inner energies, growth and change.[52]

Three Gentle Words from a Fool, a drawing of 1924, delineates a stage appearance for the jester whose traditional belled cap extends into a nose shape in his face, and down to a trinity of numbered mouths. He prefigures

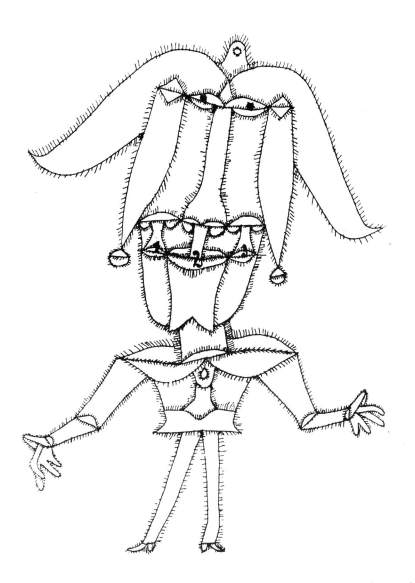

75 *Three Gentle Words from a Fool*, 1924

the 1927 *Allegorical Figurine* in full harlequin action. Awkward stumbling flight is implied by the busy kaleidoscoping of the pattern of the jester's costume, which swamps and overtakes the figure so that large hands, thin legs, and face overpowered by a single eye are helpless at the edges of a spinning costume. Two years later *Fool in a Trance*, in both a drawing and a painting, tumbles around in similar plight. His traditional costume, with its checks and pointed tails, has itself been seen as symbolic of lack of symmetry and, therefore, lack of reason.[53]

XIV

That the *commedia dell'arte* figure is allegorical scarcely needs demonstration. He is the classic fumbler, the fool, and not the tragic figure who has strength enough to rise above the fray. Klee's allegorical figurine is a little Everyman, with wild eyes and helpless hands.

The situation in which the *commedia* figure finds himself is a stock situation involving flight, calamity, wilful action, punishment. As we have seen, Klee interested himself in such situations as early as 1912. To activate such comedies in order to make their moral point felt, the artist must possess a basic compassion; only then can these comic figures fall into Robert Motherwell's 'curve of anguish'.

Klee uses characters professionally involved in humour and balance, revamped, in affinity with Expressionist, Dada and Bauhaus theatre. They are, for Klee, characters who can represent his own linear acrobatics and his awareness of the modern artist's concern with intricate formal problems. When he says: 'From the principles of perspective I went on to the sense of balance in man,' it is not just a statement of a formal progress, elucidating a design problem for his students.[54] It expresses a belief that runs throughout his teaching: that the elements of art can enact a balance which is both moral and psychological – the symbol on the surface. Klee's paintings, far from containing abstruse and private allusions, as some critics have claimed,[55] frequently depict the most traditional and archetypal of figures, instantly recognizable.

5 Towards the Dance of Death

The circus, close to folk art, with its traditions of improvisation and recognizable figures, was one of the mainsprings of the inspiration of the Bauhaus stage. But Schlemmer was also a dancer, seeking Kleist's precision and grace. The allegory of the dancing puppets is shown by making the dance symbolic of imprisonment and gravity. For Kleist, 'each puppet has a focal point in movement, a centre of gravity'.[1] The movements of the puppets are movements from 'a centre'; almost without manipulation the dolls fall into 'the intricate movements of the dance'. Klee often felt 'the earth-shunning forces';[2] he visually affirms the words spoken by Kleist for his puppets: 'The force that pulls them into the air is more powerful than that which shackles them to the earth. . . . These marionettes, like fairies, use the earth only as a point of departure.'[3] In Klee's teaching terminology – matter-of-fact, didactic rather than evocative and poetic – 'gravitation and momentum add up to earthly cosmic tension'; 'the purest form of movement, the cosmic form, arises from the elimination of gravity, of our bond with earth'.[4]

We have seen that the pattern of motion displayed by the dancer fascinated many modern artists who had inherited the arabesque of Art Nouveau and Jugendstil. A concern with movement is recorded in Klee's diary as early as 1902. The famous 'line going for a walk' pays late homage to Jugendstil, but goes beyond being the decorative curve to become an explanation of the growth of the creative process.

This unfolding, this metamorphosis, was recognized by painters and poets who saw a new 'poetry' in the music-hall dance of Isadora Duncan and Loïe Fuller, and believed 'art itself' to be most perfectly embodied in the dancer.[5] Indeed the dancer became the very metaphor for art. Valéry, inspired by Degas, saw the dance as a temporal pattern of related movements and gestures, altering the body and abstracting it through movement.[6] Mallarmé also saw the denaturalizing element of the dance: he wrote of the abdication of the human element in the dancing of Loïe Fuller, the merging of the human and the inhuman.[7] One of the pleasures of watching her was to identify the butterflies and orchids conjured by her famous draperies of fine Indian gauze. She was the essence of the Art Nouveau style, inspiring Toulouse-Lautrec to

76 Henri de Toulouse-Lautrec, *Loïe Fuller*, 1892

one of his most abstract lithographs, and Jacques Lipchitz, as late as 1955, to make a bronze in flower-like shapes.[8] That elegant spokesman of the 1890s, Arthur Symons, quoted earlier, spoke of the dance in similes clearly inspired by Fuller:

By its rapidity of flight within bounds, its bird-like and flower-like caprices of colour and motion, that appeal to the imagination which comes from silence, by its appeal to the eye and to the senses, its adorable artificiality, the ballet has tempted every draughtsman.[9]

For the post-Symbolist poets – like Yeats, not wishing to separate dancer from dance – the dance was the epitome of femininity and the expression of the poet's beloved union of artist and work of art.[10] For Rainer Maria Rilke, the young girl must dance in answer to the music of Orpheus.[11] For Nietzsche's Zarathustra, the dance songs are the highest moment of the

journey down from the mountains.[12] For Apollinaire, Loïe Fuller's serpentine dances were re-embodied in the painting of Marie Laurencin.[13]

The apostles of the free dance, Fuller and Duncan, were well known in Germany where they had a considerable influence. In *Concerning the Spiritual in Art*, Kandinsky wrote of the dancer as the embodiment of movement and a symbol of fusion. The correspondences of rhythm in dance and in music he sees clarifying the new problems in painting:

Isadora Duncan forged a link between Greek dancing and that of the future. In this she is working parallel to those painters who are looking for inspiration in the primitives. In dance, as in painting, this is a stage of transition. In both mediums we are on the threshold of a future art. The same law, utilization of pure motion, which is the principal element of dance, applies to painting too.[14]

Kandinsky chose Matisse's *Dance* – one of the seminal paintings from the first decade of the twentieth century – for one of the illustrations of the *Blaue Reiter Almanac*.[15] Roger Fry had called it one of the main dance pictures of the early century, 'a perfect equilibrium of motion',[16] and Alfred H. Barr has conjectured: 'It is tempting to believe that Isadora's magnificently Dionysian art, which electrified Paris during 1909, must have had some effect on Matisse, who was struggling with his *Dance* that very year.'[17] Over a decade later, Klee was to use the picture in a Bauhaus class. He showed slides of formal elements which were intended to lead up to Matisse's *Dance*. 'He then had the students draw diagrams of the composition, once he even made them do it in the dark.'[18]

The dance provided artists with a motif which aided the release of line and distancing of naturalism. Klee acknowledged the importance of Matisse's painting. Rodin's dance drawings, fluent with a sense of speed, exaggerating the movement, have already been mentioned for their importance to Klee's early work. Above all, it was the dance subject which encouraged Rodin to distort and abstract the human figure.[19] After 1906, the year of the visit of the Cambodian dancers to Paris, it is the central subject in his work. Rodin was asked: 'In art you attach great importance to being light, poised, as though ready to soar?' 'Certainly,' he replied, 'beauty of the first order is already there.'[20]

The contrast between order and chaos, beauty and its enemies, that essential duality of thinking, grouped around opposites, was basic to Klee from an early age. It remained basic to his teaching philosophy in the Bauhaus years. The connotations of grace in the Art Nouveau dance were highlighted by the erotic connotations that were also seen in it: beauty and spontaneity could be ugly and calculated. The dance could be a butterfly, but it could also be the expression of the unfettered *femme fatale*, and a premonition of the

dance of death, with all its sexual overtones. The maenadic dance is essentially unstable, allowing flight in its expression of ecstasy.[21] The maenadic serpentine dance recurs in various disguises throughout Klee's oeuvre and is expressive of intensity and straining. The whimsy of the child's more ingenuous dance is also glimpsed, but it provides only a veneer of innocence for a performance that remains grotesque and edges closer to death.

In the year 1926, in which one notes a darkening of subject and colour in Klee's work, the little fools begin to totter in their trances, but the curtain is allowed to rise in front of the stratified earth in *Spiral Blooms*: an intricate, coiled nature picture with the parallel lines making a likeness of nature herself unfolding. The curtain hangs over the plants and the foreground becomes a frieze-like proscenium; loops of its parallel folds grow into the strips of the earth, and the plants, like actors granted a privileged audience, move into the full spotlight. Thus it symbolizes the stage enactment of beginning and ending, with connotations of holiness and sacredness denied to Klee's beings. He said, 'The mystery is to share in the creation of form by pressing forward to the seal of mystery.'[22] In the intricate *Botanical Theatre*, and in the generously

77 *Spiral Blooms*, 1926

detailed, meticulously planned *Garden for Orpheus,* it is nature which can achieve the Kleistian grace. Any comparable human unfolding is circumscribed by fate, as early posited by the etchings and never forgotten in Klee's human narratives. The *hortus conclusus* of the painter's nature vision would seem to be reparation for the human harlequinade.

For nature, the curtain rising on quietness; for man – and woman in particular – the hysterical, maenadic dance. *Ceramic/Erotic/Religious,* subtitled *The Vessels of Aphrodite,* of 1921, suggests in the title the pre-Christian and religious nature of the dance, and its female, sexual expression. Closely related to this painting is the *Ecstatic Priestess,* with a dancing woman shown in a combination of frontal and twisted attitudes, the head in profile, the breasts bulbously turned, the legs twisted to the front. The extremities of the limbs are chopped off by the frame; the joints are transparent and hinged, again marionette-like; one armpit is formed into the symbol of the vagina, and the sexual nature of the dance is further evident in the emphatic circle

XV

129

outlined where legs join body.[23] In *Ceramic/Erotic/Religious* the figure appears to have two sets of legs, increasing the effect of lewd prancing. The background is squared, and out of the squares two vases emerge: the symbols of Aphrodite, suggesting the traditional association of the plants of life and the emblem of fertility. The vase is one of Klee's many persistent and time-honoured symbols of rebirth and regeneration.[24] Yet stars spring out from the dancer's groins and a decisive arrow points inwards. It is clear that the 'vessels of Aphrodite' are the containers of evil fumes: they share the lethal potency of Klee's *Pandora's Box* of 1920, described as an 'ominous receptacle ... emitting evil vapours from an opening clearly suggestive of the female genitals'.[25] This work, with its unambiguous image and its precise reference both to a traditional theme and to its modern theatrical incarnation, is among

79 *Pandora's Box*, 1920

Klee's most specific satirical works. In that process of visual condensation of which Klee is a master, the female body of Aphrodite takes on the shape of the vase.

A much later variation of the same theme, a cruel reversal, is *Mephistopheles as Pallas* of 1939, which identifies the devil with the goddess of love by a superimposed image which makes the torso-vase into the profile of a face with hair in flames. It is a late pronouncement of the preoccupation of the 1904 *Woman and Animal*. More than an echo of Symbolist themes of women and erotica, the 1939 painting is a renewed testimony to Klee's obsession with original sin, a restatement of the medieval theme of the vice of unchastity.[26]

7

Though the main dancer is female, the male dancer does appear in Klee's oeuvre. In 1922, in a black border, appears *The Wild Man*, a prancing automaton with a wild head of hippie hair and a headdress of agitated arrows. Underneath the curls of eyebrows, his eyes send forth a trio of down-sliding arrows; he is neatly dressed in a buttoned suit. Against the verdigris-like wash of his background, his four legs jump, and they carry between them the strongest colour accent of the painting: two phallic arrows, brilliantly red, advertising the animal thrust of his dance.

XVI

But there is, too, a more lyrical dancer, closer in movement to the nature paintings, more poetically coloured and perhaps capable of a softer 'departure from the earth'. She belongs in spirit to the paintings of bird dramas and flower myths from the years 1916 to 1919. Paintings of figures lifted into the air appear around 1920, and they recall the Art Nouveau dancers' metamorphosis of the human figure into a fantasy of nature-like shapes. *Messenger of the Air Spirit* of 1920 exists, like many of the works we have discussed, in two versions, pencil study and watercolour. It is an expression of one of Klee's favourite themes of the interaction of elements, this time expressive of the lyricism of the colour shifts in their own right rather than the satire of Venus. Though Klee was critical of the Diaghilev ballet, there is in these works a feeling of the Russian Ballet sets. In Munich he would have seen the Bakst and Benois designs in the bright neo-Byzantine manner that created the fairy-tale world of Scheherazade in technicolour Art Nouveau.[27] Klee's later spirits are not strictly dance figures, but their floating movement and their liberation from the earth connect them with the current aesthetic of the dance. These figures move like Toulouse-Lautrec's Loïe Fuller, unanchored. Their bodies are their garments. Transparent, of course, and free in their drapes which extend out from the figure in points and arrowheads of movement, they have an effect like that described by Dr Schilder: 'The connection of clothes with the body, especially with women in stage dance,

80

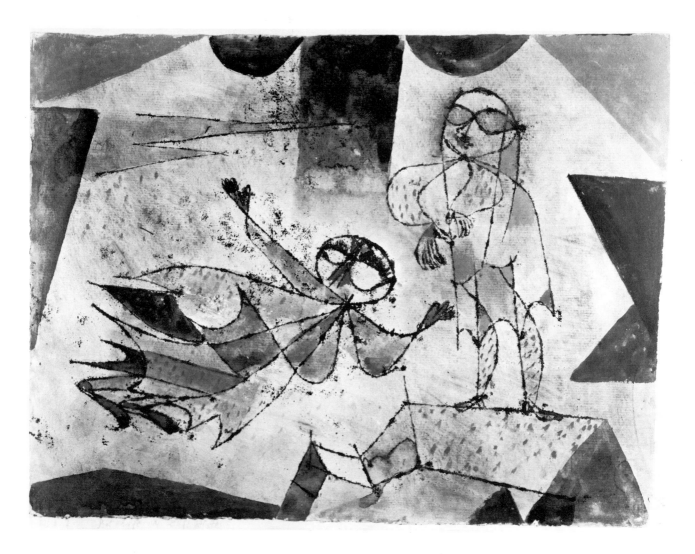

will be changed considerably and so will give an increasing feeling of freedom concerning gravity and the cohesion of the postural model of the body.'[28]

Dance of the Night Moth of 1922 is one such postural model: a moth-like creature in free movement which seems directly in the tradition of the metamorphic dance of Loïe Fuller. The watercolour version of the following year has a squared background, perhaps echoing the stage lighting created by Fuller: her famous twelve changes of light projected on to silk.[29] Light as the sole medium of a dance-like performance was one of the experiments of Ludwig Hirschfeld-Mack at the Bauhaus in the previous year, 1922.[30] As early as 1910, Klee had noted: 'To represent light by means of light elements is old stuff. Light as colour movement is somewhat newer. I am now trying to render light simply as unfolding energy' (885).

In Klee's *Storm Spirit* of 1925 – a drawing – lines are layered and transparent like an onion, and there is again that delicate flavour of the Art Nouveau dance, not only in the peeled, fused drapery of fine lines, but in the alteration

of the body image: the arrow-pointed hand which begins to shape the human dancer and allow metamorphosis into butterfly, moth or storm. Fuller's outline as a human dancer was artfully sacrificed, her shape altered by the concealed sticks which she moved underneath her veils.

In these works of the early twenties, painted at the time when part of the Bauhaus community was enamoured of movement and light, are echoed the coiled lines and diaphanous blobs of Art Nouveau. But these are not so much reminiscences of an earlier style as evidence of continuity, and further confirmation of the length to which abstraction was taken in the age of Art Nouveau. Clement Greenberg is too hasty in congratulating Klee for overcoming his Jugendstil background and adjusting to the more rigorous forms of Cubism.[31] With some peripheral attention to Cubism, but with much more sympathy for Delaunay's Orphic Cubism, Klee both absorbed and transformed the abstraction and the lyricism of Jugendstil.

The dance aesthetic, as we have seen, captured the artistic imagination in the 1890s, and was conspicuously remodelled in Munich around 1911 by Kandinsky. His *Der Gelbe Klang* was an attempt to create the dance drama of the future and to find a total art of the stage.[32] Schlemmer's dance pantomimes of the same period shared similar aims, and he even approached Schönberg with a plan (which was not accepted) for a dance to accompany the notorious *Pierrot Lunaire*.[33]

81 *Dance of the Night Moth,* 1922

82 *Storm Spirit,* 1925

Kandinsky's *Der Gelbe Klang* is fully worked out as a spectacle in six sections, to be called tableaux. The actors are variously sized and dressed: giants, puppet-like figures, children, ordinary men, men lightly costumed, other actors in loose costumes. The lighting constantly changes. Choruses and single voices alternate, singing becomes speaking, various effects of colour, light and sets are combined with the varying degrees of audibility in the music. *Der Gelbe Klang* is dance theatre, for Kandinsky stipulates the types of movement, and the individual actor is director-manipulated, with no freedom to move out of the ballet-like tableaux.[34]

Schlemmer's diary sketch of a dance drama develops similar procedures. A demon masked in yellow-orange bustles across the stage in front of a curtain, and then the main dancers are unveiled behind it. Dark brown lighting changes to red. The dancers rise and fall with the music's rise and fall; agitated colour and music builds into an erotic dance. A silver angel appears; the music lightens; a star appears in the sky; the demon lies dead, killed by colour's symbolism.[35]

In war-time Zürich, the Dada artists developed creative dance through their associations with the Laban School of Dancing.[36] Mary Wigman, who was to become well known in the twenties, was one of the pupils, and the artist Sophie Täuber-Arp was a dancer there as well as a painter. Perhaps she created her streamlined puppets with a Kleistian realization of the fallacies of the human dancer.

The Dadaists and the Laban School did 'cubist' dances, which may have been like informal versions of Picasso's *Parade* to the music of Satie – a favourite musician in Zürich. Negro dances were staged with music by mask-maker Janco.[37] *Fox trot house Flake* was a Laban School contribution by Flake, Wigman, Chrusecz and Täuber. At the last *grande soirée,* on 9 April 1919, Richter and Arp painted their 'cucumber' sets and Suzanne Perrottet, wearing Janco masks, danced to the music of Schönberg and Satie. A ballet called *Noir Kadu* was also performed. These free dances were extensions of the Art Nouveau dance, mixed with cabaret.

Meantime Hugo Ball was at work on his 'sound' novel, *Tenderenda der Phantast* (Tenderenda the Visionary), which centres finally on an image of the dance.[38]

The Bauhaus stage formalized the cabaret of Dada and centred its theatre around formal and improvised dance. Schlemmer envisaged 'plays consisting of forms, colours and lights' and the 'mute play of gesture and movement'.[39] As a perceptive commentator has observed, Schlemmer 'found his real medium for sculpture only when he was able to create choreography and costumes for his dancers'.[40]

Schlemmer may not be a central figure in modern art, but he is one of the main upholders of an idealistic view of man. In all the areas of his work – sculpture, stage and painting – the centrality of the human figure is unchallenged. As he said of his Dessau Bauhaus course of 1928, called, characteristically, 'Man': 'The purpose of the course is to become familiar with man the total being as seen from two points of view: the visible appearance and its presentation, biological and mechanistic methods of observing the body, beginning with the embryo and proceeding to "the entire chemical and psychiatric organism".'[41]

Before the Bauhaus years, Schlemmer's figure paintings were tentative, but the silhouette which was to be characteristic of his dance figures was already evident: strongly curved, with something of the outline of the figures of Seurat.[42] The body was simplified into three ovals of head, chest and tapering legs. These doll-like figures first appeared in the 1912 *Pantomime Sketches*. Cylindrical, smooth, streamlined, they are already poised for the modern dance. Many of the sketchy drawings at this time are called *Scene* or *Play*, and the first dance-titled sketch is dated 1914. Then jointed figures, cardboard-thin, appear around 1915–16. The dancer with padded legs is Schlemmer's most characteristic figure in the paintings of the Bauhaus years.

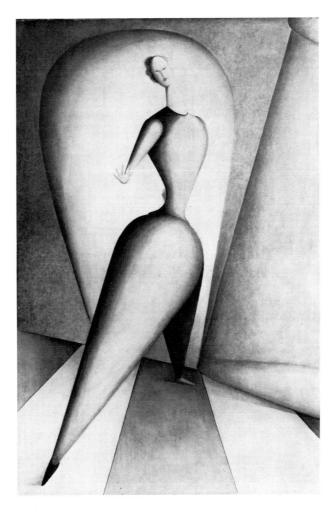

83 Oskar Schlemmer, *Female Dancer* (or *Gesture*), 1923

At the Bauhaus, Schlemmer himself became the dancer–artist in modern guise. The dancer – his *Tanzermensch* – was freed from the restraints of the traditional actor in order that he could find new realms of expression:

He is the one who can give birth to an almost endless range of expression, whether in free or abstract movement or in symbolic pantomime, whether he speaks or sings, whether he is naked or costumed, the Tanzermensch is the medium of translation into the great world of theatre (das grosse theatralische Geschehen).[43]

For Schlemmer it was no mere kinetic display. 'Man seeks meaning', and the form of the actor was created because of a Kandinskian spiritual necessity, almost by psychical impulse.

The new figure 'permits any kind of movement and any kind of position'.[44] The adaptation of puppet figures and the deliberately sought parallels with exponents of acrobatics and dance reflect Schlemmer's desire to produce a new freedom of movement on the stage, as in the visual arts. It was a challenge to which we have seen Klee responding throughout his career; other artists too had found that a way towards the renewal of the figure could be found in theatre. The Cubist figure became a real figure in Picasso's designs for the ballet *Parade*, featuring the ten-foot high Manager from New York.[45] Picasso's monumentally scaled painting *Three Dancers* of 1925, like his earlier *Three Musicians*, gave new form to the human figure as dancer–actor.

But we are concerned principally with the shared views of Klee and Schlemmer, and with the closeness at times of their aims during the Bauhaus decade. Schlemmer's early graphic experiments may have been influenced by Klee; almost certainly Schlemmer would have known the acrobat drawings published in *Der Sturm*, and in 1916 he recorded a tribute to Klee who 'offered his wisdom in a few strokes', and shared his precision with Blake.[46] During the Bauhaus years, Klee would, in his turn, have read Schlemmer's writings on the stage and observed his productions, witness to his desire to transform the human figure.

Klee's figures, his notions of lighting and of the cohesion of figure and ground, must also have been an inspiration for the Bauhaus stage. One of the former students of the Bauhaus theatre, George Teltscher, has said that he came to the Bauhaus from Vienna in admiration of Klee.[47] He very probably knew Klee's painting *The Runner*, which was reproduced in the first monograph on Klee, by Leopold Zahn, in 1920. *The Runner* is theatrically presented, focused stage-fashion in the centre spotlight, turning to the audience and making clear dance-like gestures. The face is mask-like, striped and asymmetrical, one-eyed.

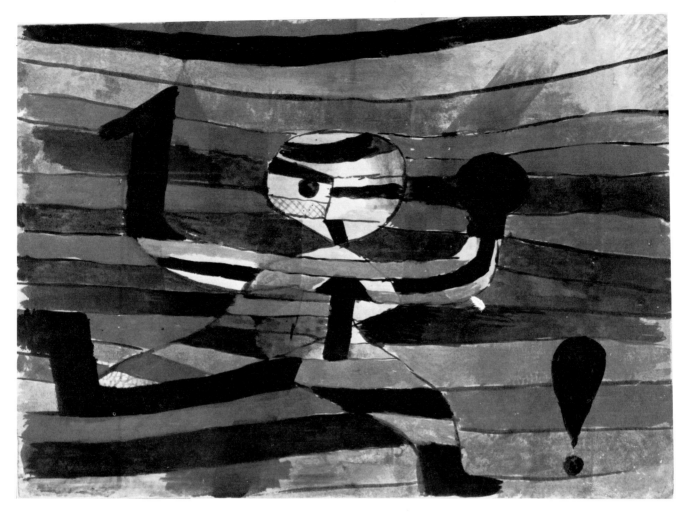

In the ballets designed by George Teltscher and Kurt Schmidt there is an echo of *The Runner*'s two-dimensional pose. Their *Mechanical Ballet*, created in 1923, used dancers costumed in black leotards over which flat pieces of grey cardboard were strapped.[48] They performed in two-dimensional planes. Faces were entirely hidden by the cardboard strips, and the sets took up the strip shapes of the figures.

Such abstract dance-like movements of shapes were one of the main effects sought on the Bauhaus stage. Xanti Schawinsky began a project significantly titled *Play, Life Illusion*, on which he continued to work much later at Black Mountain College after the dissolution of the Bauhaus.[49] It was a stage demonstration of form and colour in motion. Dancers and actors appeared from black drapes and side flaps, demonstrating the colour of their costume and its character in their dance.

But it was Schlemmer's *Triadic Ballet* which was the most elaborate and stylish production of the Bauhaus theatre.[50] He had started already on the

84 *The Runner*, 1920
85

XVII

137

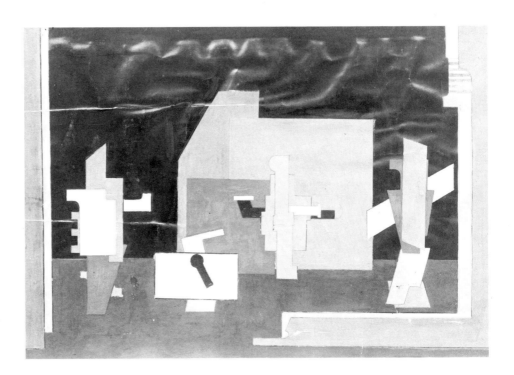

85 Kurt Schmidt, K. W.
Bogler and George Teltscher,
design for *Mechanical Ballet*,
1923

idea in 1912, in the Kandinskian atmosphere of *Der Gelbe Klang* and the
Schönbergian world of *Pierrot Lunaire*. The first actual performance took
place in 1916. It attempted to be more than a mere transformation of the
actor, for it was conceived with allegorical intent to express a range of
emotion and meaning, 'from the supernatural to the nonsensical, from the
sublime to the comic'.[51] It moved between humour and seriousness, playing
with the triadic division of three colours to reflect the three-part change of
mood. Schlemmer described it: 'The first is a gay burlesque with lemon yellow
curtains. The second, ceremonious and solemn, is on a rose-coloured stage.
And the third is a mystical fantasy on a black stage.' There were eighteen
different costumes worked out as varied silhouettes and padded shapes, in
designs according to the action and function of the figure.

The *Triadic Ballet* gave a new vocabulary of forms to the theatre. It
may be seen as a farewell to the fluidity of the costume of the Art Nouveau
dancer and to the jagged sets, still contemporary, of the Expressionist stage.
Schlemmer's designs for Kokoschka's *Mörder, Hoffnung der Frauen*
(Murderer, Women's Hope), produced in Stuttgart in 1921, showed the new
orientation of his thinking; his interest in the dancer and space, and in the
geometric elements of circle and square, was developed prior to his Bauhaus
appointment.[52]

In *The Triadic Ballet* there is a ballerina of conventional contour wearing a
tutu, who dances beside an armless automaton with a round head inscribed

with three circles. There is a cotton-reel man, a priestlike figure with metallic elongated head, and the inevitable marionette with tapering waist and bent arms. The huge padded legs and the height of some figures add to the diversity of design and effect. Big hips taper to tiny feet; a woman with broad hips narrows to an apex, like a spinning-top, and bears herself very like the precise dancers that appear in Schlemmer's paintings and sculptures.

The curves which predominate in Schlemmer's costumes and stage movements are his response to the grace of shape prescribed by Kleist for his marionettes. One figure in the *Triadic Ballet* virtually disappears, for he is dressed in black tights with many wire circles attached to the waist and performs against a black set hung with large circles of wire, anticipating the arcs of movement. The effect recalls Valéry's photographs of dancers holding torches which appear as white paths of movement.[53] Schlemmer's solo *Gesture Dance* he drew on paper as a diagram of arcs and spirals within a circle: the movement, but not the dancer, is shown.[54] On the stage the human dancer in black tights against a black background almost vanishes, leaving only the geometry of his props.

Schlemmer's dances were varied inventions. He sought different effects and contrasting images on the stage. The popular *Figural Cabaret* was two-dimensional in effect, a mixture of sense and nonsense, man and machine. Against a black backdrop recalling the 1912 sketch dances a demon with a

86 Oskar Schlemmer, diagram of *Gesture Dance*

black body and phosphorous legs, hands and head – a modern Petrouchka among mechanical figures. Eventually he shoots himself. Figures disintegrate, having moved at all heights and in all directions, floating, soaring, rotating, whirring and rattling. The comedy of this decapitation and of the mix-up of men and automata gives an air of fantasy to the mechanized Schlemmer stage. It sets itself apart from the Léger type of mechanical man of normal scale, as he dances in the *Ballet Mécanique*: heavy, straightened, unremittingly in line, like a vast drainpipe.[55] Schlemmer's pantomime is light and humorous; although he has 'metaphysical' ambitions, his pantomime is distanced into a *meta-physicum abstractum*.[56]

The interest of all this for Klee would seem to lie in two directions: in the recasting of the human figure as an abstract pattern in motion, and in the heightening of the sense of the allegorical and Kleistian role of the dance. A photograph of a Bauhaus stage production shows a dancer with thin phosphorous sticks moving in the light while the actual body, the agent of the movement, disappears as black tights merge into the background. A painting by Klee has a similar effect. *Rays and Rotation* of 1924 suggests a figure with turned head, but with body negated by a dark background that gives prominence to the pattern of strokes which radiate from the head.

XIX In the same year, 1924, *Exercise in Blue and Orange* hints at a figure that might be seen with legs and arms simplified into the stick dance of the Bauhaus with its highlighted colour and its lighting effects. The background of Klee's painting works in the same way as a dark foil highlighting the abstract figures, in a stage-like proscenium formed by the bands of watercolour washes.

Klee's running figures with their wide-held arms, their poses graceful, their presentation frontal and central despite their profile legs – paintings like *The Runner* and *Runner at the Goal* – are not only akin to dancers with marked movements and gestures, but also share this new integration of costume and background.

Klee was never especially interested in Schlemmer's tubular figure that cuts through space, or indeed in his very sculptural, three-dimensional projection of the figure set in blank infinity to offset its monumental bulk. He is much more proscenium-conscious, never far from the frieze presentation
VIII of the figures in *Comedy*. But there are some witty quotations of the Schlemmer figure with his characteristic padded hips and legs tapering to a point. Klee uses Schlemmer-like figures in quite different contexts, and the effect is gently comical.

In *Fragment from a Ballet to Aeolian Harp* of 1922 – a year of ballet 'inventions' – the dancers are linear creatures with heads extending out and

87 *Rays and Rotation*, 1924

88 *Fragment from a Ballet to Aeolian Harp*, 1922

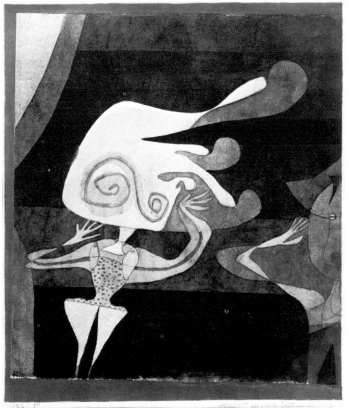

floating against a banded background. The main dancer, a female figure, has triangular legs reminiscent of Schlemmer's design: the tapering spinning-top ends in pin-point shoes and hints at a caricature of the ballerina. The fine point of the feet is almost overbalanced by vast hips, and the body and head of the figure seem dangerously overloaded. They float just off that crucial vertical. The painting itself, like the figures, is transparent, light of touch, with a marked grace, but wind-blown a little towards destruction.

XVIII *Genii* (*Figures from a Ballet*) of 1922 suggests a cultivation of the flow of movement through pronounced curves and subtle tonal shifts so that aureoles extend light boundary layers beyond the figure, giving a sense of the kaleidoscoping of gestures through time. Like the prophetic photographs of Paul Valéry, the painting plots the kinaesthetic effect of the dance in time.

But Klee is quite prepared to depict the dance as erotically dangerous, or as comical and devoid of grace. *Main Scene from a Ballet, The False Oath* of 1922 is back to the early caricatural caper. Two women dance in bikini-like costumes under two moons, one new, one old, and an exclamation point which exclaims at the dance. Their faces are twisted and their claw-like hands force themselves into suitable performance gestures. The balance is comically awry.

The dancing Venus and the maenadic shriek are never too distant. *Ballet Group, or The Family* of 1923 is another role-playing exposé, a danced-out witty sociological allegory. The curtain, certain index of the stage, reveals the mother figure, knees dragging on the ground, head distended, gestures circumscribed. She dominates in hierarchic scale her family of six, all of whom try to get up and perform, but fail because their legs are disobedient.

The impossibility of attaining harmonious movement is seen in another likeness to the Schlemmer spinning-top figure: the *Young Lady's Adventure* of 1922. The hour-glass figure is reminiscent of Seurat and De Chirico, but tapers not to pin-points, but to bound feet. The feet are enclosed within a circle and a red arrow points back on itself. The *Young Lady* is a more innocent victim

64 than that *Equilibrist* female who negotiated her ladders above the swamp. But she has the same fate, hemmed in by green-folding curtains and set around by an assembly of birds and beasts, pecking or staring. Her multiple arms are wildly fluttering, but they are powerless agents, given the bound feet. Her adventure takes place in an adolescent jungle; her free will is sadly circumscribed.

XX A rather older female dancer performs in *The Female Artist* of 1924. Poised on ungraceful legs, she wears her heart drawn on her breast; a double moon – dual symbol of romanticism and madness – is set in the sky, providing

89 *Young Lady's Adventure*, 1922

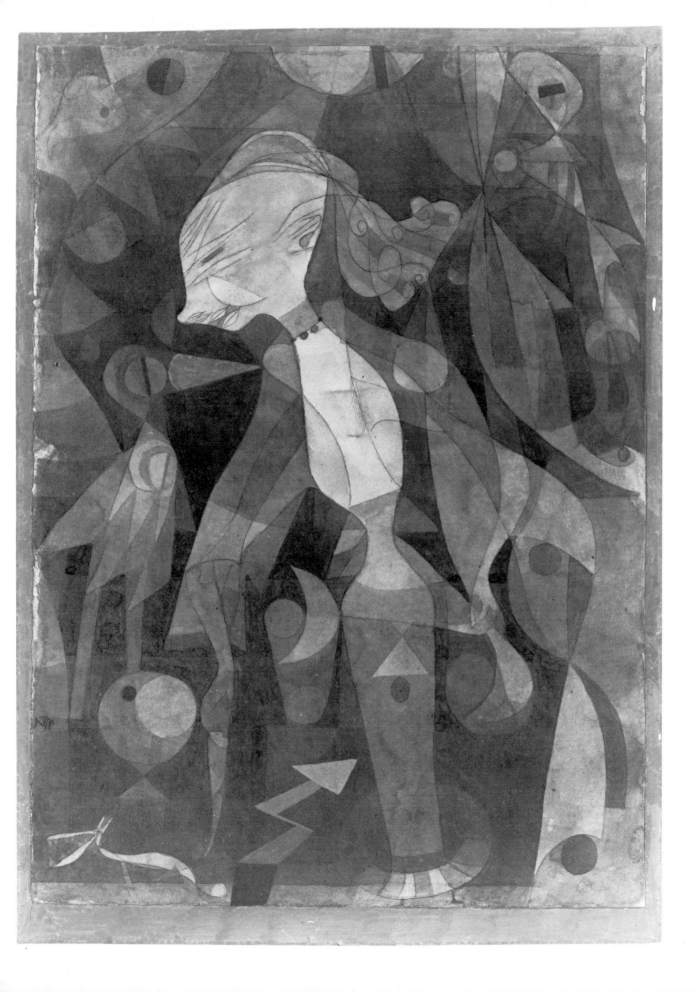

a sinister spotlight. Again she is bound, arms gesticulating and free, but legs rigid and ungainly.

Movement and poise are key effects in the figure paintings. They are also relevant in Klee's abstractions painted in the second half of the Bauhaus years. Often these works, precisely geometric, can be seen to be close to Kandinsky's; but Klee's links with Kandinsky have never been closely observed.

Kandinsky after 1911 – unlike Klee – is usually thought of as an abstract artist, but there are quite clear hints of a figurative return in his painting of the late twenties. Human figures appear as constructs of circles and triangles:[57] reflections of the dance events of the Bauhaus, in fact. In contrast to most of Klee's dance paintings, the figure retains qualities of harmony and balance, remaining as a Kleistian symbol: a crystallization of the potential of man as capable of precise movement.

Kandinsky's Blaue Reiter comments on stage composition and dance as 'the art of the future' were developed in short published notes during the Bauhaus years.[58] Schlemmer was continually inviting guest performers, and of particular note was the visit of Palucca, a pupil of Mary Wigman, already mentioned as a participant in the Dada cabarets.[59] Various accounts of Palucca's visit to the Bauhaus show how close was the conjunction between artists and dancers. Wingler writes of the importance of her Bauhaus performances:

Schlemmer had demonstrations of modern dance and dancing; the dance formed the substantial part of his stage composition. He also called prominent guests like the dancer Palucca to the Bauhaus so that the Bauhaus became a centre of spiritual discussion concerned with the problems of the avant-garde forms of the dance.[60]

Another account more directly involves Klee and Kandinsky:

Palucca belonged to the Bauhaus. She led the modern dance from the Expressionist phase into the area of the spiritual and the abstract, so that it became weightless and insubstantial. In Klee and Kandinsky she can rightly see the fathers of her great art. She not only performed her dances to students, but also her exercises, which gave an insight into the process of shaping her dance creations.[61]

Ju Aichinger-Grosche, long after the Bauhaus years, wrote in *Erinnerungen an Paul Klee* (Reminiscences of Paul Klee) in such a way as to suggest Klee's very positive admiration for the dance:

Gret Palucca, for me one of the most musical and abstract of dancers, never missed visiting the Klees when she had engagements at Berne. I remember how moved Klee was when he saw her dance to an aria of Gluck. 'This is gliding into the beyond – already being in another realm – a wonderful death,' he said.[62]

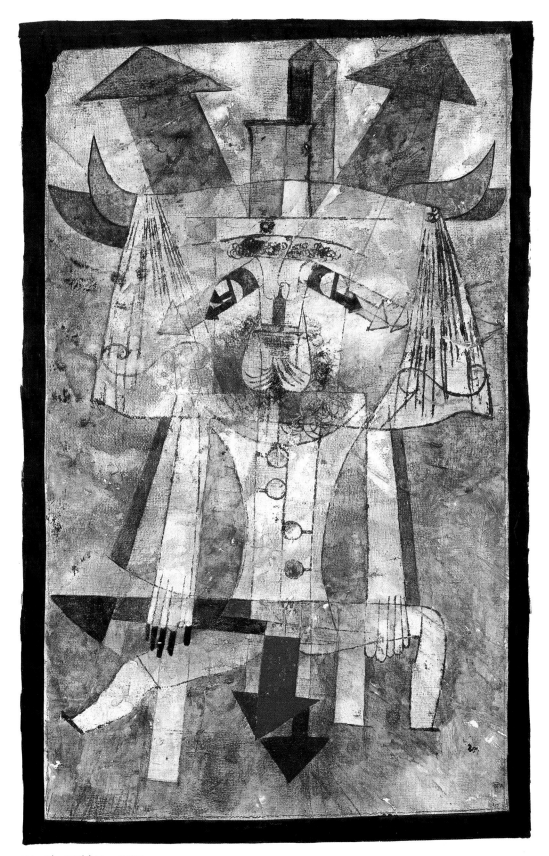

XVI *The Wild Man*, 1922

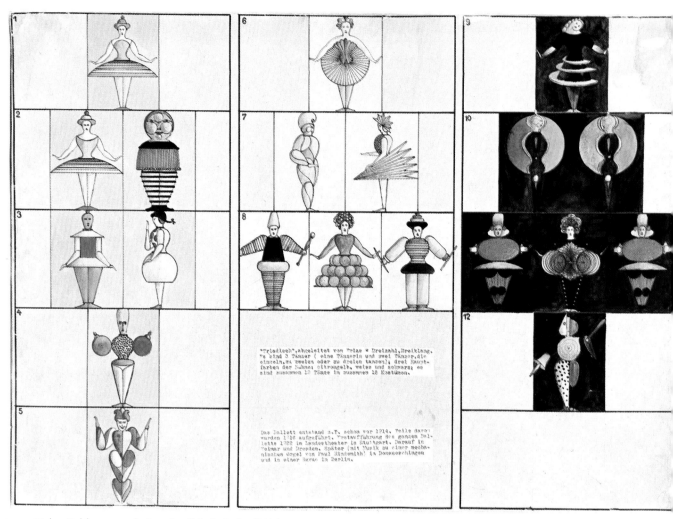

XVII Oskar Schlemmer, designs for *Triadic Ballet*, 1922/6

XVIII *Genii (Figures from a Ballet)*, 192

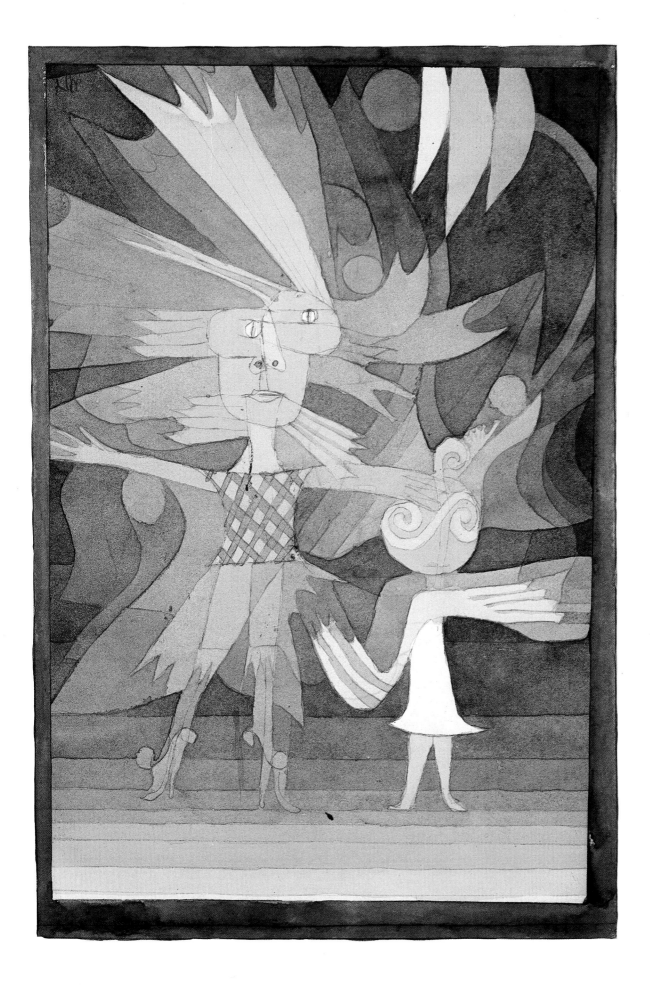

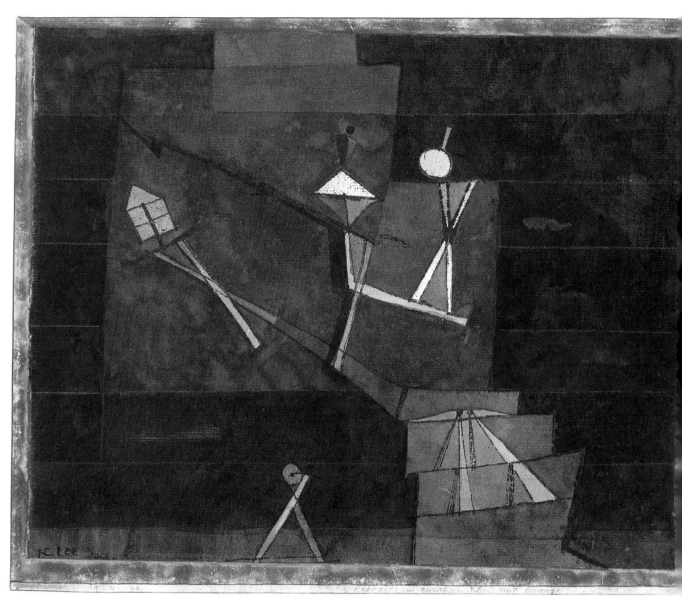

XIX *Exercise in Blue and Orange*, 1924

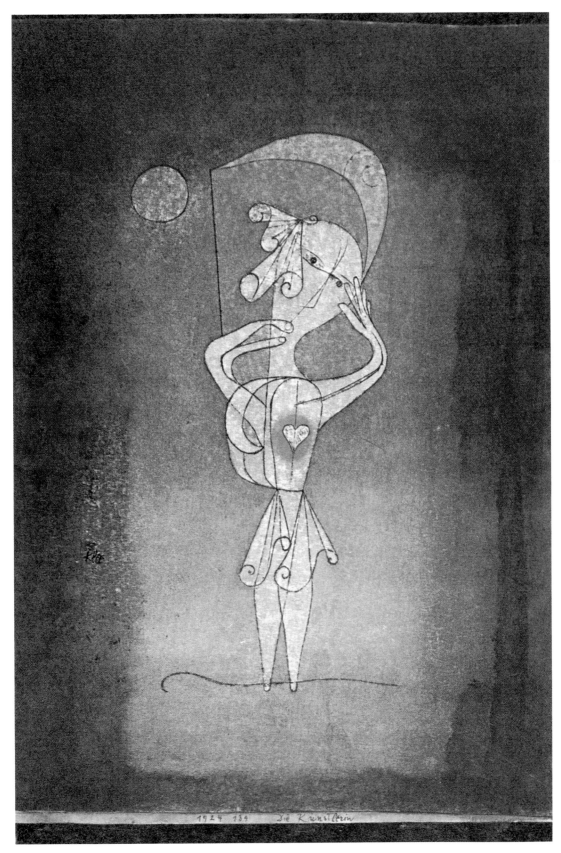

xx *The Female Artist*, 1924

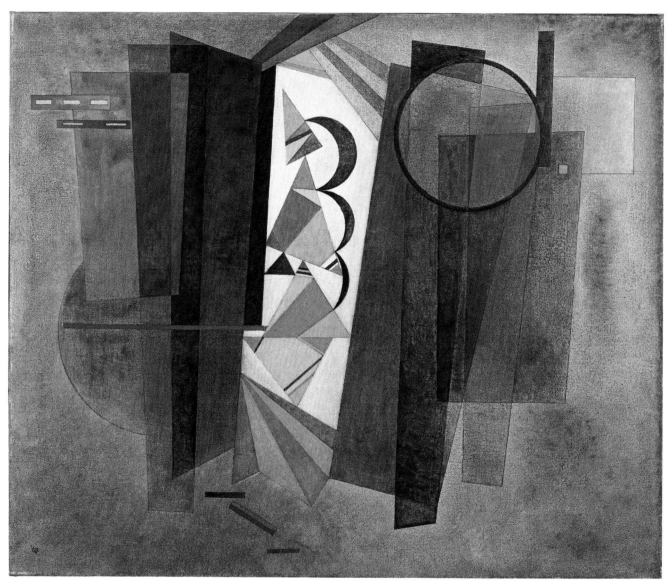

XXI Wassily Kandinsky, *Development in Brown*, 1933

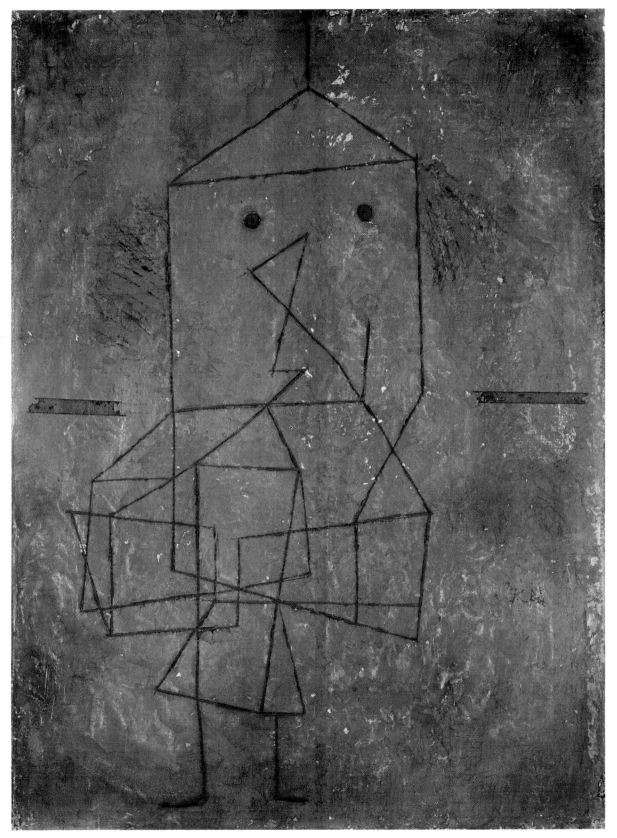

XXII *The Burdened One*, 1929

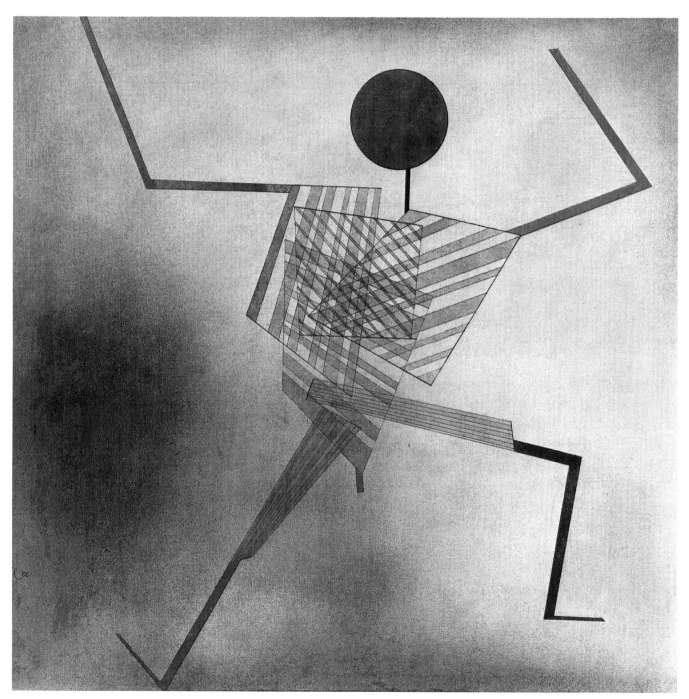

XXIII *Acrobat*, 1930

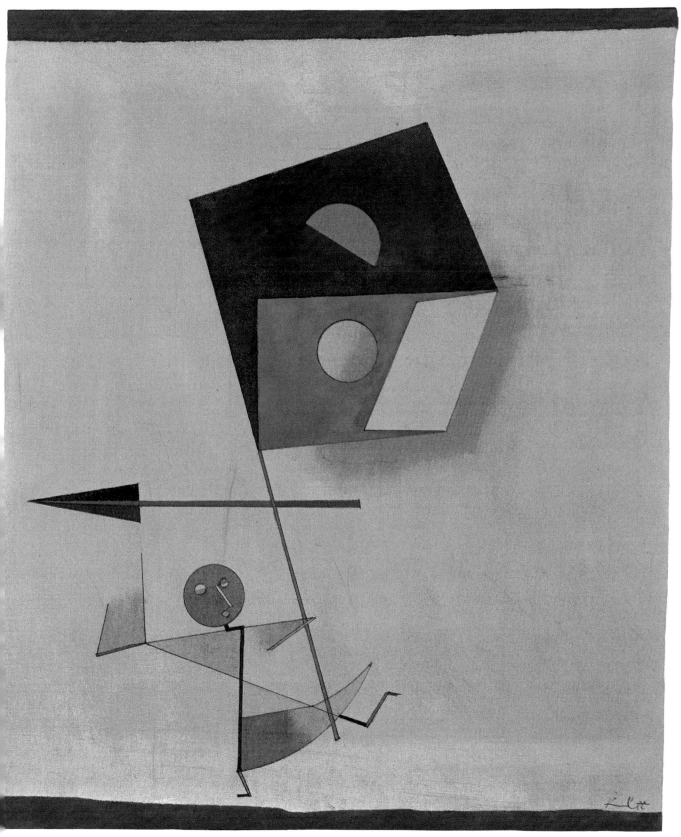

IV *Conqueror*, 1930

XXV *Fire Mask*, 1939

XXVI *Voice from the Ether: 'and you will eat your fill'*, 1939

XXVII *Overexcited, 1939*

XXVIII *Death and Fire*, 1940

XXIX *Demonry*, 1939

XXX *Outbreak of Fear,* 1939

XXXI *Struck from the List*, 1933

In some of Kandinsky's works we have a fascinating glimpse of the importance of the dancer's art for the 'abstract' painter. He made three drawings of Palucca exercises, using a precise, almost ruled, stick figure schema, possibly working from photographs, for the drawings were published with the photographs in *Der Sturm*. He published his notes on 'dance curves' in *Das Kunstblatt* of 1926, further emphasizing the attractive exactitude of the dance: though it may appear merely simple to the layman, the artist knows how to treasure its precision. He points admiringly to the very simplicity of the form and structure, the precision of the details, and the unity of the complex dance in time.

In 1928, with the assistance of Klee's son Felix, Kandinsky made stage designs for Mussorgsky's *Pictures at an Exhibition* for the Friedrich Theatre in Dessau.[63] Sets and figures were formed exclusively from geometrical elements – the line, the triangle and the circle. The figures appeared as two triangles: the apex of one reached to the waist, the other became the point of the feet. This frugal and severe statement of man the dancer actually enters his paintings around 1932. A figure balances on its apex points within a set of stage-like flats, suspended curves and segments of circles reminiscent of the sets for Mussorgsky. In his painting *To the Right, To the Left* of the same year,[64] a definite allegorical significance seems to be given to the figure: its precision

90 Wassily Kandinsky, sketches of the dancer Palucca published in 1926

91 Wassily Kandinsky, *To the Right, To the Left*, 1932

of delineation expresses exactitude and control of movement and behaviour. It stands, a small but exact being, in an arrangement of spaces, bars and circles.

XXI Could we not see Kandinsky's picture entitled *Development in Brown*, painted in 1933 – the year when the Bauhaus, under political threat, had to close – as a clear indication of the dancer's allegory of freedom? For around the figures, whose feet end in a fine point of balance, are brown shutters closing in. And these dark tones announce, as they did in Kandinsky's earliest ideas for the stage, the presence of evil; they are an example of the ethical correspondence of tones and colour, from light to dark.

The straight-lined figure and the geometric constructions with titles implying counterbalance and poise have precise parallels in Klee's work. Momentarily he allowed a Palucca-like dancer to perform a precision dance. XXIII In *Acrobat* of 1930, and its preparatory drawing entitled *Dancing Master*, the figure in each case is built of line of almost ruled straightness. The upper body is a cage of overlapping and striped transparent planes; hips and limbs are transparent planes suggesting the sliding action of a shadow puppet. The

head, oval, floats above the body; equilibrium and mobility of mind are suggested by bodily precision and exactitude.

But this precision is the ideal, not the reality, and Klee's statement of precision is more often non-figurative. The human figure is not present in a group of paintings from around 1930, such as *Polyphonic Setting for White, Hovering (before the ascent), Daringly Poised*. These works have geometric planes hanging in space, in ambiguous relationship one to another. Sometimes they are solids, at others transparent like box kites. Such paintings activate their components like geometric acrobats, but without figurative reference. In 1930, they show Klee nearest to non-figurative work, and yet the distance from the human figure and its allegory of equilibrium is not great. The *Conqueror* is ruled up, and close in style and colour to the abstractions, XXIV but it features a mannikin who hooks a huge kite to his arm and bears it off in the direction pointed by an arrow. Despite the scale of his load, far bigger than he, he is the victor. Precise in delineation, he is related to the triumphant *Acrobat* of the same year.

The clear space, the geometry, the precision: these give way, in Klee's last decade of work, to contemplation of disarray and of collapse, stylistically rendered in jagged and black line.

More overriding in the paintings of the thirties is the loss of balance and the increasing admission of tragedy. *The Burdened One* of 1929, explicitly XXII encumbered by the painting's title, operates as an armless figure dangling from his marionette string. It prevents his movement; his little feet hang above the ground; the body cannot move in the space in which it swings. Klee wrote of 'the tragedy of spirituality ... the consequence of this simultaneous helplessness of the body and mobility of the spirit in the dichotomy of human existence'.[65] The pressure of this belief marks the works of the thirties, where specific theatre parallels become irrelevant. Very often the dancers are children: stick figures, no longer geometric and precise, but rendered in the thick pressing black line of the late works. Behind, there are bright squares of colour – red and blue, children's primaries. But, like many of Klee's late works, these are paintings of great tension, despite the colour and the deceptively gay dance. Klee is not painting the childish exhilaration of the dance, but a potential adult bondage and collapse.

As we have seen, Klee's compassion for the child has many expressions. The child's world is often presented in a child's style; there is a deliberate artistic empathy on Klee's part. A child dancer mimes its own sadness in a small and tender drawing, *Dance of the Grieving Child* of 1921. Its head is falling back, larger than its body; its arms are stretched out, holding a peacock feather. In the giant head an umbrella eye turns upward to catch the

92 *Dance of the Grieving Child*, 1921

potential tears. A single line makes the head a sophisticated pattern of outline and closed eyelid.

The stick figure child – a drastic reduction – does not appear consistently in Klee's work until later in the twenties. An etching of 1928, *Height!*, resembles earlier Sturm drawings in its use of the framework of an acrobatic structure with precise but unsound arrangements of ladders supporting the female on the top. The child tries to balance, with arms outstretched, but one foot shoots off the top of the ladder.[66] A sun and a park with trees are drawn far below the figure, who is raised dangerously high above the ground. She has a round head, with features made of dots and straight lines. The dress is unembellished, a mere triangle.

The childlike side of Klee's work, overriding in the late years, is very often misunderstood; it is a quality that embarrasses and that strips the adult dignity from his work. Similar embarrassment is often the response to the music of Eric Satie, who often has an affinity with Klee in his wit and sense of play. For Roger Shattuck, one of Satie's commentators, he was a man 'who performed every contortion to keep sight of his childhood. Like a child who twists his body as he walks in order not to lose sight of his shadow, Satie made sure that the most treasured part of his past was always at his side.'[67] Similar

caution, even condescension, crept into George Boas's comment on Klee, in his *Cult of Childhood*:

Klee was frank about his desire to return to childhood . . . to be 'ganz schwunglos, fast Ursprung, wie neugeboren' is of course an impossibility and we all have desires that are demonstrably unattainable. . . . What makes Klee's words of interest is that once again we have an artist whose programme is the rejection of the civilization in which he is living and the demand for a condition of life best exemplified in childhood.[68]

But is it not, in Klee's case, an adult consciousness of the very impossibility of the return to the state of childhood, on the one hand, and, on the other, a realization of the tragedy of the child who is father to the man? Klee's child world is not one of regressive nostalgia, but of empathy and a sense of pathos, for the child, as he already paints it in 1923, whether it will ever know or not, is consecrated to woe.

The 1928 etching *Height!*, prophetic of the late simple style, reintroduces the early circus theme of dangerous suspension. It is one of Klee's most basic metaphors. The circus professional is changed to the child who is an initiate in

93 *Height!*, 1928

94 *Outbreak of Fear,* 1939

problems of balance: the child demonstrates the insecurity of the adult, and its own method of drawing is used further to identify its plight.

XXVII In a work of 1939, *Overexcited,* painted when Klee, ill and dispossessed, had returned to his native Switzerland, a figure dances on a tightrope that is held at one end by a man upside down, and at the other by an animal on a wheel. The line of the tightrope has a second role: a tree perched on it makes it into the line of the horizon, suggesting the earth that cannot support this child's dance. The skidding ground-line supported by wheels – those traditional bearers of fortune – is also used in *Blue Dancer,* of 1940. With a simple line – the most elementary pictorial means – Klee creates a visual simile of the earth as a tightrope.

The stick figure girl has lost any vestiges of the sophistication of the Bauhaus acrobats and dancers. Now the line is thick and urgent, less finished;

the figure is not a precise mannikin with efficient joints, but a childish and unco-ordinated amateur who must invent a haphazard choreography. Her arms are over-long, and one splays out into two sections at the elbow; hands are simple circles, like the ends of drumsticks, that will batter at the head. Above the figure, an exclamation mark.

The word 'fear' appears in many titles of the thirties. In the 1939 *Outbreak of Fear* a dislocated head spins over separate limbs hacked from a body, suggesting a psychological pressure strong enough to tear the body apart. Shambling crude dancers are caught in a similar psychic state and the bright colours that accompany them are ironical bunting. *Dancing from Fear* of 1938 is explicit in its title: crazy-Jane stick figures dance wildly. Bodies and skirts are triangular and square with the simple legs sticking out at the points.

With Green Stockings of 1939 is rather more simply gay and ingenuous, but *Dancer* and *Blue Dancer* are part of the skeletal company that enact Klee's death paintings of this year. As in *Enclosed* and the well-known *Death and*

96

XXVIII

95 *Dancing from Fear,* 1938

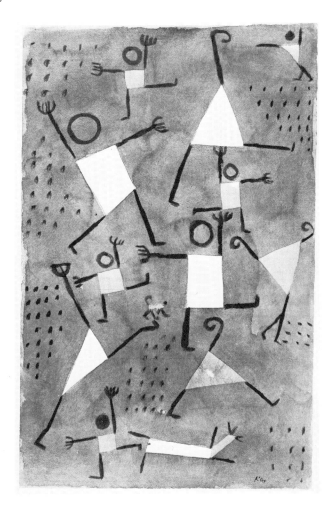

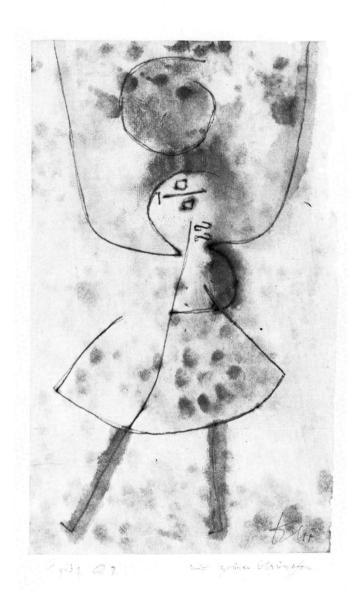

96 *With Green Stockings,*
1939

Fire, the black stick figure is the final pared-down statement of the completely enmeshed puppet. We can hardly avoid the dance of death implications in the wild prancing of these children, for the tightrope horizon is so clearly supported on inadequate earth wheels, and the heads are thrown back with the irrational force of ancient maenad dancers. Their faces reflect the simple terror of the masks of these years: round heads with circle eyes, a simple line nose moved off-centre, breaking the faces into lines of anguish.

'Pathos', wrote Klee, 'is expressed in art as a motor impulse off the vertical, or as deviation or disruption of the vertical.'[69] His statement recalls Symbolist and neo-Impressionist aesthetics: the Charles Henry idea of the feeling

implicit in the direction of line.[70] Klee's expression is developed in response to the human centre of his art; its effects mark both abstract and figurative works. The angular dancers are evidence not of a naïvety of form, rather of the choice of the most direct and simple means of expressing human plight. When Klee's forms are at their most simple in the last years of his life, the content of his art is most pressing and deeply felt.

If the meaning of the puppet changes in the thirties, so too does the mask, becoming more savage, and simpler. A twist of features, a displacement of head from body: the innocent face returns to the grotesque. The last heads are unambiguous masks, simple circles with round dot eyes and a mouth twisted to the side. A confrontation with death and a realization of political destruction and chaos are expressed through the sombre line and skeletal mask face.[71]

The terrorized face first appears in the 1932 *Mask of Fear* where the head 97
forms the total body, and is set with four legs. No longer is the mask donned for concealment or the metamorphosis of the game; it is the real state, the whole body walks in constant fear. Similar pressures are seen in an almost naturalistic drawing of 1932, *Masked–Naked*, which is sparsely linear, delineating the discomposure of body and face.

Some of the last masks still retain a comic gaiety, but there is a new brutality. *Mask with Three Teeth* (1932) is a high-toned oval on a speckled background; the features are in black, very separated; three teeth leap out. *Black Mask* of 1938 is thickly painted with a macabre gusto: a black blob with wild scribble hair, earrings, one large eye – almost, but not quite, beguiling. The red-streaked *Fire Mask* of 1939 is the face of an incendiary: a slab of red XXV
with dotted eyes and row of teeth.

Klee's mask, as consistently presented in the last years, is broken and awry. It is seen in the disintegrated jack-in-the-box face of *Diseased Melancholic* of 1932, with staring eyes and features irretrievably separated. *Broken Mask* of 1934 lies on the floor, only a shell with no head behind.

Some of the late masks must be seen in political terms as allegories of propaganda. *Voice from the Ether: 'and you will eat your fill'* has been XXVI
interpreted as a representation of a German listening to his leaders in 1939. C. M. Kaufmann describes it:

The head is strong and economically rendered. Short hair, staring eyes, and a mouth dripping with saliva are the sitter's unpleasing characteristics. . . . The head may be interpreted as a portrayal primarily of the greed whetted by the promises of Nazi propaganda.[72]

The face with 'SS' ears alludes to the actual situation in Germany. Klee's consciousness of threat we have seen to be quite explicit in his work since

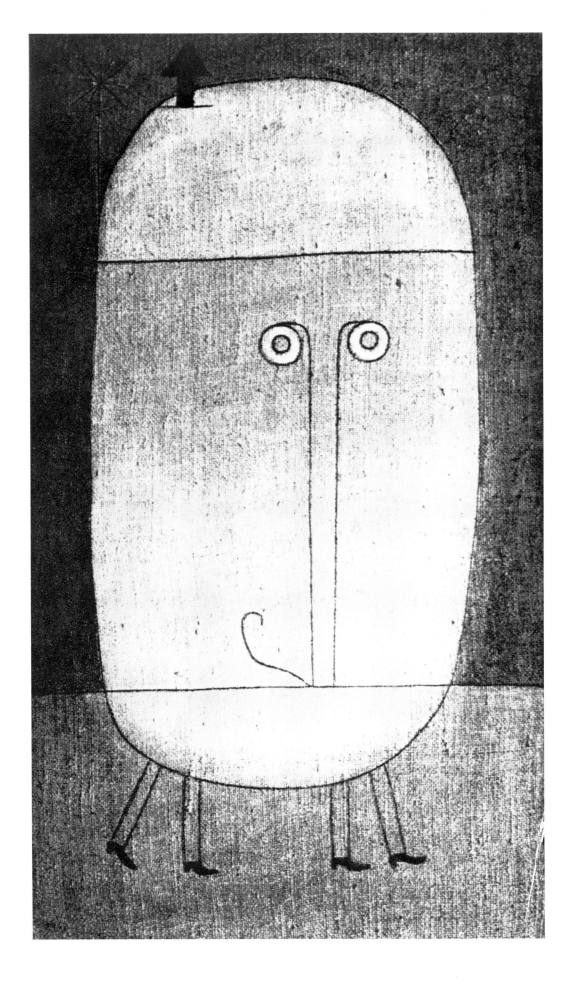

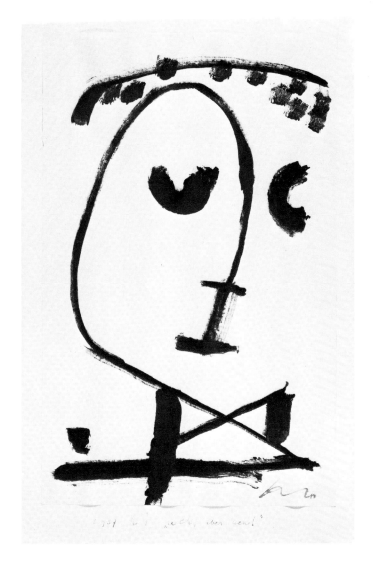

1933. The painted head, *Struck from the List* of 1933, must allude to the political situation, leading up to the exhibition of *entartete Kunst* in 1937 by the elimination of artists from teaching positions and possibilities of exhibitions.[73] The eliminated head is clumsy, shapeless, stitched together like an ungainly patchwork. It resembles a straw dummy for bayonet practice. And the 'X' is scored heavily over it – not across the features, but over the back of the skull, as if to suggest that it is not the outward face which will suffer, but the mind itself. Here is the political mask which is one of Klee's major motifs from 1932 until 1940. The mask registers historical events, showing imposition of external actions upon the individual.

Many of the masks, figures and faces of these years similarly suggest the paralysis resulting from political organization, from *Mask of Fear* of 1932 to the roughly sketched *Alas!* of 1937, the thin line pen drawing of a disembodied

XXXI

97 *Mask of Fear*, 1932

171

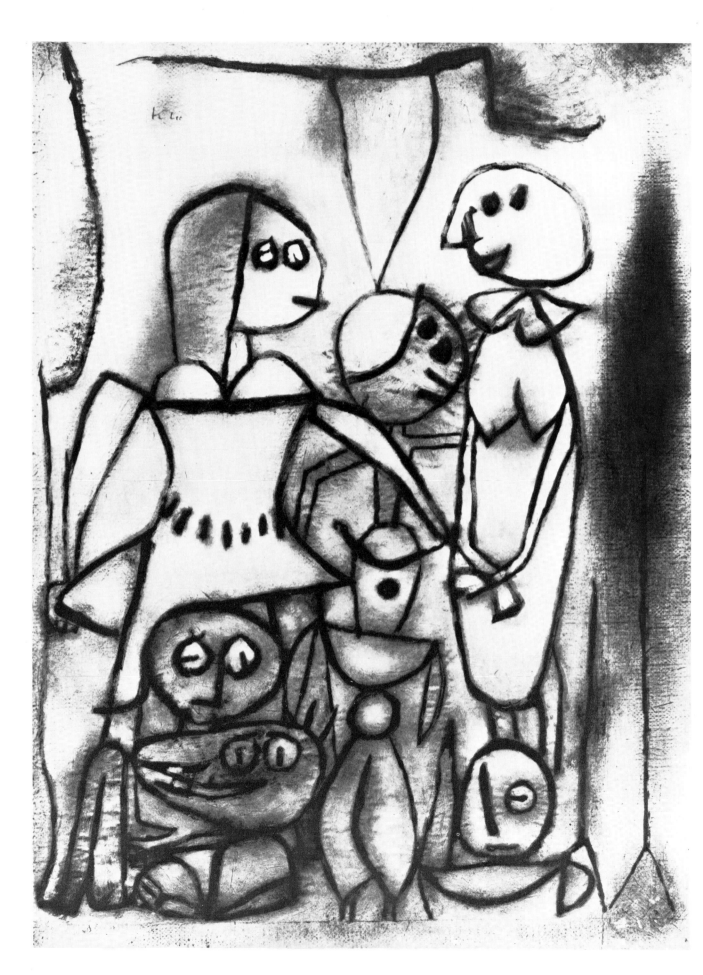

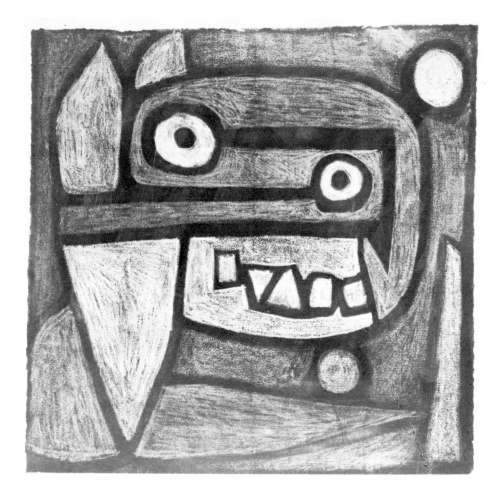

head called *Outbreak of Fear* (1939), and the related painting of the same title. The toppling bared-teeth heads of *Trio Conversing* of 1939 speak the same language as the pared-away head of *After the Act of Violence* of 1940.

Group of Masks of 1939 collects the faces, jumbles and reduces the bodies to shrunken remnants that lie beside the distended heads. It announces a mass disintegration, a fracturing of society: Klee, like Mozart, could no longer 'neglect the inferno'.

The discomfort of emotion expressed by caricatures and twisted faces affects too the dislocated stick figures. The marionette is no longer a distanced and neutral figure acting out a domestic satire. It has become a charred and dehumanized remnant, craftily manipulated and afraid. The face cannot result from a playful character or a lyrical metamorphosis, as in the mask of the twenties. It is now a serious diagrammatic graph of spiritual dislocation.

The unequivocal grimace is present in the last robot heads: *Mask* of 1940, *Demonry* and *Death and Fire*. Clearly these heads are symbols of death, the unavoidable metamorphosis. Klee now returns to the old iconographical

tradition of the human face and the skull in a grim echo of Dürer, Holbein and Ensor. One is reminded of the moving act of the mime artist Marcel Marceau, who plays the mask-maker trying on his creations: the sad, the gay, the wry, all alternate; the Senecan artist plays with the full range of human passions. But finally the tragic mask will not away and mask and artist are sealed together.

Around 1938, the pastel gardens and the undersea flowers – the lyrical nature paintings of the last years which counterbalance the fear paintings of the thirties – become less frequent. Most of the late paintings are figures. There are angels appearing, most often in the drawings, but their comfort seems without conviction.[74] The innocence of the sources of the last works should not obscure the inevitability of fate which is the constant meaning of these works, where puppet, mask and dance are used to perform their most relentless rituals.

There is no point in evoking or labouring any specific theatre analogy, since the themes of the early years are so transmuted in this bleak last style: they are continuous, and yet different. But Hugo von Hofmannsthal's description of the death dance from his *Das grosse Salzburger Welttheater* (Great Salzburg World Theatre), produced spectacularly by Max Reinhardt in Salzburg in 1922, might serve to enrich the sense of Klee's sure return to the medieval tradition in his *Death and Fire*:

Death forces the King by his drumbeats to descend from the throne and to follow him, step by step.
 But the power of his drumming is such that the King is simultaneously attracted and repelled by it.
 He no longer walks like a living creature being led by an instrument, but as though his soul had gone out of him and is now part of the drumbeats.
 Like a puppet dangling on wires, whose limbs hang slack, the King follows the drummer . . .[75]

Klee's *Death and Fire* is in the modern painter's tradition of the clown/pierrot artist, and the fool/king lineage of the older past. The white-faced clown is a double play with the face becoming a skeleton, already outlined against the red hell-fire. He needs no separate figure of death to provide his drumming, for as in the case of the girl of *Overexcited*, who still remains in the world of parks and trees and daylight, arms are the drumsticks and the beating is self-generated and inevitable.

XXVII

The weight and predicament of the human figure in Klee's output has been obscured by his emphasis on abstraction, his pedagogical concern with the elements and the process of art, the musical analogies of harmony and form: his interest, in short, in providing a grammar for modern art. But when he said

in his Jena Lecture, 'We need a people,' he was not indulging merely in social rhetoric. His teaching may seem to be primarily concerned with an abstract development of forms, but there is an inherent physiognomy in his use of lines, weights and colours. The earliest etchings demonstrate his idea of art as disclosure: nature pictures from 1914 uncover the secure cycle of the harmonies of nature. But his figure paintings express his central pre-occupation with harmony threatened: the dance is symbolic of mankind's striving to leave the earth. The last dances of the children express the pathos of equilibrium lost – on a personal level, on a national and political level, for all mankind. The simple child forms express anew the most ancient themes of art and allegory: the passage through life, the eruption of fear, and the final dance of death.

Schlemmer wrote in his diary, 6 July 1940: 'Today the news that Paul Klee is dead! Only a year after he turned sixty ... What a visual and spiritual contribution he made to the world of the artist. And what wisdom!'[76]

Notes on the Text

Introduction: Klee's Allegory

1 The teaching notes so far published centre on the study of nature: Paul Klee, *The Thinking Eye: the Notebooks*, and *Notebooks* vol. 2, *The Nature of Nature* (both ed. Jürg Spiller), Lund Humphries, London, 1961 and 1973. See Max Huggler, 'Die Kunsttheorie von Paul Klee' in *Festschrift Hans R. Hahnloser zum 60. Geburtstag* (ed. E. J. Beer, P. Hofer, L. Mojon), Birkhäuser, Basel/Stuttgart, 1961, p. 425ff. The use of the line is central to Klee's 'Creative Credo', first published as 'Schöpferische Konfession' in *Tribüne der Kunst und Zeit*, vol. XIII, 1920, p. 28ff., Erich Reiss, Berlin; English translation in *The Thinking Eye*; and to his *Pädagogisches Skizzenbuch*, Bauhaus Book no. 2 (ed. W. Gropius and L. Moholy-Nagy), Albert Langen, Munich, 1925; English translation, *Pedagogical Sketchbook* (introduction and translation by Sybil Moholy-Nagy), Faber and Faber, London, 1953.

2 For succinct discussion of the theories of organic growth in German thought, see M. H. Abrams, *The Mirror and the Lamp: Romantic Theory and the Critical Tradition*, Oxford University Press, New York, 1953, ch. VII, 'The Psychology of Literary Invention: unconscious genesis and organic growth', p. 184ff.

3 See Richard Verdi, 'Musical influences in the art of Paul Klee' in *Chicago Museum Studies*, no. 3, 1968, p. 81ff., and Hellmuth Christian Wolff, 'Das Musikalische in der modernen Malerei' in *Jahrbuch für Ästhetik und allgemeine Kunstwissenschaft*, vol. VII, 1962, p. 48ff.

4 Paul Klee's poems published: *Gedichte* (ed. Felix Klee), Die Arche Verlag, Zürich, 1960; and in translation: *Three Painter-Poets: Arp/Schwitters/Klee, Selected Poems* (translated with an introduction by Harriett Watts), Penguin, Harmondsworth, 1974. See Walter Sorell, *The Duality of Vision*, Thames and Hudson, London, 1970, p. 160ff.

5 Cf. Paul Klee, *The Diaries 1898–1918* (ed. and with an introduction by Felix Klee), University of California Press, 1964, p. 124 (1900):

Now I had achieved a good deal. I was a poet, I was a playboy, I was a satirist, an artist, a violinist.

750 (1906):

This time I just read World Literature.

and 826 (1908):

All sorts of books read and performances attended in June and July.

6 Some of the *Die Alpen* reviews are incorporated in the *Diaries*: e.g. 905, 916.

7 Cf. 'The Shooting Star' in the *Pedagogical Sketchbook*, whose peril is 'to be tied forever to the earth', p. 49.

8 The evidence of the *Diaries* is often incomplete; some parts are full, and yet others tantalizingly blank. After 1909 Klee's listing of his reading is less frequent; the last theatre-going entry concerns Shaw's *Caesar and Cleopatra* (898). For three years before there is little mention of drama.

There are comments in all the major monographs on Klee's interest in the theatre. Felix Klee has loosely grouped the titles of paintings connected with theatre and opera in his *Paul Klee, His Life and Work in Documents*, George Braziller, New York, 1962, p. 93. See also Will Grohmann, *Paul Klee*, Lund Humphries, London, 1954, p. 247ff., and G. di San Lazzaro, *Paul Klee*, Thames and Hudson, London, 1957, p. 175. James Thrall Soby, *The Prints of Paul Klee*, C. Valentin, New York, 1945, makes thoughtful reference to the 'theatricality' of the early etchings, p. 11.

9 Many comments show that he regarded opera as drama in which the music was intrinsic to the dramatic effect. He makes a sustained diary entry on Puccini's *La Bohème*:

A work in which all components, given equal importance, interact. ... As a drama this primitive, unmotivated business would make only a poor

impression. Through the music, however, everything is humanized with such penetrating emphasis that the keenest pity extends to these people and their destinies are ennobled. The fateful language of the music accomplishes this. (365)

Cf. Joseph Kerman, *Opera as Drama*, Vintage Books, New York, 1956, *passim*, but especially p. 13. For further comment on Klee's interest in opera, see Christian Geelhaar, *Paul Klee and the Bauhaus*, Adams and Dart, Bath, 1973, p. 81ff., 'The World of Opera'; Felix Klee, *Paul Klee*, p. 93; and Grohmann, *Paul Klee*, p. 80: '. . . the Düsseldorf years. . . . Klee heard works by Janacek and Weill. . . .'

10 *The Thinking Eye*, p. 388.

11 See Grohmann, *Paul Klee*, p. 70; and the reminiscences of Karl Grebe, who played chamber music with Klee, in *Erinnerungen an Paul Klee* (ed. Ludwig Grote), Prestel Verlag, Munich, 1966, p. 58.

12 See Paul Hadermann, 'Expressionist literature and painting' in *Expressionism as an International Literary Phenomenon: twenty-one essays and a bibliography* (ed. Ulrich Weisstein), Budapest and Paris, 1973, p. 111ff.

13 For a description of the German theatre and its leading playwrights at the turn of the century, see René Lauret, *Le théâtre allemand d'aujourd'hui*, Gallimard, Paris, 1934.

14 Klee had read *Maria Magdalena* (488), *Genoveva* and *Judith* (513), *Gyges and his Ring* (488), *Die Nibelungen* (559), *Michelangelo, Herod and Mariamne* (702), and *The Treasure Box* (778). He had read the *Diaries* in 1905, *My Opinion about Drama* and other theoretical writings (520), and the *Epigrams* (513).

15 See Hugo Ball, 'Das Münchener Künstlertheater (eine prinzipielle Beleuchtung)' in *Phöbus*, no. 2, 1914, p. 68. See also Edward Henry Gordon Craig's account of the 1908 theatre in *On the Art of the Theatre* (first published 1911), Mercury, London, 1962, p. 128ff., 'The theatre in Russia, Germany and England'.

16 *Diaries*, 1134.

17 Grohmann, *Paul Klee*, p. 70.

18 See Annabelle Henkin Melzer, 'The Dada actor and performance theory' in *Artforum*, December 1973, p. 51ff.

19 Edgar Wind, *Art and Anarchy*, Faber, London, 1962, pp. 132–3, and Lisa Appignanesi, *The Cabaret*, Studio Vista, London, 1975, especially p. 72, 'Cabaret as a Vehicle of the Artistic Vanguard'.

20 See Felix Klee, *Paul Klee*, p. 35.

21 'On Stage Composition' in Wassily Kandinsky and Franz Marc, *The Blaue Reiter Almanac* (ed. Klaus Lankheit), Documents of Twentieth Century Art, Thames and Hudson, London, and Viking, New York, 1974, p. 190ff.; and 'The Yellow Sound, a Stage Composition', ibid., p. 207ff. On Kandinsky's synthesis of the arts see Peter Selz, 'The aesthetic theories of Wassily Kandinsky and their relationship to the origin of non-objective painting' in *Art Bulletin*, vol. 39, June 1957, p. 127ff.

22 See Paul Overy, 'Colour and Sound' in *Apollo*, vol. 79, May 1964, p. 407ff.

23 Hugo Ball, *The Flight out of Time*, Documents of Twentieth Century Art, Viking, New York, 1974, p. 4.

24 Ibid., p. 9.

25 Lothar Schreyer, *Erinnerungen an Sturm und Bauhaus*, Verlag Taschenbücher, Munich, 1966, p. 17:

Ich – wie meine Berliner Freunde – erstrebte für die Bühne das Einheitskunstwerk, in dem alle Mittel der Bühnengestalt, also Wort, Ton, Bewegung, Farbform, zur Ganzheit und Einheit einer in sich geschlossenen Kunstgestalt erhoben sind.

I, like many of my Berlin friends, was striving for a total work of art for the theatre, in which all the resources of the stage – word, sound, movement, colour-form – would be elevated and fused in an art form complete in itself.

26 Klee participated in the Sturm exhibition held in 1913 in Berlin, and translated Robert Delaunay's essay 'On Light' for the periodical *Der Sturm*, vol. 3; Grohmann, *Paul Klee*, pp. 50 and 53. He was photographed for the Der Sturm postcard: Felix Klee, *Paul Klee*, p. 146.

27 Lothar Schreyer, *Erinnerungen an Sturm und Bauhaus*, p. 21, 'Kindsterben'.

28 See the introduction to Oskar Schlemmer, Laszlo Moholy-Nagy, Farkas Molnar, *The Theatre of the Bauhaus* (ed. and with an introduction by W. Gropius, translated by A. S. Weisinger), Wesleyan University Press, Middletown, Connecticut, 1961, pp. 7–14; for the general Bauhaus philosophy of 'synthesis', see Siegfried Giedion, *Walter Gropius, Team and Teamwork*,

Architectural Press, London, 1954, and Gilbert Herbert, *The Synthetic Vision of Walter Gropius*, Witwatersrand University Press, Johannesburg, 1959, *passim*.

The Bauhaus theatre has not received generous treatment at the hands of theatre historians; but see Paul Pörtner, *Experiment Theater: Chronik und Dokumente*, Die Arche Verlag, Zürich, 1960, and the catalogue of the Zürich exhibition *Oskar Schlemmer und die abstrakte Bühne*, Kunstgewerbemuseum, 1961. E. T. Kirby, in his *Total Theatre, A Critical Anthology*, Dutton, New York, 1969, includes the Moholy-Nagy essay 'Theatre, Circus, Variety', p. 114ff.

29 See Schlemmer's diagram of the 'Schema for Stage, Cult and Popular Entertainment' in *The Theatre of the Bauhaus*, p. 19, and Moholy-Nagy, 'Theatre, Circus, Variety', ibid., p. 50ff.

30 For further comment on the interrelation of the arts in the Jugendstil period, see Hans H. Hofstätter, *Geschichte der europäischen Jugendstilmalerei*, Du Mont, Cologne, 1963, p. 14, 'Das Gesamtkunstwerk als Problemstellung'.

The relationship of contemporary French artists to the theatre (ie. Bonnard, Sérusier, Vuillard, Toulouse-Lautrec etc.) is discussed in Peter Selz, *Art Nouveau – Art at the Turn of the Century*, Museum of Modern Art, New York, 1959, p. 55. See also Robert Goldwater, 'Symbolist art and theatre: Vuillard, Bonnard, Maurice Denis' in *Magazine of Art*, December 1946, p. 366ff., and William Rubin, 'Shadows, Pantomimes and the Art of the *fin de siècle*' in *Magazine of Art*, vol. 46, March 1953, p. 114ff.

31 See Grohmann, *Paul Klee*, p. 82.

32 Klee's influence on the second generation of twentieth-century painters has only been cursorily noted. Irving Sandler, in his *The Triumph of American Painting: A History of Abstract Expressionism*, Praeger, New York, 1970, mentions Klee in relation to Baziotes, De Kooning and Gottlieb. Max Kozloff notes the obvious connection with Dubuffet, in his *Renderings: Critical Essays on a Century of Modern Art*, Simon and Schuster, New York, 1968, p. 67. Leo Steinberg describes Klee's work as 'one of the potent forces behind modern abstraction' in *Other Criteria: Confrontations with Twentieth-Century Art*, Oxford University Press, New York, 1975, p. 302, and Dora Ashton comments in *The Unknown Shore, A View of Contemporary Art*, Little, Brown and Co., Boston and Toronto, 1969, p. 43: 'Too little has been said of Klee's influence, though it permeates modern art.'

1 From Comedian to Comedy

1 The etchings are reproduced and fully catalogued in Eberhard W. Kornfeld, *Verzeichnis des graphischen Werkes von Paul Klee*, Kornfeld und Klipstein, Berne, 1963. For letters giving a background to the etchings, see catalogue of the Baden-Baden exhibition *Der frühe Klee*, Staatliche Kunsthalle, 1964.

2 See Eberhard W. Kornfeld, *Paul Klee: Bern und Umgebung, Aquarell und Zeichnung, 1898–1915*, Stampfli et Cie, Berne, 1962.

3 See Jürgen Glaesemer, *Paul Klee: Handzeichnungen I*, Kunstmuseum, Berne, 1973, pp. 201–205, 'Studien und Skizzen bei Knirr'.

4 See Arthur Symons, *Aubrey Beardsley*, At the Sign of the Unicorn, London, 1898, p. 21:

Beardsley's sacrifice, together with that of all decadent art, the art of Rops or the art of Baudelaire, is really the sacrifice to eternal beauty and only seemingly to the powers of evil.

p. 24:

In these drawings of Beardsley which are grotesque rather than beautiful, in which lines begin to grow deformed, in which all beauty takes refuge, is itself a moral judgement.

and p. 25:

It is because he loved beauty that beauty's degradation obsesses him; it is because he is surprisingly conscious of virtues that vice has power to lay hold upon him.

The philosophy of the ugly and its relation to beauty by contrast appears in Benedetto Croce's *Aesthetic* (first published 1909), Noonday, New York, 1960, p. 88:

The ugly in art was looked upon as adapted for the service of the beautiful, a stimulant and a condiment of aesthetic pleasure.

For discussion of Klee's experience of classical art and his reaction see the valuable article by Marcel Franciscono, 'Paul Klee's Italian journey and the classical tradition' in *Pantheon*, vol. 32, no. 1, January–March 1974, pp. 54–66.

5 Quoted by Peter Selz in 'The aesthetic theories of Wassily Kandinsky and their relationship to the origin of non-objective painting' in *Art Bulletin*, vol. 39, June 1957, p. 129. Cf. the general article on the human figure in German Expressionist painting by Charles S. Kessler, 'Sunworship and Anxiety – Nature, Nakedness and Nihilism in German Expressionist Painting' in *Magazine of Art*, vol. 46, 1953, p. 304ff.

6 Quoted by Hans Richter, *Dada – Art and Anti-Art*, Thames and Hudson, London, 1966, p. 41.

7 Bourdelle, for example, in a contemporary interpretation, saw them in the fulsome classical Greek tradition: see Elisabeth Chase Geissbuhler, *Rodin – Later Drawings, with interpretations by Antoine Bourdelle*, Peter Owen, London, 1964.

8 The Japanese influence in nineteenth-century art, particularly Impressionism, has been given cursory attention in John Rewald's two volumes *The History of Impressionism*, Museum of Modern Art, New York, 1962. Japanese influence on the Art Nouveau style is discussed in Clay Lancaster, 'Oriental Contributions to Art Nouveau' in *Art Bulletin*, XXIV, 1952, p. 297, and C. H. Madsen, *Art Nouveau*, Weidenfeld and Nicolson, London, 1967, p. 58, 'Japanese and Oriental influence'. See also *Japonisme: Japanese influence on French Art, 1854–1910*, Cleveland Museum of Art, Rutgers University Art Gallery and The Walters Art Gallery, 1975.

9 For a general survey of the mask in art, ritual and theatre see Walter Sorell, *The Other Face: the Mask in the Arts*, Thames and Hudson, London, 1974. For an iconographic survey of the mask see Enrico Crispolti, 'The modern mask since the Renaissance' in *Encyclopedia of World Art*, vol. IX, McGraw-Hill, London, 1964, pp. 538–42; for a brief comment on the Greek mask see T. B. Webster, 'The Poet and the Mask' in *Classical Drama and its Influence* (ed. M. J. Anderson), Methuen, London, 1965, p. 3ff. James Thrall Soby has made the only sustained comment on the theatrical mask in Klee's work, in *The Prints of Paul Klee*, C. Valentin, New York, 1945, p. xii. James Smith Pierce discusses Klee's use of the primitive mask in *Paul Klee and Primitive Art*, Outstanding Dissertations in the Fine Arts, Garland, New York and London, 1976, p. 11, and p. 30ff., 'African, Oceanic and Precolumbian Art'.

10 Klee's most sustained comment on his supra-human endeavours appears in his comparison of himself with Franz Marc, *The Diaries, 1898–1918*, University of California Press, 1964, 108. Cf. Milton C. Nam, 'The theological background of the idea of the theory of the artist as creator' in *Journal of the History of Ideas*, June 1947, p. 36; Ernst Kris, *Psychoanalytic Explorations in Art*, International Universities Press, New York, 1965, p. 64ff., 'The image of the artist'; and Max Kozloff, 'The Authoritarian Personality in Modern Art' in *Artforum*, May 1974, p. 40ff., particularly the section 'The Natural History of Godly Art'.

11 See the invaluable article on the early etchings, Hans H. Hofstätter, 'Symbolismus und Jugendstil im Frühwerk von Paul Klee' in *Kunst in Hessen und am Mittelrhein*, vol. 4, 1964, p. 97ff. Klee was critical of a lecture he attended on physiognomy, see *Diaries*, 489 (1903). See also Felix Klee, *Paul Klee, His Life and Work in Documents*, George Braziller, New York, 1962, p. 137, 'Physiognomy'; and two articles on physiognomy and its contribution to twentieth-century art by Isa Lohmann-Siems, 'J. A. Grohmanns "Ideen zu einer physiognomischen Anthropologie" aus dem Jahre 1791: eine Vorwegnahme kunsttheoretischer Gedanken des 20. Jahrhunderts' in *Jahrbuch der Hamburger Kunstsammlungen*, vol. 8, 1963, p. 67ff., and 'Der universale Formbegriff in der Physiognomik des 18. Jahrhunderts, ein Beitrag zur Geschichte der gegenwärtigen Kunsttheorie' in *Jahrbuch der Hamburger Kunstsammlungen*, vol. 9, 1964, p. 49ff.

12 *The Thinking Eye: the Notebooks of Paul Klee* (ed. Jürg Spiller), Lund Humphries, London, 1961, p. 76.

13 Ibid., p. 128.

14 See illustrations of the Greek mask in Allardyce Nicoll, *The Development of the Theatre*, Harrap, London, 1927, p. 42ff. (Note that Nicoll's bibliography on the Greek stage is drawn from German scholarship published between 1896 and 1912, p. 230.) Peter Gay, in *Weimar Culture, the Outsider as Insider*, Penguin, Harmondsworth, 1968, alludes to the German cult of Greece, p. 61ff.

15 The tonal scale used by Klee suggests Goya, although Klee did not really register his interest in Goya until he had completed the series of etchings. See his comments, *Diaries*, 602 and 765. Cf. Crispolti, 'The modern mask since the Renaissance', p. 539:

Goya also linked the mask to physiognomy. In pages from the *Madrid Sketchbook*, the word *mascara* ('masked man', 'mummer') is used in reference to carnival and burlesque scenes which take on the value of enlightened criticism of the ethical and natural abnormality of contemporary society. In his *Caprichos* and later in the *Disparates* the bifront form reappears and the mask signifies duplicity and deceit. The *Entierro de la Sardina* demonstrates the irrational popular exaltation of artificiality in a mask. Here, as in the *Disparates*, the theme of masks and of the ambiguity of the bifront becomes a new revelation of the unconscious or preconscious areas of human personality.

On the nature of Klee's titles, see the rather inadequate statement by Will Grohmann, *Paul Klee, Drawings*, Thames and Hudson, London, 1960, p. 15ff., 'The role of titles: Klee as poet'. Cf. Ernst Gombrich's comment, *Meditations on a Hobby Horse*, Phaidon, London, 1963, p. 54, 'Expression and Communication': 'Klee's titles are an additional contextual aid to make precise the guess at the communication of the work of art.'

16 For a succinct summary of metaphors of the world stage see Ernst Robert Curtius, *European Literature and the Latin Middle Ages*, Harper, New York, 1963, p. 138ff. Cf. also Frances Yates, *The Art of Memory*, Routledge and Kegan Paul, London, 1966; Henry Krauss, *The Living Theatre of Medieval Art*, Thames and Hudson, London, 1968.

17 On the seductive subject of the Medusa and her lineage see Mario Praz, *The Romantic Agony*, Fontana, London, 1962, p. 43. Franz von Stuck's *Medusa* is illustrated in Hans H. Hofstätter, *Symbolismus und die Kunst der Jahrhundertwende*, Du Mont, Cologne, 1965, p. 72. See also Alessandra Comini, 'Vampires, Virgins and Voyeurism in Imperial Vienna' in *Woman as Sex Object: Studies in Erotic Art, 1730–1970* (ed. Thomas B. Bess and Linda Nochlin), Newsweek, New York, 1972, p. 207ff.

18 See Glaesemer, *Paul Klee: Handzeichnungen I*, p. 64.

19 Cf. Allardyce Nicoll, *Masks, Mimes and Miracles*, Harrap, London, 1931, p. 187, 'The medieval devils', and the Innsbruck collection of masks, p. 193 (fig. 130).

20 Cf. Carola Giedion-Welcker, *Paul Klee*, Faber, London, 1952, p. 15:

Menacing Head, the last page of this cycle of satiric etchings, exemplifies a pure 'symbolist' attitude. A comparison with Beardsley's illustration for Poe's story, *The Black Cat*, reveals a definite relationship. The obsession in both cases is expressed in the inexorably frontal view with symbolist trappings.

21 Cf. Carol Duncan, 'Virility and Domination in early Twentieth-Century Vanguard Painting' in *Artforum*, December 1973, p. 30.

22 Cf. Hans H. Hofstätter, *Symbolismus und die Kunst der Jahrhundertwende, passim*. Victor Arwas, *Félicien Rops*, Academy Editions, London, 1972, especially E.525, 'A document on the inability to love', E.898, 'Humanity', E.843, 'Study for the Temptation of Saint Anthony or the Woman on the Cross', and the series of *Les Diaboliques* (505–13). For Kubin, see Jürgen Glaesemer, 'Paul Klees persönliche und künsteinische Begegnung mit Alfred Kubin' in *Pantheon*, vol. 32, no. 2, April–June 1974, pp. 152–62, and Wolfgang K. Müller-Thalheim, *Erotik und Dämonie im Werk Alfred Kubins: eine psychopathologische Studie*, Nymphenburger Verlagshandlung, Munich, 1970, pp. 16, 17, 18 etc.

23 A persistent theme through Hofstätter's article 'Symbolismus und Jugendstil im Frühwerk von Paul Klee'.

24 For an English commentary anthology, see Stanley Appelbaum, *Simplicissimus, 180 satirical drawings from the famous German weekly*, Dover, New York, 1975. The satirical flavour of the Munich cabarets and the *Simplicissimus* circle is captured in Lisa Appignanesi, *The Cabaret*, Studio Vista, London, 1975, p. 35ff and p. 55ff.

25 J. Huizinga, *Homo Ludens: a study of the play element in culture*, Temple Smith, London, 1970, p. 167.

26 Consider the allegorical interpretation in Maurice L. Schapiro, 'Klee's Twittering Machine' in *Art Bulletin*, vol. 50, March 1968, p. 67ff.

27 Quoted in full by Felix Klee, *Paul Klee*, p. 175 (a more dramatic translation than that of *The Thinking Eye*, p. 910).
 Consider also the possible psychological interpretation of:

Movement in one direction, considered theoretically in relation to Norm (N) and Abnorm (N^n). From the psychological point of view, primary contrasts side by side give a powerful impression.

(*The Thinking Eye*, p. 319.)

28 Cf. Peg Weiss, 'Kandinsky and the "Jugendstil" Arts and Crafts Movement' in *Burlington Magazine*, May 1975, p. 270ff, Frank Anderson Trapp, 'Art Nouveau Aspects of Early Matisse' in *Art Journal*, vol. 26/1, Fall 1966, p. 2ff, and Werner Hofmann, *Turning Points in Twentieth-Century Art, 1890–1917* (translated by Charles Kessler), Allen Lane, London, 1969, *passim*.

29 Cf. Schlemmer's comment on the curtain which 'imposes a state of excitement on both sides', in *Theatre of the Bauhaus*, Wesleyan University Press, Middletown, Connecticut, 1961, p. 92. James Smith Pierce, however, relates Klee's curtain to the curtains depicted in Bavarian folk icons: see *Paul Klee and Primitive Art*, p. 21.

30 For illustrations with a particular bias towards the participation of painters in the theatre see Léon Moussinac, *Tendances nouvelles du théâtre*, Albert Léon, Paris, 1931. See also Walter René Fuerst and Samuel J. Hume, *Twentieth-Century Stage Decoration*, 2 vols., Dover, New York, 1967.

31 *The Thinking Eye*, p. 76.

2 The Mask Face

1 Cf. Ernst Kris, *Psychoanalytic Explorations in Art*, International Universities Press, New York, 1965, p. 173ff., 'The Psychology of Caricature'. See Wylie Sypher (ed.), *The Meaning of Comedy*, Doubleday, New York, 1956, which includes George Meredith's classic essay; also Charles Baudelaire, 'The essence of laughter, and generally of the comic in the plastic arts', in *Selected Writings on Art and Artists* (translated with an introduction by P. E. Charnel), Penguin Classics, Harmondsworth, 1972, p. 140ff; Henri Bergson, *Laughter, an essay on the meaning of the comic* (authoritative translation by C. Brereton and F. Rothwell), Macmillan, London, 1911.

2 Cf. entries in *The Diaries, 1898–1918*, University of California Press, 1964: 664; 822; 828; 869 and 892.

3 Klee wrote rather sorrowfully of 'the legend of my childishness' in his Jena lecture 'On Modern Art', in *The Thinking Eye: the Notebooks* (ed. Jürg Spiller), Lund Humphries, London, 1961, p. 95:

The legend about the childishness of my drawing must have started with those of my linear compositions in which I tried to combine a concrete representation, let us say a man, with a pure use of the linear element.

See Ellen Marsh, 'Paul Klee and the Art of Children' in *College Art Journal*, vol. XVI, Winter 1957, p. 132ff, and Robert Goldwater, *Primitivism in Modern Painting* (revised ed.), Vintage Books, New York, 1966, p. 192ff. James Smith Pierce includes child art as an aspect of Klee's primitivism in his *Paul Klee and Primitive Art*, Garland, New York and London, 1976: see especially ch. III, 'Children's Drawings', p. 72ff.

4 Wassily Kandinsky and Franz Marc, *The Blaue Reiter Almanac*, Documents of Twentieth Century Art, Thames and Hudson, London, and Viking, New York, 1974, children's drawings, p. 59 and p. 89. Ibid., p. 85, where August Macke asks: 'Are not children more creative in drawing directly from the secret of their sensations than the imitators of Greek forms?' See also the invaluable essay by J. C. Middleton, 'The rise of primitivism and its relevance to the poetry of Expressionism and Dada' in *The Discontinuous Tradition: Studies in honour of Ernst Ludwig Stahl* (ed. P. F. Ganz), Clarendon Press, Oxford, 1971, p. 182ff.

5 Paul Haesaerts, *James Ensor*, Elsevier, Brussels, 1957, reproduced photographs and caricatures of Ensor in his studio, as well as the paintings discussed below.

6 Libby Tannenbaum, *James Ensor*, Museum of Modern Art, New York, 1951, p. 109. Klee's etchings referred to are reproduced in Eberhard W. Kornfeld, *Verzeichnis des graphischen Werkes von Paul Klee*, Kornfeld und Klipstein, Berne, 1963, plates 47 and 48.

7 Jürgen Glaesemer, *Paul Klee: Handzeichnungen I*, Kunstmuseum, Berne, 1973, p. 143.

8 Klee saw an exhibition of Nolde's in 1913: see *Diaries*, 916. Much later, in 1927, Klee wrote a characteristic tribute for Nolde's sixtieth birthday: 'Nolde is more than simply earthly. He is also the spirit of the earth. Even those who dwell in other spheres find an affinity and a close relationship on the lower plane.' (Originally published in the *Festschrift für Emil Nolde anlässlich seines 60. Geburtstags*, and quoted in the Marlborough Gallery catalogue for the combined exhibition of Klee and Nolde, *Klee and Nolde – Vision and Intellect*, London, 1966.)

Not only the mask, but also the 'Dionysiac' children's dance, was a subject for both Klee and Nolde, especially for Klee in his late paintings. Comparison can be made between Klee's *Lady and Gentleman in a Box* of 1908 and Nolde's *In the Box* of 1918 (both paintings in the Berne Kunstmuseum), and between Nolde's Christ-head woodcut, *Prophet*, of 1912 (illustrated in Peter Selz, *Emile Nolde*, Museum of Modern Art, New York, 1961, p. 57) and Klee's pen drawing *Christ*, 1926 (illustrated in Will Grohmann, *Paul Klee*, Lund Humphries, London, 1954, p. 69).

For Nolde's relationship with Ensor, see Selz, *Emil Nolde*, p. 32: '... early in 1911, he had visited James Ensor in Ostend ...'.

9 It is not surprising that a painter of the mask was a lover of theatre. Cf. Selz, ibid., also p. 32:

... for a while he could be seen almost nightly in Max Reinhardt's famous theatre, sketching the most celebrated personalities of the Berlin stage in plays by Shakespeare, Molière, Goethe and Hebbel. He went to

the circus, cafés, cabarets, and dance halls, sketching singers, dancers, nightclub impresarios, as well as spectators.

Beckmann was also a mask painter and a theatre lover: see the memoir by Perry T. Rathbone in Peter Selz, *Max Beckmann*, Museum of Modern Art, New York, p. 127.

10 Illustrated in Emil Nolde, *Das eigene Leben: Zeit der Jugend, 1867–1902*, Christian Wolff, Flensburg, 1949, p. 150ff and p. 164ff.

11 For a range of illustrations of the self-portraits see Grohmann, *Paul Klee*, p. 385.

12 Cf. Paul Schilder, *The Image and Appearance of the Human Body*, International Universities Press, New York, 1950, p. 83:

Ross has made experiments on the perception of the face when the eyes are closed. When the head is turned sideways and the subject tries to get an impression of his own face, he gets the impression that his face is looking forward but is flattened out.

13 The artist's withdrawal, his donning of the mask, are the overture for his exercise of magical powers, his self-presentation as the initiate. Cf. T. H. Robsjohn-Gibbings, *Mona Lisa's Mustache: a Dissection of Modern Art*, Alfred Knopf, New York, 1948, p. 13.

14 The symptoms of a psychotic state suggest themselves, as this method of drawing the eyes has analogies with psychotic art. Cf. Georg Schmidt, *Though this be Madness: a study in psychotic art*, Thames and Hudson, London, 1961, p. 65. One of Schmidt's cases depicted faces consistently as masks; he notes that 'This method of depicting the eyes seems to have special significance. . .'. Cf. also p. 515: 'In respect to schizophrenic drawings in general, fragmentation or disruption is perhaps the most consistent symptom ... this is countered unmistakably throughout by an equally strong tendency towards control [in Klee's work].'

The influence of the art of the insane is an important aspect of Klee's primitivism: see H. Prinzhorn's contemporary study of psychotic art, *Bildnerei des Geisteskranken: ein Beitrag zur Psychologie und Psychopathologie der Gestaltung*, Julius Springer, Berlin, 1922 and 1968. Felix Klee notes Klee's interest in this regard in his *Paul Klee, His Life and Work in Documents*, George Braziller, New York, 1962, p. 183, and Schlemmer expresses his interest too: *The Letters and Diaries of Oskar Schlemmer* (ed. Tut Schlemmer, translated with an introduction by Krishna Winston), Wesleyan University Press, Middletown, Connecticut, 1972, p. 83:

Saturday evening was invited to Hildebrandts' – quite a party. A psychiatrist from Heidelberg, Dr Prinzhorn, formerly an art historian, gave a talk on the drawings of the insane – very interesting illustrative moderns: to Klee, for instance, who has seen these things and is enthusiastic.

The oscillation between fragmentation and control, well handled by Klee, corresponds with Anton Ehrenzweig's description of the mature creative process, in *The Hidden Order of Art*, Weidenfeld, London, 1967, p. 108, and ch. 7 generally, 'The three phases of creativity', p. 95ff.

15 *Mallarmé* (introduced and edited by Anthony Hartley), Penguin, Harmondsworth, 1965, p. 117:

Nulle enseigne ne vous régale du spectacle intérieur, car il n'est pas maintenant un peintre capable d'en donner une ombre triste.

No sign entertains you with the show inside, for now there is no painter capable of giving a wretched shadow of it.

Also quoted by Werner Hofmann, *The Inward Vision, Watercolours – Drawings – Writings by Paul Klee*, Thames and Hudson, London, 1958, p. 15.

See also Gaston Bachelard's speculations in *The Poetics of Space* (translated from the French by Maria Jolas), Beacon Press, Boston, 1960, ch. 9, 'The Dialectics of Outside and Inside', p. 211ff.

16 Cf. *Diaries*, 902:

This summer in Munich a group of young artists gathered into an association that will bear the name 'Sema', the 'sign'. I am one of the founding members, probably through Wilhelm Michel's doing.

17 Klee noted reading Hoffmann's *Zinnober* and *Phantasiestücke* in 1906 (*Diaries*, 750), and Poe in 1907 (804). In 1921 he made a lithograph, *Hoffmannesque Scene*, illustrated in Kornfeld, *Verzeichnis des graphischen Werkes von Paul Klee*, pl. 82, with a drainpipe house and a ticking clock. Schlemmer's *Figural Cabaret* contains a 'Hoffmannesque Scene', described by Schlemmer in *Theatre of the Bauhaus*, Wesleyan University Press, Middletown, Connecticut, 1961, p. 40:

In the midst, the Master, E. T. A. Hoffmann's Spalanzani, spooking around, directing, gesticulating, telephoning, shooting himself in the head, and dying a thousand deaths from worry about the function of the functional.

Wolfgang Kayser writes at length on Poe and Hoffmann, the classical writers of the grotesque, in *The Grotesque in Art and Literature*, Indiana University Press, Bloomington, 1963, p. 105ff.

18 Wilhelm Michel, *Das Teuflische und Groteske in der Kunst*, Piper, Munich, 1911.

19 Basil W. Robinson, *Kuniyoshi*, HMSO, London, 1961, p. 459.

20 See in general Donald Keene, *The Art of Bunraku: the Art of the Japanese Puppet Theatre*, Kodansha International, Tokyo, 1965. See also James McCormick, 'Japan, the mask and the mask-like face' in *Journal of Aesthetics and Art Criticism*, vol. XV, December 1956, p. 198ff.

21 Alfred H. Barr, *Paul Klee*, Museum of Modern Art, New York, 1930, p. 9. Cf. the interpretation of James Smith Pierce, *Paul Klee and Primitive Art*, p. 45ff.

22 Brecht's interest in oriental theatre contributed to his central dramatic idea of *Verfremdungseffekte*. See 'Alienation effects in Chinese acting' in *Brecht on Theatre: the development of an aesthetic* (translation and notes by John Willett), Methuen, London, 1964, p. 91ff.
Yeats was introduced to the Noh drama through Ezra Pound, and he produced *At the Hawk's Well* with masks in 1915: see Richard Ellmann, *Yeats – the Man and his Masks*, Macmillan, London, 1952, p. 215.
The film director Sergei Eisenstein was deeply interested in the oriental theatre. He wrote, however, that Meyerhold had 'already plundered everything of use from the Japanese theatre', in *Film Form and the Film Sense*, Meridian, New York, 1957, p. 18ff.; see also pp. 42–4.

23 Robert Goldwater, *Primitivism in Modern Painting*, ch. 1, 'Primitive art in Europe: the accessibility of the material: the development of ethnological museums', p. 3ff. See also appendix: 'Summary chronology of Ethnographical Museums and Exhibitions', p. 273ff.
See 'Notes on Paul Klee' in *Paul Klee: Paintings, Watercolours, 1913–1939* (ed. Karl Nierendorf), Oxford University Press, New York, 1941, p. 2: 'There were in his studio primitive Bavarian paintings on glass, masks, collected nature objects'; also quoted by Herbert Read in *The Philosophy of Modern Art*, Meridian, New York, 1954, p. 295.

24 Wilhelm Hausenstein, *Barbaren und Klassiker: ein Buch von der Bildnerei exotischer Völker*, Piper, Munich, 1923, figs. 12 and 13.

25 Amédée Ozenfant, *Foundations of Modern Art* (first published 1928) (translated by John Rodker), Dover, New York, 1952, p. 239.

26 J. Huizinga, *Homo Ludens: a study of the play element in culture*, Temple Smith, London, 1970, p. 45. Also T. H. Robsjohn-Gibbings, *Mona Lisa's Mustache*, p. 13. Cf. too Paul Schilder, *The Image and Appearance of the Human Body*, p. 204:

When people wear enormous masks at the carnival in Nice, they are not merely changing the physiological basis of their body-image but are actually becoming giants themselves. One of the pleasures to be derived from this pageant is the possibility of playing with the enlargement of our body-image and thus increasing our own importance. Our body-image is in a continuous process of enlargement and shrinking and we enjoy these changes in it. The body-image changes continually and we triumph over the limitation of the body by adding masks and clothes to the body-image. This is the explanation of the animal masks of primitive peoples which actually identify the wearer with the animal.

27 Kandinsky and Marc, *Blaue Reiter Almanac*, p. 190.

28 Ibid., p. 85: 'Man expresses his life in forms. Each form of art is an expression of his inner life. The exterior of the form of art is its interior.'
The 'will to form' was a central idea in Alois Riegl's *Stilfragen: Grundlegungen zu einer Geschichte der Ornamentik*, Berlin, 1893, in which he emphasized the contribution to European styles of art from the ornamental traditions of art outside Europe. Wilhelm Worringer popularized these ideas in his *Abstraktion und Einfühlung: ein Beitrag zur Stilpsychologie*, Piper, Munich, 1908, which made an impact on the Blaue Reiter group.

29 Kandinsky and Marc, *Blaue Reiter Almanac*, p. 89.

30 Klaus Lankheit, 'A History of the Almanac', ibid., p. 19.

31 Ibid., p. 19.

32 H. F. Peters, *Rainer Maria Rilke: Masks and the Man*, McGraw-Hill, New York, 1963, which takes its beginning from Nietzsche's comments on the mask, and studies the leitmotif of the mask in Rilke's poetry.

33 But Rilke did not accept the implications of abstraction in Klee's work. See Rilke's reference to Klee in his *Letters to Merline, 1919–1922* (translated by Violet M. Macdonald: introduction by J. B. Leishman), Methuen, London, 1951, p. 88ff., 28 February 1921:

During the war years (in 1915 Klee brought me about 60 of his drawings – coloured ones – and let me keep them for some months: I found them attractive and engaging in many ways, especially as you could still

detect a feeling of Kairuan in them, a place I know); during the war years, as I say, I often felt I was expressing that very thing – the abolition of the subject (for it was a matter of faith, how far we accept any such thing, and further, are prepared to express ourselves by means of it: if so, then broken men are best represented by the fragment and sherds). . . . You must have the obstinacy of a town dweller (and Hausenstein is one) to declare that nothing exists any more.

34 Rainer Maria Rilke, *The Notebooks of Malte Laurids Brigge* (translated by M. D. Nerter Norton), Capricorn Books, New York, 1941, p. 70.

35 Ibid., p. 93.

36 Consider also Michael Hamburger's interpretation of Hugo von Hofmannsthal, 'Art as Second Nature' in *Romantic Mythologies* (ed. Ian Fletcher), Routledge and Kegan Paul, London, 1967, p. 229:

Hofmannsthal began by celebrating the 'truth of masks' and of that dream image which the stage opposes to the 'terrifying stage, reality' . . .

and p. 233:

Dance forms an important part of several of Hofmannsthal's dramatic works, beginning with the climax of his *Electra*, that 'nameless dance' of the heroine that is pure ecstasy and ends with her collapse . . .

37 'Duineser Elegien' (viertes Buch) in *Gesammelte Gedichte*, Insel Verlag, Frankfurt am Main, 1962, p. 454ff. For English translation, see *The Duino Elegies* (dual text, translation, introduction and commentary by J. B. Leishman and Stephen Spender), 3rd ed., Hogarth Press, London, 1948, p. 49:

I will not have these half-filled masks! No, no, rather the doll. That's full. I'll force myself to bear the husk, the wire, and even the face that's all outside. Here! I am sitting on.

and p. 51:

 . . . when I feel like it, to wait before the puppet stage, – no, rather gaze so intensely on it that at last a counterpoising angel has to come and play a part there, snatching up the husks? Angel and doll! Then there's at last a play.

38 See Francis Haskell, 'The Sad Clown: some notes on a nineteenth-century myth' in *French Nineteenth-Century Painting and Literature* (ed. Ulrich Finke), Manchester University Press, Manchester, 1972, p. 2ff; A. G. Lehmann, 'Pierrot and *fin de siècle*' in *Romantic Mythologies* (ed. Ian Fletcher), Routledge and Kegan Paul, London, 1967, p. 209ff; Fritz Usinger, *Die geistige Figur des Clowns in unserer Zeit*, Akademie der Wissenschaften und der Literatur, Mainz, 1964;

and Jean Starobinski, *Portrait de l'artiste en saltimbanque*, Skira, Geneva, 1970.

Various writers have studied the two extremes of the human social position embodied by the king and the clown. Such studies have accumulated round the classic juxtaposition in Shakespeare's *King Lear*. Jan Kott stresses the burlesque bearing of the king and the elevation of the clown in *Shakespeare, our Contemporary*, Methuen, London, 1964, and John Danby writes of the single figure of Lear and Fool in *Shakespeare's Doctrine of Nature*, Faber, London, 1949.

39 Theodore Reff, 'Harlequins, Saltimbanques, Clowns and Fools' in *Artforum*, October 1971, p. 31ff.

40 *Diaries*, 950. Klee would have known of Mozart's enthusiasm for carnival and mask. In February 1788 Mozart asked his father to send his harlequin costume; in a later letter he described the half-hour pantomime which he had composed, with himself playing Harlequin. Recounted by Eric Schenk, *Mozart and his Times*, Mercury, London, 1960, p. 336.

41 Cf. Ernst Gombrich, *Art and Illusion: A Study in the Psychology of Pictorial Representation*, Phaidon, London, 1960, p. 334: 'The discovery and simplification of facial expression provide the best example of the course taken by an artistic invention.' Chapter X, 'The Experiment of Caricature', provides valuable material on facial simplification and distortion. See p. 330ff.

3 Acrobat, Dancer and Clown

1 A modern edition with Klee's illustrations: Voltaire, *Candide oder der Optimismus*, mit 27 Zeichnungen von Paul Klee, 2nd ed., Droste Verlag, Düsseldorf, 1964.

For comment see Jürgen Glaesemer, *Paul Klee: Handzeichnungen I*, Kunstmuseum, Berne, 1973, p. 178ff., Christian Geelhaar, 'Bande dessinée: Voltaire scénariste, Klee illustrateur de Candide' in *L'Oeil*, April 1975, p. 22ff., and Lothar Lang, *Expressionist Book Illustration in Germany, 1907–1927*, Thames and Hudson, London, 1976, p. 50ff.

2 The likeness of Klee's *Virgin in a Tree* to Segantini's *Evil Mother* has often been noted. See Hans H. Hofstätter, *Symbolismus und die Kunst der Jahrhundertwende*, Du Mont, Cologne, 1965, p. 85, and Carola Giedion-Welcker, *Paul Klee*, Faber, London, 1952, p. 13. Kubin and Klee met in 1911, and Klee writes of Kubin's

liking for his work. See *Diaries*, 888: 'Kubin, my benefactor, has arrived. He acted so enthusiastic that he carried me away. We actually sat entranced in front of my drawings!'

3 Cf. Carola Giedion-Welcker, *Paul Klee*, p. 96: 'For an early instance of motion shown in simultaneously radiating stages, see Klee's treatment of bodily violence in *Candide*.'

4 For a survey anthology of circus paintings, see 'The treasury of the circus' in *Art News Annual*, vol. XIX, 1949, p. 53ff. Studies in related iconography in E. Tietze-Conrat, *Dwarfs and Jesters in Art*, Phaidon, London, 1959, and Allardyce Nicoll, *The World of Harlequin: a critical study of the Commedia dell'Arte*, Cambridge University Press, Cambridge, 1963.

5 'Body image' refers to the psycho-physiological sense of the body as clarified by Paul Schilder in *The Image and Appearance of the Human Body,* International Universities Press, New York, 1950, p. 174ff. A recent symposium extends Schilder's work: see *The Body Percept* (eds. Seymour Sapner and Heinz Werner), Random House Studies in Psychology, New York, 1965, and *The Body, a Medium of Expression: an anthology* (edited and with an introduction by Jonathan Benthall and Ted Polhemus), Dutton, New York, 1975.

6 A condensed definition of the theatre of the absurd:

This diagnoses humanity's plight as purposelessness in an existence out of harmony with its surroundings. ... All semblance of logical construction, of the rational linking of idea with idea in an intellectually viable argument, is abandoned, instead the irrationality of the experience is transferred to the stage.

(John Russell Taylor, *The Penguin Dictionary of the Theatre*, Penguin, Harmondsworth, 1966, p. 80.) See also Martin Esslin, *The Theatre of the Absurd*, Eyre & Spottiswoode, London, 1968. Cf. Eric Bentley, *The Life of the Drama*, Atheneum, London, 1965, p. 270:

A slight study of the characters of tragedy and comedy will reveal that both genres explore extreme deviations from the human form, extreme disturbance of the human balance.

7 Paul Klee, *The Diaries, 1898–1918*, University of California Press, 1964, 493:

Sunday afternoons in Bern are so depressing. One would like to rejoice, as in *Faust*, when everybody is out walking after a week's work. But these poor people are so ugly for the most part that they are hateful rather than pitiable. ... Cretinism is growing in importance.

8 Paul Klee, *The Thinking Eye: the Notebooks* (ed. Jürg Spiller), Lund Humphries, London, 1961, p. 78:

Didn't Feuerbach say: For the understanding of a picture, a chair is needed? ...

All becoming is based on movement. ... In the work of art, paths are laid out for the beholder's eye, which gropes like a grazing beast (in music, as everyone knows, there are channels leading to the ear – in drama we have both varieties). The pictorial work springs from movement, it is itself fixated movement, and it is grasped in movement (eye muscles).

9 The essay is included without comment in *Five Essays on Paul Klee* (ed. Merle Armitage), Duell Sloan and Pearce, New York, 1950, p. 63ff. Kleist's essay was first published in four instalments in the *Berliner Abendblatt*, 12–15 December 1810. Its importance for theatre aesthetic seems to date from the early critical examinations of the essay in 1911: Hanna Hellman, *Heinrich von Kleist, Darstellung des Problems*, Heidelberg, 1911, and Wilhelm Herzog, *Heinrich von Kleist, sein Leben und sein Werk*, Munich, 1911. 'In the Weimar period Kleist scholarship became a passion, the cult a crusade,' Peter Gay comments in *Weimar Culture: the Outsider as Insider*, Penguin, Harmondsworth, 1968, p. 64. For one interpretation that tries to limit the central position of *Das Marionettentheater* in Kleist's thought, see Walter Silz, *Heinrich von Kleist, Studies in his Work and Literary Character*, University of Pennsylvania Press, Philadelphia, 1961, ch. IV, p. 69ff.

For the puppet in contemporary literature see Wolfgang Kayser, *The Grotesque in Art and Literature*, Indiana University Press, Bloomington, 1963, p. 113: 'Lenz, Büchner, and Wedekind – in the works of these three we find a dramaturgy which, using the metaphor of the puppet as the basis for its treatment of stage characters, points toward the grotesque.' Hugo von Hofmannsthal's *Das kleine Welttheater* of 1897 was conceived as a puppet play, and his festival play of 1922, *Das grosse Salzburger Welttheater*, with its allegorical medieval personae, has been described as 'puppet-like' in its qualities: see Brian Coghlan, *Hofmannsthal's Festival Dramas*, Cambridge University Press, Cambridge and Melbourne, 1964, p. 177.

10 A thoughtful description of the significance of the automata can be found in the *Encyclopedia of World Art*, McGraw-Hill, New York, Toronto, London, 1960, vol. 3, p. 182:

Automata deserve separate treatment above all because their essential quality lies in their imitation and elaboration of movement. Made to be seen in action, the development of which seeks a musical rhythm, they pose problems analagous to the dance

and animated cartoons, though in a more dramatic fashion. . . . Not only complete and independent works of art but also capable of a free, almost impersonal performance, they constitute the extreme limit of mimesis. Since ancient times, automata have been connected with important cycles of legend and myth.

Jack Burnham gives a fascinating history of automata in *Beyond Modern Sculpture*, Allen Lane, London, 1968, ch. 5, 'Sculpture and Automata', p. 185ff.

11 Bil Baird, *The Art of the Puppet*, Macmillan, New York, 1965, p. 185.

12 Edward Henry Gordon Craig, *On the Art of the Theatre*, Mercury, London, 1962, p. 25. See also Paul Pörtner, *Experiment Theater: Chronik und Dokumente*, Die Arche Verlag, Zürich, 1960, and Allardyce Nicoll, *The Development of the Theatre*, Harrap, London, 1931, p. 208ff.

13 Cf. again note 8, ch. 2 above.

14 Craig, *On the Art of the Theatre*, p. 81ff.

15 See in particular vol. 5, no. 2, October 1912, announcing 'Gentlemen − the marionette', an entire issue devoted to the marionette; and Adolf Furst, 'A note on marionettes' in vol. 2, 1909, p. 72.

16 See Alfred Jarry, *Selected Works* (ed. Roger Shattuck and Simon Watson Taylor), Grove Press, London, 1966. The editors write, p. 10: 'Perpetual experiments with marionettes gave him the authority to attack the naturalistic tendencies of the theatre of the time.' For Jarry's own formulation of the attack see 'On the futility of the theatrical in the theatre', ibid., p. 69ff. Jarry's puppets are illustrated in Pörtner, *Experiment Theater*, fig. 27. *Ubu Roi* has been illustrated by Rouault, Bonnard, Max Ernst and Picasso, to mention just a few artists paying later homage to Jarry. In 1966 David Hockney designed sets for a Royal Court production: see Gene Baro, 'Hockney's Ubu' in *Art and Artists*, May 1966, p. 8ff.

17 Arthur Symons, *Studies in the Seven Arts*, Archibald Constable, London, 1906, p. 377. For a recent comment on *Ubu Roi* see Christopher Gray, *Cubist Aesthetic Theories*, The Johns Hopkins Press, Baltimore, 1953, pp. 23–4.

18 Quoted in Max von Boehn's standard study *Dolls and Puppets* (first published Munich, 1929) (translated by Josephine Nicoll with a note on puppets by G. B. Shaw), Cooper Square Publishers, New York, 1966, p. 5.

19 Sir James Frazer, 'Taboo and the Perils of the Soul', part 2 of *The Golden Bough: a study in magic and religion*, 3rd ed., Macmillan, London, and St Martin's Press, New York, 1966, p. 53ff. and p. 62ff.

20 Bil Baird, *The Art of the Puppet*, p. 168. Illustrations of Brann's puppets, p. 166. (Grohmann makes no mention of Paul Brann in his monographs on Klee and Kandinsky.)

21 *Enciclopedia dello Spettacolo*, Casa Editrice Le Maschere, Rome, 1954, vol. II, p. 1007.

22 Max von Boehn, *Dolls and Puppets*, pp. 406–7.

23 Wassily Kandinsky, *Concerning the Spiritual in Art*, Wittenborn Documents of Modern Art, New York, 1947, p. 40: 'The peculiar power of the different arts may be coordinated, and this coordination will eventually lead to an art which we may glimpse even now − the truly monumental art.'

24 See the 'Variety Theatre' manifesto in Michael Kirby, *Futurist Performance, with manifestos and playscripts,* Dutton, New York, 1971, p. 19. The first English translation of Marinetti's manifesto appeared in *The Mask*, vol. 6 no. 3, January 1914, p. 188ff.

25 Marinetti's mannikin is reproduced in Basil Taylor, *Futurism*, Museum of Modern Art, New York, 1961, p. 110.

26 *Conversations with Igor Stravinsky and Robert Craft*, Faber, London, 1959, p. 938. The fascination with the metaphors of mask and marionette (as well as their actual use on the stage) is seen in Italian writing at this time − e.g. Luigi Chiarelli's *La Maschera e il volto* (1916): see Wolfgang Kayser, *The Grotesque in Art and Literature*, p. 135.

27 Will Grohmann, *Paul Klee*, Lund Humphries, London, 1954, p. 70. Schlemmer designed sets for Stravinsky productions: see *Oskar Schlemmer und die abstrakte Bühne*, Kunstgewerbemuseum, Zürich, April 1961, p. 80 for illustrations of his designs for *Les Noces* (1927) and *Nachtigall* (1929). See also Oskar Schlemmer, *The Letters and Diaries*, Wesleyan University Press, Middletown, Connecticut, 1961, pp. 211–12.

28 Essay by Nicholas Nabakov in *Stravinsky in the Theatre* (ed. Minna Lederman), Pellegrini & Cudahy, New York, 1949, p. 113ff.

29 See Maurizio Fagiolo dell'Arco, 'Balla's Prophecies' in *Art International*, Summer 1968, p. 63ff. Illustration of set for Stravinsky's ballet *Feu d'artifice*, p. 67. Cf. *Bühnenlandschaftartig* (A Kind of Stage Landscape) in Glaesemer, *Paul Klee: Handzeichnungen* I, cat. 593: the Klee drawing, with its flat pointed forms, is strikingly close to Balla's design.

30 See Rosa Trillo Clough, *Futurism: the Story of a Modern Art Movement: a new appraisal*, Greenwood Press, New York, 1961, pp. 146–7 for Depero illustrations.

31 James Thrall Soby, *Giorgio de Chirico*, Museum of Modern Art, New York, 1955, p. 97.

32 Hans Richter, *Dada – Art and Anti-Art*, Thames and Hudson, London, 1966, p. 39.

33 Wassily Kandinsky and Franz Marc, *The Blaue Reiter Almanac* (ed. Klaus Lankheit), Documents of Twentieth Century Art, Thames and Hudson, London, and Viking, New York, 1974, p. 46, 'Kandinsky and Marc'.

34 Bil Baird, *The Art of the Puppet*, p. 168. Jacques Polieri, '50 ans de Recherches dans le Spectacle' in *Aujourd'hui – l'Art et l'Architecture*, vol. 17, ch. 3, May 1958, pp. 52–3. See also in general Georg Schmidt, *Sophie Täuber-Arp*, Basel, 1948. Sophie Täuber-Arp abstracts are illustrated in Michel Seuphor, *Abstract Painting*, Dell, New York, 1964, p. 33 and p. 57ff.

35 Hans Richter, *Dada – Art and Anti-Art*, p. 23. One of Janco's masks is reproduced in William S. Rubin, *Dada and Surrealism and their Heritage*, Museum of Modern Art, New York, 1968, p. 233.

36 Tristan Tzara, 'Zurich Chronicle', 1915–1919, in Richter, *Dada – Art and Anti-Art*, p. 225.

37 Cf. Alessandra Comini, 'Vampires, Virgins and Voyeurism in Imperial Vienna' in *Woman as Sex Object: Studies in Erotic Art, 1730–1970* (ed. Thomas B. Bess and Linda Nochlin), Newsweek, New York, 1972, p. 207ff.

38 Hans Richter, *Dada – Art and Anti-Art*, p. 225.

39 Cf. introduction by Walter H. Sokel (ed.) to *An Anthology of German Expressionist Drama: a prelude to the absurd*, Doubleday, New York, 1963, p. xiv: 'Kokoschka, more famous as a painter, wrote the first Expressionist play, *Murderer, Women's Hope*, in 1907.' Two of Kokoschka's plays are included in the above selection: *Murderer, Women's Hope*, translated by Michael Hamburger, p. 17ff., and *Job*, translated by Walter H. and Jacqueline Sokel, p. 158ff. See also the German edition of Kokoschka's writings: *Schriften, 1907–1955*, Albert Langen/Georg Müller, Munich, 1956.

40 See W. I. Lucas, 'Kokoschka' in *German Men of Letters*, vol. 3 (ed. Alex Natan), Oswald Wolff, London, 1964, p. 37ff.

41 Werner Hofmann discusses the theatrical background in Vienna in his *Gustav Klimt*, Studio Vista, London, 1972. On p. 41 he gives an account of *Murderer, Hope of Women*, at the Garden Theatre in 1908. He quotes Kokoschka: 'In my first play I transgressed against the thoughtfulness of our male civilization with the revolutionary idea that man is mortal and woman is immortal.' Hofmann comments: 'This revolutionary idea was lifted from Klimt.'

42 Illustrated in Hans M. Wingler, *Kokoschka – the work of the painter*, Verlag Galerie Welz, Salzburg (and London), 1956, p. 9.

43 Ibid., part 2, section D1 (quoted from Ludwig Hevesi, *Alt-Kunst Neue Kunst*, Vienna, 1909).

44 Cf. the poster for *Simplicissimus* by Bruno Paul, reproduced in Hellmut Rademacher, *Das deutsche Plakat von den Anfängen bis zur Gegenwart*, Verlag der Kunst, Leipzig, 1965, p. 87; or, in similar if more sexual vein, *Masques parisiens* (1889) by Félicien Rops, illustrated in Victor Arwas, *Félicien Rops*, Academy Editions, London, 1972, E.522.

45 Cf. his caricatures of Hugo Stinnes for *The Face of the Ruling Class* (1921) and *Stinnes and his President – and his Puppets*, reproduced in Beth Irwin Lewis, *George Grosz: Art and Politics in the Weimar Republic*, University of Wisconsin Press, Madison, 1971, p. 158.

46 J. E. Cirlot, *A Dictionary of Symbols*, Routledge and Kegan Paul, London, 1962, p. 3:

Because of his acrobatics, which often involve reversing the normal position of the human body by standing on his hands, the acrobat is a living symbol of inversion or reversal, that is to say, of that need which always arises in times of crisis (personal, social or collective historical crises) to upset and reverse the established order . . .

47 *Refuge*, illustrated in Grohmann, *Paul Klee*, p. 401.

48 Cf. Schilder, *The Image and Appearance of the Human Body*, p. 206.

49 Henri Bergson, *Laughter, an essay on the meaning of the comic*, Macmillan, London, 1911, p. 141. Cf. also pp. 18, 29, 51, 57, 88, 128 and 133. See Arthur Koestler, *The Act of Creation*, Hutchinson, London, 1964, p. 45, 'Man and Machine'.

50 Anthony Blunt and Phoebe Pool, *Picasso – the formative years: a study of his sources*, Studio, London, 1962, p. 22:

Professor Meyer Schapiro has suggested that the tendency in the later nineteenth century to represent spectacles and theatrical performances is connected with the painter's preoccupation with his own art at a time when the cult of 'Art for Art's sake' sometimes replaced orthodox religious feelings.

It is suggested that 'the skill of the acrobat or ballet dancer symbolises the discipline and struggle with his material experienced by the painter himself'.

51 Erich Heller, *The Disinherited Mind: Essays in Modern German Literature and Thought*, Penguin, Harmondsworth, 1961, p. 152.

52 Cf. Wylie Sypher, *The Meaning of Comedy*, Doubleday, New York, 1956, p. 129: 'What is called wit is a certain dramatic way of thinking . . . a witty reaction is, of necessity, a reaction that is enamoured of the theatre.' See also Sigmund Freud's study *Jokes and their Relation to the Unconscious*, Routledge and Kegan Paul, London, 1960.

53 For Daumier's *saltimbanques* and their political status see T. J. Clark, *The Absolute Bourgeois: Artists and Politics in France 1848–1851*, Thames and Hudson, London, 1975, p. 118ff. In 1907 Klee mentioned Daumier with admiration and two exclamation points in the *Diaries*, 798.

54 See John Russell, *Rouault*, The Arts Council, London, 1966, p. 40. An interesting discussion of the many appearances of the *Doppelgänger* in the German cinema of the twenties is found in Lotte Eisner, *The Haunted Screen*, Thames and Hudson, London, 1969, p. 109ff, 'The Sway of the Doppelgänger'.

55 George Painter, *Marcel Proust*, 2 vols., Chatto & Windus, London, 1959 and 1964: vol. 1, p. 81ff.

56 Giuseppe Verdi, *Rigoletto* (libretto by Francesco Maria Piave), EMI, London, p. 13. For English translation, see dual text, with translation by Joseph Machlis, Belwin Mills, Melville, N.Y., 1959, p. 5:

What torment – always the jester!
I must laugh, I must clown, I must amuse them all;
Yet forever denied the comfort of weeping . . .

57 Arthur Symons, *Aubrey Beardsley*, At the Sign of the Unicorn, London, 1898, p. 8.

58 The quotations from Prince Peter Lieven, *The Birth of the Ballets Russes* (translated by L. Zarine), George Allen and Unwin, London, 1936, pp. 145 and 146. See also ch. 1, p. 130ff.: 'This ballet is the greatest achievement of the friends; the spirit of their work shines there with special clarity.'

59 Suzanne K. Langer, *Feeling and Form: a theory of art*, Routledge and Kegan Paul, London, 1953, p. 181ff., 'The Magic Circle'.

60 Douglas Cooper, *Picasso: Théâtre*, Editions Cercle d'Art, Paris, 1967, p. 42ff. Cf. also pp. 26–34, ' "Parade" et la peinture de Picasso'.

61 Lederman, *Stravinsky in the Theatre*, p. 55ff., for *Renard, L'Histoire du Soldat* and *Pulcinella*.

62 Edelgard Hajek, *Literarischer Jugendstil: vergleichende Studien zur Dichtung und Malerei um 1900*, Bertelsmann Universitätsverlag, Düsseldorf, 1971, p. 93ff., 'Zur Funktion des Vorspiels in Hofmannsthals *Ariadne auf Naxos*'.

63 H. H. Stuckenschmidt, *Arnold Schoenberg*, John Calder, London, 1959, p. 49ff. And see in general Donald Mitchell, *The Language of Modern Music*, Faber, London, 1973, ch. I, 'Schönberg: the principle capable of serving as a rule', p. 13ff., which is rich in observations on the relationship of music and the visual arts in the early twentieth century. See also ch. 5, 'Cross-currents with Expressionism', p. 134ff., which makes interesting comparisons with Kandinsky.

64 Edward Henry Gordon Craig, 'The Russian Ballet' in *The Mask*, vol. 6, no. 1, July 1913, pp. 13–14.

65 John Balance, 'Kleptomania or the Russian Theatre' in *The Mask*, vol. 4, p. 97.

66 Raffaele Carrieri, *Futurism* (translated from the Italian by L. van Rensclaer White), Edizione del Milione, Milan, 1963, p. 49.

67 H. H. Arnason, *Calder*, Van Nostrand, Princeton, 1966, p. 16.

68 'Miró . . . had avidly attended the ballet as a youth in Spain': James Thrall Soby, *Joan Miró*, Museum of Modern Art, New York, 1959. Sonia Delaunay's watercolours of dancers around 1916 have circular skirts formed of the characteristic Delaunay colour-wheel. In 1926 she costumed a dancer in tights of zigzag asymmetrical design: see Michel Hoog, *Robert et Sonia Delaunay*, Editions des Musées Nationaux, Paris, 1967, pp. 158–63.

69 Also see note 7, ch. 1 above.

See Denys Sutton, *The Triumphant Satyr: the world of Auguste Rodin*, Country Life, London, 1966, ch. 7, p. 99ff.; Mario Amaya, 'Rodin's Dancers' in *Dance and Dancers*, vol. 14, March 1963, pp. 24–5; and Cécile Goldscheider, 'Rodin et la Danse' in *Revue annuelle de l'art ancien et moderne*, Art de France, Paris, 1963, p. 322ff.

70 *Enciclopedia dello Spettacolo*, pp. 142–3. (Also entries on other dancers Klee saw.)

71 Klee, *The Thinking Eye*, pp. 389, 397, 407.

72 See Frank Kermode, 'Poet and Dancer before Diaghilev' in *Puzzles and Epiphanies: essays and reviews, 1958–1961*, Routledge and Kegan Paul, London, 1962, and Deidre Priddin, *The Art of the Dance in French Literature*, Black, London, 1952. The background of Art Nouveau dance is to be more fully discussed in ch. 5 below.

73 Hugo von Hofmannsthal, *Gesammelte Werke: Prosa II*, S. Fischer, Frankfurt am Main, 1951, p. 260, 'Die unvergleichliche Tänzerin – Ruth St Denis'. See also Michael Hamburger, 'Art as Second Nature – the figures of the Actor and Dancer in the work of Hugo von Hofmannsthal' in *Romantic Mythologies* (ed. Ian Fletcher), Routledge and Kegan Paul, London, 1967, p. 255ff. Klee's taste for the dance and its philosophy is very similar. For documentation of exotic dance in Europe see Curt Sachs, *World History of the Dance* (translated by Bessie Schönberg), W. W. Norton & Co., New York, 1937, *passim*, and André Levinson, *La Danse d'aujourd'hui*, Paris, 1929, p. 259ff., 'Le Cycle Exotique'. Photographs of Eastern dance appeared frequently in *Kunst und Künstler* between 1900 and 1910.

74 See Sutton, *The Triumphant Satyr*, p. 104.

75 See also the two important articles on the depiction of movement in this period (and the late nineteenth century): Aaron Scharf, 'Painting, photography and the image of movement' in *Burlington Magazine*, May 1962, p. 186ff.; Ernst Gombrich, 'Moment and Movement in Art' in *Journal of the Warburg and Courtauld Institutes*, vol. 27, 1964, p. 293ff. Cf. Paul Schilder's comment in *The Image and Appearance of the Human Body*: on p. 207 he gives a psychological justification for the multiple image.

76 Cf. the interesting speculations of psychologist David D. McClelland in 'The Harlequin Complex' in *The Study of Lives: Essays on Personality in Honor of Henry A. Murray* (ed. Robert W. White), Atherton Press, New York, and Prentice-Hall International, London, 1963, p. 95ff.

77 See Mario Praz, *The Romantic Agony*, Fontana, London, 1962, especially ch. V., 'Byzantium', p. 322ff. Cf. also p. 332: 'It was Wilde who finally fixed the legend of Salomé's horrible passion.' See Hofstätter, *Symbolismus und die Kunst der Jahrhundertwende*, pp. 42, 88.

Contemporary photographs of the serpentine dance in C. W. Ceram (pseud.), *Archaeology of the Cinema*, Thames and Hudson, London, 1965, figs. 210–11.

78 See Hajek, *Literarischer Jugendstil: vergleichende Studien zur Dichtung und Malerei um 1900*, p. 40ff., 'Oscar Wildes Salome'.

79 *The Letters of Oscar Wilde* (ed. Rupert Hart-Davis), Hart-Davis, London, 1962, p. 348.

80 See Jürgen Glaesemer, *Paul Klee: Handzeichnungen I*, p. 254ff., 'Illustrationen zu "Potsdamer Platz oder Die Nächte des neuen Messias"'.

Lothar Lang describes the theme as 'the relationship between the sexes, woman's salvation through sex – vital and mythical', in *Expressionist Book Illustration in Germany*, p. 51.

4 The Bauhaus Stage

1 H. von Wedderkop, *Paul Klee*, Klinkhart und Biermann, Leipzig, 1920 (Junge Kunst, vol. 13), and Leopold Zahn, *Paul Klee: Leben, Werk, Geist*, Gustav Kiepenhauer, Potsdam, 1920.

2 Hans Bloesch, 'Ein moderner Graphiker, Paul Klee' in *Die Alpen*, vol. 6 no. 5, January 1912, p. 264ff.

3 Theodor Däubler's 'Paul Klee', originally published in *Das Kunstblatt* (Weimar), vol. 1, January 1918, and republished in Theodor

Däubler, *Dichtungen und Schriften*, Kösel Verlag, Munich, 1956, pp. 848–52. Klee did a painting of Däubler's poem *Silberne Sichel* in 1918: *The Waning Moon showed me the Face of an Englishman, an infamous Lord*, reproduced in the catalogue of the Paul Klee exhibition, Musée National d'Art Moderne, Paris, 1970, pl. 31.

4 As often remarked, Delaunay's art was decisive for Klee's development as a painter. See Gerd Heinniger, 'Paul Klee und Robert Delaunay' in *Quadrum*, no. 3, 1957, p. 137; Peter Selz, 'The influence of Cubism and Orphism on the "Blaue Reiter"' in *Festschrift Ulrich Middeldorf* (ed. Antje Kossegarten and Peter Tilger), Walter de Gruyter, Berlin, 1968, p. 582ff.; and Herschel B. Chipp, 'Orphism and Colour Theory' in *Art Bulletin*, vol. XL, 1958, p. 55ff.

5 Reproduced in facsimile in Werner Hofmann, *The Inward Vision: Watercolours – Drawings – Writings by Paul Klee*, Thames and Hudson, London, 1958, p. 44.

6 Cf. Robert Rosenblum, *Modern Painting and the Northern Romantic Tradition: Friedrich to Rothko*, Thames and Hudson, London, 1975. He describes, p. 156, 'Klee's ability to re-enchant . . . a Friedrichian motif'.

7 *Stage Landscape* reproduced in Will Grohmann, *Paul Klee*, Lund Humphries, London, 1954, p. 396, and *Hermitage*, ibid., p. 389.

8 See the photograph of the 'Orators' in Hans Richter, *Dada – Art and Anti-Art*, Thames and Hudson, London, 1966, pl. 94.

9 Lothar Schreyer, *Erinnerungen an Sturm und Bauhaus*, Verlag Taschenbücher, Munich, 1966, p. 21:

Manche Masken, wie *Der Tod* in *Kindsterben* waren überlebensgross, die Masken in *Sünde* bis drei Meter hoch, und wurden durch ihre Träger von innen bewegt. Für das Spiel *Kindsterben* gelang es auch, grosse und kleine Farbformfiguren zu bauen, die gleichsam kristallisierte Kraftzentren des Spiels waren – jede dieser Figuren ein ungegenständlich-plastisch-farbiges Kunstwerk. Die Arbeit an den Masken war uns immer eine neue Freude, ein Ausgleich für das überaus schwere Erwecken des Klangsprechens, das eine so hohe Konzentration erforderte wie keine andere künstlerische Arbeit.

See also Schreyer's conversation with Schlemmer, 'Die Kunstfigur', ibid., p. 94ff., in which they agree that the stage should present unknown configurations of the figure of man, and that the mask in particular would contribute: see p. 97. Moholy-Nagy, on the other hand, wanted to get rid of the mask, which he saw as an outmoded relic of primitivism: p. 140.

10 Oskar Schlemmer, 'Aus dem Vortrag "Bühnen-Elemente" gehalten im Kunstgewerbemuseum Zürich, 25 April 1931', quoted in *Oskar Schlemmer und die abstrakte Bühne*, Kunstgewerbemuseum, Zürich, April 1961, p. 29:

Meine Versuche mit Masken haben mich das Eigentümliche gelehrt, dass ein Minimum des Ausdrucks, ja: die Unterdrückung jeglichen Ausdrucks die Maske nicht hindern kann, Ausdruck zu haben, eben jenen faszinierenden, stereotypen, der ihr Wesen ausmacht.

11 Oskar Schlemmer, *The Theatre of the Bauhaus*, Wesleyan University Press, Middletown, Connecticut, 1961, p. 25.

12 See Hans M. Wingler, *The Bauhaus – Weimar, Dessau, Berlin, Chicago*, MIT Press, Cambridge, Mass., 1969, p. 482ff., and Herbert Bayer and Walter and Ise Gropius, *Bauhaus 1919–1928*, Museum of Modern Art, Boston, 1959, p. 84. Also see Schlemmer's engaging account of the festival of February 1929 in *The Letters and Diaries*, Wesleyan University Press, Middletown, Connecticut, 1961, pp. 238–40.

13 Ibid., pp. 227 and 236.

14 Klee's postcard is reproduced in Eberhard W. Kornfeld, *Verzeichnis des graphischen Werkes von Paul Klee*, Kornfeld und Klipstein, Berne, 1963, p. 89.

15 Schlemmer, *Letters and Diaries*, p. 196.

16 Ernst Kris has observed that the child's acquisition of language control comes through punning and language games and develops at an early age as a demonstration of manipulative skill. See *Psychoanalytic Explorations in Art*, International Universities Press, New York, 1965, p. 182, 'The psychology of caricature'.

Rudolf Arnheim, in his study of child art, makes a similar point in relation to the infant's delight in drawing scribbles and shaping them into a correspondence of objects in the everyday world. See *Art and Visual Perception*, University of California Press, Berkeley and Los Angeles, 1974, ch. 4, 'Growth', p. 162.

Klee's interest in his son Felix's speech and drawing is attested in *The Diaries, 1898–1918*, University of California Press, 1964, p. 420ff., 'Felix Calendar'.

17 Ernst Gombrich, 'Freud's Aesthetics' in *Encounter*, January 1966, p. 30ff.

18 Paul Klee, *The Thinking Eye: the Notebooks* (ed. Jürg Spiller), Lund Humphries, London, 1961, p. 155.

19 Lyonel Feininger, in *Erinnerungen an Paul Klee* (ed. Ludwig Grote), Prestel Verlag, Munich, 1966, p. 74:

Aber das Schönste von allem diesen waren doch die Masken und Figuren für das Kasperletheater, das Klee für Felix verfertigt hatte. Unbeschreiblich ausdrucksvoll jede einzelne Gestalt, sogar Porträts naher Freunde treffend in Charakterisierung, voller Humor karikiert, und des Lachens und der Begeisterung war kein Ende, wenn Felix in seiner grotesken Art eine Vorstellung gab. Klee sass dann irgendwo in einer Ecke, rauchte sein Pfeife und lächelte stillvergnügt vor sich hin.

20 Marianne Abfeld-Heymann, in *Erinnerungen an Paul Klee*, p. 66:

Er hatte für seinen Sohn Felix ein grosses Puppentheater gebaut, dunkelblau mit roten Rändern. Die Puppen, geheimnisvolle Wesen aus Gips geformt, in Pastelltönen gehalten, waren teils unheimlich, zart, grotesk und witzig. Ich sehe unter anderem noch vor mir jenes Gespenst aus einer elektrischen Steckdose mit Nussschalen als Augenhöhlen! Eines Abends spielte Klee im Nebenzimmer eine alte Sarabande für Violine allein. Plötzlich verschwand Felix hinter der Bühne und improvisierte einen Tanz des Todes mit der 'Todin'. Unvergesslich war das!

21 Illustrated in Schlemmer, *Theatre of the Bauhaus*, pp. 58 and 59.

22 Willy Rotzler, 'Ziel – das totale Theater' in *Oskar Schlemmer und die abstrakte Bühne*, p. 8ff.

23 See Hans M. Wingler, *Graphic Work of the Bauhaus*, Lund Humphries, London, 1969, pls. 18 and 19.

24 See catalogue *Nell Walden – Sammlung und eigene Werke*, Kunstmuseum, Berne, 1966, p. 34.

25 Schlemmer, *Theatre of the Bauhaus*, p. 26.

26 Schlemmer, *Letters and Diaries*, p. 265.

27 The mechanized man in the mechanized theatre was the special interest of Moholy-Nagy. See his notes for 'The Mechanized Eccentric' in Schlemmer, *Theatre of the Bauhaus*, p. 52ff. Cf. also Jack Burnham, *Beyond Modern Sculpture*, Allen Lane, London, 1968, p. 185, which stresses the mechanical originality of the Bauhaus stage.

For Klee 'mechanized', see Siegfried Giedion, *Mechanization takes Command: a contribution to anonymous history*, Oxford University Press, New York, 1948, pp. 109–13.

28 See Beth Irwin Lewis, *George Grosz: Art and Politics in the Weimar Republic*, University of Wisconsin Press, Madison, 1971, ch. 7, 'Critics and Trials', p. 211ff.

29 Will Grohmann, *Paul Klee*, p. 223. Gert Schiff, in the review 'Paul Klee at the Guggenheim' in *Artforum*, May 1967, p. 49, makes thoughtful description of Klee's space:

Klee develops a new concept of space, more expressive and more mysterious than the various spatial concepts of Cubism and Orphism from which he derived some of its elements. His is a spatial concept which is based on a constant and logically inextricable punning with inside and outside; what seems hollow in one context appears solid in another, and top and bottom seem reversible and at times exchange roles.

Cf. Clement Greenberg's less enamoured account in 'On Paul Klee, 1879–1940' in *Partisan Review*, vol. 8, 1941, p. 224ff.

30 Cf. J. E. Cirlot, *A Dictionary of Symbols*, Routledge and Kegan Paul, London, 1962, p. 297:

[The ladder] is a symbol which is very common in iconography all over the world. It embraces the following essential ideas: ascension, gradation, and communication between different vertical levels.

31 The trestle stage was popular in the new theatre, particularly in the Russian theatre. Cf. Meyerhold productions, variously illustrated in Marc Slonim, *Russian Theatre from the Empire to the Soviet*, World Publishing Co., Cleveland, 1961, and in Lotte Eisner's discussion of the Jessnertreppe in *The Haunted Screen*, Thames and Hudson, London, 1969, p. 119ff.

32 *The Thinking Eye*, p. 197. A similar idea is expressed by Max Beckmann in his 'Letters to a Woman Painter' (1948), translated by Mathilde Q. Beckmann and Perry T. Rathbone, in Peter Selz, *Max Beckmann*, Museum of Modern Art, New York, 1964, p. 134:

We are all tightrope walkers. With them it is the same as with artists, and so with all mankind. As the Chinese philosopher Laotse says, we have 'the desire to achieve balance, and to keep it'.

And cf. Sidney Tarachow, 'Circuses and Clowns' in *Psychoanalysis and the Social Sciences* (ed. Geza Roheim), vol. II, New York, 1951, p. 174:

The circus offers terror, but pleasure in reassurance against the terror. The terror is dramatically conquered for the spectator by the skill and grace and success of the performers. Much emphasis is laid on

the conquering of gravity and problems of equilibrium. . . . Space, falling and equilibrium problems are constantly encountered in the dreams of individuals, in analysis or out: Such anxieties are ubiquitous.

33 Friedrich Nietzsche, *Thus Spoke Zarathustra* (translated by R. J. Hollingdale), Penguin, Harmondsworth, 1961, p. 48.

34 Cf. Moholy-Nagy in Schlemmer, *Theatre of the Bauhaus*, p. 64: 'Today's circus, operetta, vaudeville, the clowns in America and elsewhere (Chaplin, Fratellini), have accomplished great things.'

35 F. T. Marinetti, 'In praise of the variety theatre' in *The Mask*, vol. 6, no. 3, 1913–14, p. 189. Cf. also T. H. Robsjohn-Gibbings, *Mona Lisa's Mustache*, Alfred Knopf, New York, 1948, p. 106:

Taking their cues from the irrational behaviour of circus clowns, which they considered the nearest modern equivalent of the masked and painted magicians of Africa, the futurists rang up the curtain.

and Michael Kirby, *Futurist Performance*, Dutton, New York, 1971, *passim*.

36 Schlemmer, *Theatre of the Bauhaus*, p. 51.

37 For illustration, ibid., p. 66.

38 See Moholy-Nagy, ibid., p. 64.

39 See Tarachow, 'Circuses and Clowns' in *Psychoanalysis and the Social Sciences*, p. 173:

The circus is the degraded pregenital arm of the theater, but it is the theater nevertheless. It is the child's theater, dramatising the child's fantasies, conscious and unconscious, his daydreams, his games, his nightmares, his anxieties. . . . The child is presented not only with victory over space and gravity, magic and illusion, as well as triumphs over ferocious animals . . .

40 Schlemmer, *Theatre of the Bauhaus*, p. 52: '. . . The Dadaist and Futurist Theatre of Surprises, . . . aimed at the elimination of logical-intellectual (literary) aspects.'

41 Hermann Hesse, *Steppenwolf* (first published 1927) (translated from the German by Basil Creighton: revised by Walter Sorell), Penguin, Harmondsworth, 1965, p. 228. See also Ernst Rose, *Faith from the Abyss: Hermann Hesse's Way from Romanticism to Modernity*, Peter Owen, London, 1966, especially pp. 65–6, for comment on Hesse's interest in Klee.

42 As usual, Schlemmer is the best witness to these events: see *Letters and Diaries*, p. 226, and other entries.

43 Cf. Cirlot, *Dictionary of Symbols*, p. 32: 'The bridge is always symbolic of a transition from one state to another – of change or the desire for change.'

44 Wolfgang Kayser has pointed out that the quality of the grotesque in the *commedia dell'arte* is especially strong in the work of Jacques Callot. See *The Grotesque in Art and Literature*, Indiana University Press, Bloomington, 1963, p. 39ff., 'The chimeric world of the *commedia dell'arte*'.
Cf. also Jan Kott, *Shakespeare, our Contemporary*, Methuen, London, 1964, p. 105:

A striking feature of the new theatre is its grotesque quality. Despite appearances to the contrary, this new grotesque has not replaced the old drama and comedy of manners. It deals with problems, conflicts and themes of tragedy, such as: human fate, the meaning of existence, freedom and inevitability, the discrepancy between the absolute and the fragile human order. Grotesque means tragedy re-written in different terms . . .

45 Cf. Robert Knott, 'The Myth of the Androgyne' in *Artforum*, November 1975, p. 38ff.

46 See David McClelland, 'The Harlequin Complex' in *The Study of Lives* (ed. Robert W. White), Atherton Press, New York, and Prentice-Hall International, London, 1963, p. 99, for a discussion of the association of the harlequin and the devil.

47 Felix Klee recalls that Klee was not a great film-lover (although he saw with interest the experimental films of Eggeling and Richter in 1930 and suggested that through these film might become an art), but his taste for the silent comic films was marked: see *Paul Klee, His Life and Work in Documents*, George Braziller, New York, 1962, p. 117. Schlemmer was a Chaplin fan: see *Letters and Diaries*, p. 126: 'Chaplin performs wonders when he equates complete inhumanity with artistic perfection.'

48 Cf. Suzanne K. Langer, *Feeling and Form*, Routledge and Kegan Paul, London, 1953, p. 342.

49 Quoted in Frank O'Hara, *Robert Motherwell*, Museum of Modern Art, New York, 1965, p. 45.

50 Moholy-Nagy, in Schlemmer, *Theatre of the Bauhaus*, p. 49.

51 Klee, *The Thinking Eye*, p. 130.

52 Ibid., p. 128.

53 Cf. D. J. Gifford, 'Iconographical notes towards a definition of the medieval fool' in *Journal of the Warburg and Courtauld Institutes*, vol. 37, 1974, p. 337: 'Dress varies in colour, but in most cases seems to try and underline the lack of symmetry which goes with lack of reason.'

54 Letter to Lily Klee, November 1921, quoted in *The Thinking Eye*, p. 33.

55 Cf. Greenberg, 'On Paul Klee, 1879–1940', p. 229: '. . . Klee was rather complacent about the privateness of his art *qua* privateness and strove to accentuate rather than diminish it in his most characteristic productions. . .'.

5 Towards the Dance of Death

1 Heinrich von Kleist, 'The marionette theatre' in *Five Essays on Paul Klee* (ed. Merle Armitage), Duell Sloan and Pearce, New York, 1950, p. 65.

2 Paul Klee, *The Thinking Eye: the Notebooks* (ed. Jürg Spiller), Lund Humphries, London, 1961, p. 92. Cf. p. 67: 'We are led to the upper ways by yearning to free ourselves from earthly bonds.'

3 Kleist, in *Five Essays on Paul Klee* (ed. Armitage), p. 72ff.

4 Klee, *The Thinking Eye*, pp. 389, 397 and 407.

5 For this central conception of the dance which emanated in particular from Symbolist France, see Frank Kermode, 'Poet and Dancer before Diaghilev' in *Puzzles and Epiphanies*, Routledge and Kegan Paul, London, 1962. Kleist also expected that his puppeteer would identify with his puppet – 'the puppeteer himself must dance': 'The marionette theatre' in *Five Essays on Paul Klee* (ed. Armitage), p. 67. For the German tradition of the dance see Walter Sorell, *The Dancer's Image: Points and Counterpoints*, Columbia University Press, New York, 1971, p. 345ff., 'German Dance and Ambivalence'.

6 Paul Valéry, *Collected Works*, Bollinger, New York: vol. 12, *Degas, Manet, Morisot* (ed. Jackson Mathews, translated by David Paul with an introduction by Douglas Cooper), 1960, and vol. 13, *Aesthetics* (ed. Jackson Mathews, translated by Ralph Mannheim), 1964, particularly p. 197ff., 'The Philosophy of the Dance'.

7 Stéphane Mallarmé, *Oeuvres Complètes*, Librairie Gallimard, Paris, 1945: his observations on the dance are scattered through 'Crayonné au Théâtre', p. 293ff.

8 Cf. Kermode, 'Poet and Dancer before Diaghilev' in *Puzzles and Epiphanies*, p. 12, and Lincoln F. Johnson's discussion of Toulouse-Lautrec's representation of Fuller, 'Time and Motion in Toulouse-Lautrec' in *College Art Journal*, vol. XVI, 1956, p. 13ff. Jacques Lipschitz's Loïe Fuller is illustrated in *Modern Art Yesterday and Tomorrow: an Anthology of Writings on Modern Art from the European Art Magazine 'L'Oeil'* (ed. Georges and Rosamond Bernier), A. Zwemmer, London, 1960, p. 71.

9 Arthur Symons, *Studies in the Seven Arts*, Archibald Constable, London, 1906, p. 387. Cf. also his essay 'The world as ballet', pp. 387–91. Robert Schmutzler writes of the role of metamorphosis in *Art Nouveau*, Thames and Hudson, London, 1964, p. 10:

Metamorphosis, the vital force of self-transformation, plays an essential part in the world of forms, patterns and ideas of Art Nouveau . . . the human figure was subjected to an alienation that created something not human, non-anthropomorphic, a self-impelling ornament which reminds one less of a human being than a jellyfish or a Tiffany glass.

10 Kermode, *The Romantic Image*, Routledge and Kegan Paul, London, 1957, ch. 4, 'The Dancer', p. 49.

11 Rainer Maria Rilke, *Gesammelte Gedichte*, Insel Verlag, Frankfurt am Main, 1962, 'Die Sonetten an Orpheus' IX, p. 496; XVII, p. 519. Cf. Walter A. Strauss, *Descent and Return, the Orphic Theme in Modern Literature*, Harvard University Press, Cambridge, Mass., 1971, ch. 5, 'Rilke: Orpheus and the Double Realm', p. 140ff.

12 Friedrich Nietzsche, *Thus Spoke Zarathustra*, Penguin, Harmondsworth, 1961, p. 130, 'The Dance Song'; p. 241, 'The Second Dance Song'.

13 Guillaume Apollinaire, *The Cubist Painters: Aesthetic Meditations*, Wittenborn Documents of Modern Art, New York, 1949, p. 41.

14 Wassily Kandinsky, *Concerning the Spiritual in Art*, Wittenborn Documents of Modern Art, New York, 1947, p. 71.

15 Wassily Kandinsky and Franz Marc, *The Blaue Reiter Almanac* (ed. Klaus Lankheit), Documents of Twentieth Century Art, Thames and Hudson, London, and Viking, New York, 1974, p. 107.

16 Roger Fry, in *The Nation*, 12 November 1912. See exhibition catalogue *Roger Fry, Vision and Design*, Arts Council of Great Britain, London, 1966.

17 Alfred H. Barr, *Henri Matisse: his art and his public*, Secker and Warburg, London, 1975, p. 135.

18 Klee, *The Thinking Eye*, p. 31.

19 Denys Sutton, *The Triumphant Satyr: the world of Auguste Rodin*, Country Life, London, 1966, p. 101: 'Rodin's sympathy for the modern dancer was revealed when, after seeing Loïe Fuller perform for the first time at the Folies-Bergère, he said she had opened the road for the art of the future.' And see note 69, ch. 3 above.

20 Elisabeth Chase Geissbuhler, *Rodin – Later Drawings, with interpretations by Antoine Bourdelle*, Peter Owen, London, 1964, p. 40.

21 Cf. Kenneth Clark writing of the maenadic dance in Hellenistic art in *The Nude – a Study in Ideal Art*, John Murray, London, 1956, ch. VII, 'Ecstasy', p. 264.

22 Klee, *The Thinking Eye*, p. 60. For the tradition of the tomb curtain see Erwin Panofsky, *Studies in Iconology*, Harper, New York, 1962, p. 185.

23 Cf. Paul Schilder, *The Image and Appearance of the Human Body*, International Universities Press, New York, 1950, p. 298:

What goes on in one part of the body may be transposed into another part of the body. The hole of the female genital organs may appear as a cavity in other parts of the body. . . . The cavities and entrances of the body are freely interchangeable.

24 Cf. Charles S. Kessler's allusion to the vase in his intricate iconographical piece 'Science and Mysticism in Paul Klee's "Around the Fish" ' in *Journal of Aesthetics and Art Criticism*, vol. XVI, September 1957, p. 76ff.

25 Dora and Erwin Panofsky, *Pandora's Box, the changing aspects of a mythical symbol*, Routledge and Kegan Paul, London, 1956, pp. 111–13. The reference to Klee is brief, but it is one of few pertinent comments on the sexual symbolism of his later work.

26 Cf. Henry Krauss, *The Living Theatre of Medieval Art*, Thames and Hudson, London, 1968, ch. III, 'Eve and Mary – conflicting images of medieval woman', p. 41ff.

27 Cf. Deirdre Priddin, *The Art of the Dance in French Literature*, Black, London, 1952, p. 107:

The first period of the Ballets Russes, from 1909 to the outbreak of war, was essentially romantic in nature. Exoticism, colour, emotion, *rêverie*, fairy-tale and legend were the sole themes of the early repertoire.

28 Schilder, *The Image and Appearance of the Human Body*, p. 208.

29 Kermode, 'Poet and Dancer before Diaghilev' in *Puzzles and Epiphanies*, p. 17ff. Clare de Morinni, 'Loïe Fuller, the Fairy of Light' in *Chronicles of the American Dance* (ed. Paul Magriel), Henry Holt, New York, 1948, p. 203, suggests the influence of Fuller on Max Reinhardt (whom we know Klee admired) and beyond:

Max Reinhardt's glass floor for 'The Miracle', and his fingers of light picking out solo actors in mass spectacles at the Grosses Schauspielhaus during the early days of the Weimar Republic, connect Loïe with the post-Wagnerian décor of a Nuremberg Congress, when, transfixed on the grid of searchlights, the new Siegfried howls.

30 The Bauhaus light plays were first performed by Hirschfeld-Mack in the summer of 1922. See Hans M. Wingler, *The Bauhaus*, pp. 370–71, and Basil Gilbert, 'The reflected light compositions of Ludwig Hirschfeld-Mack' in *Form*, no. 2, September 1966, p. 10ff. Schlemmer commented on the aesthetics of creative lighting in 1927 in a lecture delivered to the Friends of the Bauhaus (quoted in Herbert Bayer and Walter and Ise Gropius, *Bauhaus 1919–1928*, Museum of Modern Art, Boston, 1959, p. 162):

. . . if forms in motion provide mysterious and surprising effects through invisible mechanical devices, if space is transformed with the help of changing forms, colors, lights, then all the requirements of spectacle, a noble 'feast for the eyes' will be fulfilled.

For the contribution of the Bauhaus to current trends of kinetic/light art see Willoughby Sharp, 'Luminism and Kineticism' in *Minimal Art, a Critical Anthology* (ed. Gregory Battcock), Dutton, New York, 1968 – 'The Bauhaus Contribution', p. 322.

31 Clement Greenberg, in *Five Essays on Paul Klee* (ed. Armitage), p. 40.

32 'The Yellow Sound: A Stage Composition' in Kandinsky and Marc, *Blaue Reiter Almanac*, p. 207ff.

33 Oskar Schlemmer, *The Letters and Diaries*, Wesleyan University Press, Middletown, Connecticut, 1972, p. 8.

34 Kandinsky and Marc, *Blaue Reiter Almanac*, p. 213: 'From right to left intensely yellow giants (as large as possible) slide forth (as if gliding over the stage) . . . they turn their heads toward each other *very* s. . .lowly.'

35 Schlemmer, *Letters and Diaries*, p. 7.

36 Hans Richter described the Laban ballet school as the Dadaists' 'Celestial headquarters', in *Dada – Art and Anti-Art*, Thames and Hudson, London, 1966, p. 69. Laban's importance as 'the German pioneer of the modern dance movement' is discussed by Katharine Everett Gilbert in 'Mind and Medium in the Modern Dance' in *Journal of Aesthetics and Art Criticism*, vol. I, Fall 1943, p. 106ff. For Mary Wigman's contribution see André Levinson, 'The modern dance in Germany' in *Theatre Arts Monthly*, February 1939, p. 489, and Ernst Scheyer, 'The Shapes of Space: the art of Mary Wigman and Oskar Schlemmer' in *Dance Perspectives*, no. 41, Spring 1970, pp. 7–49.

37 Richter, *Dada – Art and Anti-Art*, p. 223.

38 See S. S. Prawer, 'Dada dances: Hugo Ball's *Tenderenda der Phantast*' in *The Discontinuous Tradition, Studies in German Literature in Honour of Ernst Ludwig Stahl*, Clarendon Press, Oxford, 1971, p. 204ff., and especially p. 223.

39 Oskar Schlemmer, *The Theatre of the Bauhaus*, Wesleyan University Press, Middletown, Connecticut, 1961, p. 22.

40 Jack Burnham, *Beyond Modern Sculpture*, Allen Lane, London, 1968, p. 214.

41 Quoted in catalogue of exhibition *50 Years Bauhaus*, sponsored by the Federal Republic of Germany, Royal Academy of Arts, London, 1968, p. 56. Schlemmer's 'Man' course: *Der Mensch, Unterricht am Bauhaus*, Kupferberg Verlag, Mainz, 1969.

42 For illustrations of this period of Schlemmer's work see Hans Hildebrant, *Oskar Schlemmer*, Prestel Verlag, Munich, 1952, pls. 53–65; Will Grohmann, *Oskar Schlemmers Zeichnungen und Graphik*, Verlag Gerd Hatje, Stuttgart, 1965; and Karin von Maur, *Oskar Schlemmer*, Thames and Hudson, London, 1972.

43 Schlemmer, *Theatre of the Bauhaus*, p. 25.

44 Ibid., p. 22. Cf. also p. 25: 'The psychical impulses determine the dancer's movements which will be organic and emotional.'

45 See Alfred H. Barr, *Picasso, fifty years of his art*, Museum of Modern Art, New York, 1951, pp. 99, 100, 142; and Douglas Cooper, *Picasso: Théâtre*, Editions Cercle d'Art, Paris, 1967, pls. 77ff.

46 Schlemmer, *Letters and Diaries*, p. 41.

47 In conversation, July 1966. Schlemmer referred to the popularity of the dances at the Bauhaus in *Theatre of the Bauhaus*, p. 83:

During the course of our growth it changed from the crude country dancing of our 'youth hostelers' to the full-dress fox trot. . . . Group dancing found its image reflected on the stage and in the dance of the individual.

48 Ibid., pp. 54–5, and *Oskar Schlemmer und die abstrakte Bühne*, Kunstgewerbemuseum, Zürich, April 1961, pl. 91.

49 See Xanti Schawinsky, 'Spectodrama – Play, Life, Illusion, 1924–37' in *Form*, no. 8, September 1968, p. 16ff.

50 See note on the origins of *The Triadic Ballet* in Schlemmer, *Theatre of the Bauhaus*, p. 34:

Originated 1911 in Stuttgart in co-operation with the dance team Albert Burger and Elsa Hotzel and the master craftsman Carl Schlemmer. First performance of parts of the ballet in 1915. First performance of the entire ballet, September 1922, in the Stuttgart Landstheater. Also performed in 1923 during the Bauhaus week at the National Theater, Weimar, and at the annual Exhibition of German Crafts, Dresden.

Wingler considered *The Triadic Ballet* to be Schlemmer's choreographic masterpiece, in his foreword (not translated in English edition) to Schlemmer, *Die Bühne im Bauhaus* (conclusion by Walter Gropius), Mainz, 1965 (facsimile reprint of the 1925 edition).

Some idea of the reputation of Schlemmer's creations outside Germany may be gleaned from a short note in *Archives Internationales de la Danse*, 1933, p. 15:

Da la conception, ses tendances, ses orientations, le but spécial de ses recherches, Le Ballet Triadique doit apporter une note originale dans le mouvement moderne de l'évolution chorégraphique.

In its conception, its tendencies, its orientation and the particular objectives of its research, *The Triadic Ballet* contributes a note of originality to the modern movement in the evolution of choreography.

A less sympathetic, more recent assessment was made by Giulio Carlo Argan in his essay 'Oskar Schlemmer ed il teatro' in *Salvezza e*

Caduta nell'arte moderna: Studi e note II, Il Saggiatore, Milan, 1964, p. 164ff. Argan suggests that the mechanical organ of Hindemith's music was an appropriately hollow sound for a hollow spectacle, and compares Schlemmer with Brecht, to Schlemmer's disadvantage.

51 Schlemmer, *Theatre of the Bauhaus*, p. 29.

52 Will Grohmann, 'Kokoschka, Hindemith, Schlemmer' in *Der Cicerone*, vol. XIX, 1927, p. 90ff.

53 Kermode, 'Poet and Dancer before Diaghilev' in *Puzzles and Epiphanies*, p. 26:

Valéry's collection of ballet photographs ... of a special sort, *chronophotographies*; the plates were exposed in darkness, the dancers carrying lights, and the result was a whirl of white lines, a record of the pattern of aimless poetic acts.

54 See the diagram of the gesture dance in Schlemmer, *Theatre of the Bauhaus*, p. 86, and cf. a drawing by Nijinsky illustrated in Paul Magriel, *Nijinsky, an illustrated monograph*, Black, London, 1948, p. 68.

55 See Christopher Green, *Léger and the Avant-Garde*, Yale University Press, New Haven and London, 1976, ch. 5, 'Man and the machine. Léger's synthetic styles, 1917–19', p. 136ff.; and Standish D. Lawder, 'Fernand Léger and Ballet Mécanique' in *Image*, October 1965, p. 13ff.

56 Schlemmer, *Theatre of the Bauhaus*, p. 40. Eberhard Roters discusses this favourite word of Schlemmer's in *Painters of the Bauhaus*, A. Zwemmer, London, 1969, pp. 72–3, 'Oskar Schlemmer'. Schlemmer often used the words 'metaphysics' and 'metaphysical'. An entry in his diary of November 1922 says: 'There remains the metaphysical – in other words, Art'; and, speaking of dance, he mentioned 'the metaphysics which dwell within the human body' and 'exact metaphysics'.

57 See Rose-Carol Washton Long, 'Kandinsky and abstraction: the role of the hidden image' in *Artforum*, June 1972, p. 42ff., and 'Kandinsky's abstract style: the veiling of apocalyptic folk imagery' in *Art Journal*, Spring 1975, p. 217ff.

58 Wassily Kandinsky, *Essays über Kunst und Künstler* (edited and with notes by Max Bill), Verlag Gerd Hatje, Stuttgart, 1955, p. 75, 'Tanzkurven' and p. 69, 'Über die Bühnensynthese'.

59 See Scheyer, in *Dance Perspectives*, p. 29ff.

60 Wingler, *The Bauhaus*, p. 52.

61 *Erinnerungen an Paul Klee* (ed. Ludwig Grote), Prestel Verlag, Munich, 1966, p. 8:

Zum Bauhaus gehörte auch die Palucca, die den modernen Tanz aus seiner expressionistischen Phase in den Bereich des Geistes und der Abstraktion führte, so dass er schwerelos und immateriell wurde. In Kandinsky und Klee kann sie mit Recht die Väter ihrer grossen Kunst sehen. Den Studierenden führte sie nicht nur ihre Tänze, sondern auch ihre Übungen vor, die Einblick gewährten in den Gestaltungsprozess ihrer tänzerischen Schöpfungen.

62 Ibid., p. 51:

Gret Palucca, für mich eine der musikalischsten und abstraktesten Tänzerinnen, versäumte nie, bei ihren Tanzabenden in Bern Klees aufzusuchen. Ich erinnere mich, wie erschüttert Paul Klee war, als wir sie eine Arie von Gluck tanzen sahen. 'Das ist das Hinübergleiten, das Schon-wo-anders-Sein, der wunderbare Tod', sagte er.

63 The Mussorgsky sets illustrated in Kandinsky, *Essays über Kunst und Künstler*, p. 110, and *50 Years Bauhaus*, Royal Academy, figs. 152–6.

64 The Kandinsky paintings discussed below were exhibited at the Galérie Maeght, Paris, November 1965. See catalogue *Derrière le Miroir – Kandinsky – Bauhaus de Dessau, 1927–33*, with an essay (in French) by Werner Haftmann.

65 Klee, *The Thinking Eye*, p. 407.

66 In relation to *Height!*, consider some of the comments of Donald G. Macrae, 'The Body and Social Metaphor' in *The Body, a Medium of Expression* (ed. Jonathan Benthall and Ted Polhemus), Dutton, New York, 1975, p. 63:

The human body is basically bilaterally symmetrical. This external symmetry is imperfect, but dominant. Our conceptions of relations in space come not only from our binocular vision but above all from our experience of a fixed eye-level above a fixed ground ...

67 Roger Shattuck, *The Banquet Years*, Faber, London, 1959, p. 98.

68 George Boas, *The Cult of Childhood*, Studies of the Warburg Institute, London, 1966, p. 96.

69 Klee, *The Thinking Eye*, p. 191.

70 Cf. H. F. Rookmaaker, *Synthetist Art Theories*, Suete and Zeitlinger, Amsterdam, 1959, p. 165, and William Innes Homer, *Seurat and the*

Science of Painting, MIT Press, Cambridge, Mass., 1964, p. 181ff.

71 Klee himself made the pressures quite explicit in a Curriculum Vitae he wrote in 1933: *The Diaries, 1898–1918,* University of California Press, 1964, p. xx:

The political turmoil in Germany affected the fine arts too, constricting not only my freedom to teach but the free exercise of my creative talent. Since I had by then achieved an international reputation as a painter, I felt confident enough to give up my post and make my livelihood by my own creative work.

Cf. also the introduction by Donald Hall to the exhibition catalogue *Paul Klee – The Last Years,* an exhibition from the collection of his son, Arts Council of Great Britain, London, 1974, pp. 3–5.

72 C. M. Kaufmann, 'An allegory of propaganda by Paul Klee' in *Victoria and Albert Museum Bulletin,* vol. II no. 2, April 1966, pp. 71 and 74.

73 John Willet, *Expressionism,* Weidenfeld and Nicolson, London, 1970, ch. 8, '1933 to 1945', p. 196ff., and John Elderfield, 'Total and totalitarian art' in *Studio International,* April 1970, p. 149ff.

74 See Walter Ueberwasser, 'Klee's "Engel" und "Inseln" ' in *Festschrift Kurt Bauch: Kunstgeschichtliche Beiträge zum 25. November 1957* (ed. Berthold Hackelsberger, Georg Himmelheber, Michael Meier), Deutscher Kunstverlag, Munich, 1957, p. 256ff.

75 Hugo von Hofmannsthal, *Aufzeichnungen,* quoted by Margret Dietrich, 'Music and Dance in the productions of Max Reinhardt' in *Total Theatre, a Critical Anthology* (ed. E. T. Kirby), Dutton, New York, 1969, p. 164.

76 Schlemmer, *Letters and Diaries,* p. 382.

Selected Bibliography

AMAYA, Mario, 'Rodin's Dancers' in *Dance and Dancers*, vol. 14, March 1963, pp. 24–5.

APPIGNANESI, Lisa, *The Cabaret*, Studio Vista, London, 1975.

ARMITAGE, Merle, and others, *Five Essays on Paul Klee*, Duell Sloan and Pearce, New York, 1950.

ARTS COUNCIL of Great Britain, *Paul Klee: The Last Years*, an exhibition from the collection of his son, Edinburgh, London, Bristol, 1974.

BADEN-BADEN, Staatliche Kunsthalle, 1964, *Der Frühe Klee*.

—— 1965, *Bild und Bühne: Bühnenbilder der Gegenwart und Retrospektive, Bühnenelemente von Oskar Schlemmer*.

BAIRD, Bil, *The Art of the Puppet*, Macmillan, New York, 1965.

BALANCE, John, 'Kleptomania or the Russian Theatre' in *The Mask*, vol. 4, 1911, p. 97.

BALL, Hugo, *The Flight out of Time*, Documents of Twentieth Century Art, Viking, New York, 1974.

—— 'Das Münchener Künstlertheater (eine prinzipielle Beleuchtung)' in *Phöbus*, vol. 2, 1914, p. 68.

BARR, Alfred H., *Paul Klee*, Museum of Modern Art, New York, 1930.

BASEL, Galerie Beyler, May–June 1963, *Klee-Ausstellung*.

—— 1965, *Klee – the Later Work*.

BASEL, Kunsthalle, June–August 1967, *Paul Klee, Gesamtausstellung*.

BAYER, Herbert, and Walter and Ise Gropius, *Bauhaus 1919–1928*, Museum of Modern Art, Boston, 1959.

BAYNES, B. Helton Godwin, *Mythology of the Soul: a research into the unconscious from schizophrenic dreams and drawings*, Methuen, London, 1949.

BERGSON, Henri, *Laughter, an essay on the meaning of the comic* (authoritative translation by C. Brereton and F. Rothwell), Macmillan, London, 1911.

BERNE, Kunstmuseum, May–August 1966, *Aus der Sammlung Felix Klee*.

—— 1966, *Nell Walden – Sammlung und eigene Werke*.

BLOESCH, Hans, 'Ein moderner Grafiker, Paul Klee' in *Die Alpen*, vol. 6 no. 5, January 1912, p. 264ff.

BLUNT, Anthony, and Phoebe Pool, *Picasso – The Formative Years: a study of his sources*, Studio, London, 1962.

BOAS, George, *The Cult of Childhood*, Studies of the Warburg Institute, London, 1966.

von BOEHN, Max, *Dolls and Puppets* (first published Munich, 1929) (translated by Josephine Nicoll with a note on puppets by G. B. Shaw), Cooper Square Publishers, New York, 1966.

BURNHAM, Jack, *Beyond Modern Sculpture*, Allen Lane, London, 1968.

CHIPP, Herschel B., 'Orphism and Colour Theory' in *Art Bulletin*, vol. XL, 1958, p. 55ff.

COMINI, Alessandra, 'Vampires, Virgins and Voyeurism in Imperial Vienna' in *Woman as Sex Object: Studies in Erotic Art, 1730–1970* (ed. Thomas B. Bess and Linda Nochlin), Newsweek, New York, 1972, p. 207ff.

COOPER, Douglas, *Picasso: Théâtre*, Editions Cercle d'Art, Paris, 1967.

CRAIG, Edward Henry Gordon, 'The Russian Ballet' in *The Mask*, vol. 6 no. 1, July 1913, pp. 13–14.

—— *On the Art of the Theatre* (first published 1911), Mercury, London, 1962.

DÜSSELDORF, Kunstsammlung Nordrhein-Westfalen, Schloss Jägerhof, May 1964, *Paul Klee*.

GEELHAAR, Christian, 'Bande dessinée: Voltaire scénariste, Klee illustrateur de Candide' in *L'Oeil*, April 1975, p. 22ff.

—— *Paul Klee and the Bauhaus*, Adams and Dart, Bath, 1973.

GIEDION-WELCKER, Carola, *Paul Klee*, Faber, London, 1952.

GLAESEMER, Jürgen, *Paul Klee: Handzeichnungen I*, Kunstmuseum, Berne, 1973.

GOLDSCHNEIDER, Cécile, 'Rodin et la Danse' in *Revue annuelle de l'art ancien et moderne*, Art de France, Paris, 1963, p. 322ff.

GOLDWATER, Robert, *Primitivism in Modern Painting*, revised ed., Vintage Books, New York, 1966.

GREENBERG, Clement, 'On Paul Klee, 1879–1940' in *Partisan Review*, vol. 8, 1941, p. 224ff.

GROHMANN, WILL, 'Kokoschka, Hindemith, Schlemmer' in *Der Cicerone*, vol. XIX, 1927, p. 90ff.

—— *Paul Klee*, Lund Humphries, London, 1954.

—— *Wassily Kandinsky*, Thames and Hudson, London, 1959.

—— 'Kandinsky and Klee discover the East' in *XXe Siècle*, vol. 17, 1961, p. 49ff.

—— *Paul Klee, Drawings*, Thames and Hudson, London, 1960.

—— *Oskar Schlemmers Zeichnungen und Graphik*, Verlag Gerd Hatje, Stuttgart, 1965.

GROTE, Ludwig (ed.), *Erinnerungen an Paul Klee*, Prestel Verlag, Munich, 1966.

HADERMANN, Paul, 'Expressionist literature and painting' in *Expressionism as an International Literary Phenomenon: twenty-one essays and a bibliography* (ed. Ulrich Weisstein), Budapest and Paris, 1973, p. 111ff.

HAFTMANN, Werner, *The Mind and Work of Paul Klee*, Faber, London, 1954.

—— 'Über das Humanistische bei Paul Klee' in *Prisma*, vol. 17, 1948, p. 33.

HAMBURGER, Michael, 'Art as second Nature – the figures of the Actor and Dancer in the work of Hugo von Hofmannsthal' in *Romantic Mythologies* (ed. Ian Fletcher), Routledge and Kegan Paul, London, 1967.

HAUSENSTEIN, Wilhelm, *Barbaren und Klassiker: ein Buch von der Bildnerei exotischer Völker*, Piper, Munich, 1923.

—— *Kairuan, oder die Geschichte vom Maler Klee und von der Kunst dieses Zeitalters*, Kurt Wolff, Munich, 1921.

HEINNIGER, Gerd, 'Paul Klee und Robert Delaunay' in *Quadrum*, no. 3, 1957, p. 137.

HILDEBRANDT, Hans, *Oskar Schlemmer*, Prestel Verlag, Munich, 1952.

HOFMANN, Werner, *The Inward Vision: Watercolours – Drawings – Writings by Paul Klee*, Thames and Hudson, London, 1958.

HOFSTÄTTER, Hans H., 'Symbolismus und Jugendstil im Frühwerk von Paul Klee' in *Kunst in Hessen und am Mittelrhein*, vol. 4, 1964, p. 97ff.

—— *Symbolismus und die Kunst der Jahrhundertwende*, Du Mont, Cologne, 1965.

HUGGLER, Max, *The Drawings of Paul Klee*, Borden, New York, 1965.

—— 'Die Kunsttheorie von Paul Klee' in *Festschrift Hans R. Hahnloser zum 60. Geburtstag* (ed. E. J. Beer, P. Hofer and L. Mojon), Birkhäuser, Basel/Stuttgart, 1961, p. 425ff.

KANDINSKY, Wassily, and Franz Marc (eds.), *Der Blaue Reiter* (first published 1912) (new documentary edition by Klaus Lankheit), Munich, 1965.

—— *The Blaue Reiter Almanac* (ed. Klaus Lankheit), Documents of Twentieth Century Art, Thames and Hudson, London, and Viking, New York, 1974.

KANDINSKY, Wassily, *Concerning the Spiritual in Art*, Wittenborn Documents of Modern Art, New York, 1947.

—— *Essays über Kunst und Künstler* (edited and with notes by Max Bill), Verlag Gerd Hatje, Stuttgart, 1955.

KAUFMANN, C. M., 'An allegory of propaganda by Paul Klee' in *Victoria and Albert Museum Bulletin*, vol. II no. 2, April 1966, pp. 71 and 74.

KAYSER, Wolfgang, *The Grotesque in Art and Literature*, Indiana University Press, Bloomington, 1963.

KERMODE, Frank, *Modern Essays*, Fontana, London, 1971.

—— *The Romantic Image*, Routledge and Kegan Paul, London, 1957.

—— *Puzzles and Epiphanies: essays and reviews, 1958–1961*, Routledge and Kegan Paul, London, 1962.

KESSLER, Charles S., 'Science and Mysticism in Paul Klee's "Around the Fish" ' in *Journal of Aesthetics and Art Criticism*, vol. XIV, September 1957, p. 76ff.

KIRBY, E. T., *Total Theatre, A Critical Anthology*, Dutton, New York, 1969.

KLEE, Felix, *Paul Klee, His Life and Work in Documents*, George Braziller, New York, 1962.

KLEE, Paul, *Das bildnerische Denken*, Benno Schwabe, Basel, 1956.

—— *The Diaries, 1898–1918* (edited and with an introduction by Felix Klee), University of California Press, 1964.

—— *Gedichte* (ed. Felix Klee), Die Arche Verlag, Zürich, 1960.

—— *Notebooks* vol. 2, *The Nature of Nature* (ed. Jürg Spiller), Lund Humphries, London, 1973.

—— *Pedagogical Sketchbook* (introduction and translation by Sybil Moholy-Nagy), Faber, London, 1953.

—— *Sturm Bilderbuch III*, Der Sturm, Berlin, 1918.

—— *Tagebücher 1898–1918* (edited and with an introduction by Felix Klee), Du Mont, Cologne, 1957.

—— *The Thinking Eye: the Notebooks of Paul Klee* (ed. Jürg Spiller), Lund Humphries, London, 1961.

KORNFELD, Eberhard W., *Paul Klee: Bern und Umgebung, Aquarell und Zeichnung, 1898–1915*, Stampfli et Cie, Berne, 1962.

—— *Verzeichnis des graphischen Werkes von Paul Klee*, Kornfeld und Klipstein, Berne, 1963.

LEHMANN, A. G., 'Pierrot and *fin de siècle*' in *Romantic Mythologies* (ed. Ian Fletcher), Routledge and Kegan Paul, London, 1967.

MICHEL, Wilhelm, *Das Teuflische und Groteske in der Kunst*, Piper, Munich, 1911.

NEW YORK, Museum of Modern Art, 1949, *Paintings, Drawings and Prints from the Paul Klee Foundation, Berne, with additions from American Collections*, 1949.

NICOLL, Allardyce, *Masks, Mimes and Miracles*, Harrap, London, 1931.

—— *The world of Harlequin: a critical study of the Commedia dell'Arte*, Cambridge University Press, Cambridge, 1963.

PARIS, Berggruen et Cie, *Paul Klee – les années 20*, 1971.

—— Galérie Maeght, November 1965, *Derrière le Miroir – Kandinsky – Bauhaus de Dessau, 1927–33*, with an essay (in French) by Werner Haftmann.

PRAWER, S. S., 'Dada dances: Hugo Ball's *Tenderenda der Phantast*' in *The Discontinuous Tradition, Studies in German Literature in Honour of Ernst Ludwig Stahl*, Clarendon Press, Oxford, 1971, p. 204ff.

REFF, Theodore, 'Harlequins, Saltimbanques, Clowns and Fools' in *Artforum*, October 1971, p. 31ff.

SAN LAZZARO, G. di, *Paul Klee*, Thames and Hudson, London, 1957.

SCHAPIRO, Maurice L., 'Klee's Twittering Machine' in *Art Bulletin*, vol. 50, March 1968, p. 67ff.

SCHEYER, Ernst, 'The Shapes of Space: the art of Mary Wigman and Oskar Schlemmer' in *Dance Perspectives*, no. 41, Spring 1970, p. 7ff.

SCHILDER, Paul, *The Image and Appearance of the Human Body*, International Universities

Press, New York, 1950.

SCHLEMMER, Oskar, *Briefe und Tagebücher* (ed. Tut Schlemmer), A. Langen, Munich, 1958.

—— *The Letters and Diaries of Oskar Schlemmer* (ed. Tut Schlemmer, translated and with an introduction by Krishna Winston), Wesleyan University Press, Middletown, Connecticut, 1972.

SCHLEMMER, Oskar, Laszlo Moholy-Nagy and Farkas Molnar, *Die Bühne im Bauhaus* (conclusion by Walter Gropius), Kupferberg Verlag, Mainz, 1965 (facsimile reprint of the 1925 edition).

—— *The Theatre of the Bauhaus* (edited and with an introduction by W. Gropius, translated by A. S. Weisinger), Wesleyan University Press, Middletown, Connecticut, 1961.

SCHREYER, Lothar, *Erinnerungen an Sturm und Bauhaus*, Verlag Taschenbücher, Munich, 1966.

SELZ, Peter, 'The aesthetic theories of Wassily Kandinsky and their relationship to the origin of non-objective painting' in *Art Bulletin*, vol. 39, June 1957, p. 127ff.

SMITH PIERCE, James, *Paul Klee and Primitive Art,* Outstanding Dissertations in the Fine Arts, Garland, New York and London, 1976.

SOBY, James Thrall, *The Prints of Paul Klee*, C. Valentin, New York, 1945.

VENICE, la Biennale, XXIV Festivale internationale del Teatro di Prosa, 1965, *Mostra di Studi teatrali di Oskar Schlemmer.*

VISUAL ARTS BOARD of the Australian Council of the Arts and Pro Helvetia, Zürich, 1974, *Paul Klee.*

WINGLER, Hans M., *The Bauhaus – Weimar, Dessau, Berlin, Chicago,* MIT Press, Cambridge, Mass., 1969.

ZÜRICH, Kunstgewerbemuseum, April 1961, *Oskar Schlemmer und die abstrakte Bühne.*

List of Illustrations

Dimensions are given in centimetres and inches, height before width

Monochrome illustrations

1 *Comedian (Der Komiker)*, 1903
Etching
11.8 × 16.1 (4 ¾ × 6 ⅛)
Kupferstichkabinett, Kunstmuseum, Basle

2 *Comedian II (Der Komiker II)*, 1904
Etching
12.7 × 13.65 (5 × 5 ⅜)
Paul Klee-Stiftung, Kunstmuseum, Berne

3 *Perseus (Wit has Triumphed over Misfortune) (Perseus (Der Witz hat über das Leid gesiegt))*, 1904
Etching
10.9 × 12.5 (4 ¼ × 5)
Paul Klee-Stiftung, Kunstmuseum, Berne

4 *Threatening Head (Drohender Kopf)*, 1905
Etching
19.2 × 13.8 (7 ½ × 5 ⅜)
Paul Klee-Stiftung, Kunstmuseum, Berne

5 *Charm (Womanly Grace) (Charme (Weibliche Anmut))*, 1904
Etching
11 × 8.5 (4 ⅜ × 3 ⅜)
Paul Klee-Stiftung, Kunstmuseum, Berne

6 *Virgin in a Tree (Jungfrau im Baum)*, 1903
Etching
23.6 × 29.6 (9 ¼ × 11 ⅝)
Paul Klee-Stiftung, Kunstmuseum, Berne

7 *Woman and Animal (Weib und Tier)*, 1904
Etching
19.4 × 22.4 (7 ⅝ × 8 ⅞)
Paul Klee-Stiftung, Kunstmuseum, Berne

8 *Two Men Meeting, Each Presuming the Other to be of Higher Rank (Zwei Männer, einander in höherer Stellung vermutend, begegnen sich)*, 1903
Etching
11.6 × 22.4 (4 ½ × 8 ⅞)
Paul Klee-Stiftung, Kunstmuseum, Berne

9 *The Aged Phoenix (Greiser Phönix)*, 1905
Etching
27 × 19.7 (10 ⅝ × 7 ¾)
Paul Klee-Stiftung, Kunstmuseum, Berne

10 *The Hero with One Wing (Der Held mit dem Flügel)*, 1905
Etching
25.2 × 16 (9 ⅞ × 6 ¼)
Paul Klee-Stiftung, Kunstmuseum, Berne

11 *Concerning the Fate of Two Girls (Schicksal zweier Mädchen)*, 1921
Pen and ink
21.8 × 28.6 (8 ⅝ × 11 ¼)
Collection Sprengel, Hanover

12 *End of the Last Act of a Drama (Schluss des letzten Aktes eines Dramas)*, 1920
Watercolour on transfer drawing
20.6 × 28.8 (8 ⅛ × 11 ⅜)
Collection The Museum of Modern Art, New York, Gift of Allan Roos, M.D. and B. Mathieu Roos

13 *The Realm of the Curtain (Reich des Vorhanges)*, 1925
Pen and ink
30.5 × 26.5 (12 ⅛ × 10 ⅜)
Paul Klee-Stiftung, Kunstmuseum, Berne

14 *Form in Light, Experiment in Colour, Very Blurred (Lichtform, farbiger Versuch, Kopf en face, sehr verschwommen)*, 1910
Watercolour on blotting paper
11 × 15 (4 ⅛ × 6)
Collection fk, Berne

15 *Soothsayers Conversing (Auguren im Gespräch)*, 1906
Chalk, pen and ink
21.3 × 17.1 (8 ¼ × 6 ¾)
Paul Klee-Stiftung, Kunstmuseum, Berne

16 Six sketchbook sheets with children playing out of doors *(Skizzenblätter nach Kindern im Freien)*, 1908
Pen and ink
Top to bottom, left to right: c. 3 × c. 4 (1 ⅛ × 1 ½); c. 8.2 × 12.3 (3 ¼ × 4 ¾); 8 × 9.5 (3 ⅛ × 3 ¾); 4.5 × 8.2 (1 ¾ × 3 ¼ ; 4 × 4.2 (1 ½ × 1 ⅝); 9.1 × 10 (3 ½ × 4)
Paul Klee-Stiftung, Kunstmuseum, Berne

17 *Two Spinsters, Nude with Crests (Zwei Tanten, Akte mit Hauben)*, 1908
Pen and ink
12–14 × 12 (4 ¾–5 × 4 ¾)
Collection Sprengel, Hanover

18 *Artist Meditating (Abwägender Künstler)*, 1919
Traced drawing
20 × 16.5 (7 ⅞ × 6 ½)
Collection fk, Berne

19 *Lost in Thought – Self-Portrait – Portrait of an Expressionist (Versunkenheit – Selbstportrait – Bildnis eines Expressionisten)*, 1919
Etching
30.5 × 20.3 (12 × 8)
Paul Klee-Stiftung, Kunstmuseum, Berne

20 KATSUSHIKA HOKUSAI (1760–1849)
The Lantern Spectre from the series *A Hundred Tales*
Colour woodcut print
24.1 × 18.4 (9 ½ × 7 ¼)
By courtesy of the Trustees of the British Museum

21 *Masculine Head, Gypsy Type (Männlicher Kopf, Zigeunertypus)*, 1906
Pencil with the drawing pricked through with a needle
5.7 × 6.1 (2 ¼ × 2 ⅜)
Paul Klee-Stiftung, Kunstmuseum, Berne

22 *Mask of an Angry Woman (Maske einer Zornigen)*, 1912
Pencil
17.5 × 15.7 (7 × 6)
Paul Klee-Stiftung, Kunstmuseum, Berne

23 *Bunraku wrestler puppet*
Victoria and Albert Museum, London

24 *Pangloss-type Mask (Panglossartige Maske)*, 1912
Pen and watercolour
10.5 × 8.2 (4 ⅛ × 3 ¼)
Collection fk, Berne

25 *Cry of Fright (Schreckruf)*, 1913
Pen and wash
5.9 × 12.4 (2 ⅜ × 4 ⅞)
Paul Klee-Stiftung, Kunstmuseum, Berne

26 *Construction with Three Heads
(Konstruktion mit drei Köpfen)*, 1913
Pen and wash
11.5 × 8 (4 ½ × 3 ⅛)
Paul Klee-Stiftung, Kunstmuseum, Berne

27 *Light Would Kill Her (La lumière la tue)*,
illustration for *Candide*, 1911
Pen and wash
11.7 × 23.3 (4 ⅝ × 9 ⅛)
Paul Klee-Stiftung, Kunstmuseum, Berne

28 *Harlequinade (Harlekinade)*, 1912
Pen and ink
5.9 × 13.6 (2 ⅜ × 5 ⅜)
Paul Klee-Stiftung, Kunstmuseum, Berne

29 *Human Weakness (Menschliche
Ohnmacht)*, 1913
Pen and ink
17.6 × 9.8 (6 ⅞ × 3 ¾)
Paul Klee-Stiftung, Kunstmuseum, Berne

30 *St George (St Georg)*, 1912
Lithograph with pen and chalk
5.2 × 15.6 (2 × 6)
Kupferstichkabinett, Kunstmuseum, Basle

31 *The Higher Spirit in Mourning over the
Lower (Der höhere Geist in Trauer über dem
Tieferen)*, 1912
Lithograph
16.2 × 15.5 (6 ⅜ × 6)
Collection fk, Berne

32 *The Last Stage of Don Juan's Infatuation
(Don Juan, Letzte Stufe der Verliebtheit)*, 1913
Pen and wash
9.9 × 24.3 (4 × 9 ½)
Paul Klee-Stiftung, Kunstmuseum, Berne

33 *Collapsing Flight (Zusammenbrechende
Flucht)*, 1923
Lithograph
22.5 × 30.3 (8 ⅞ × 12)
Paul Klee-Stiftung, Kunstmuseum, Berne

34 *Temptation of a Policeman (Versuchung
eines Polizisten)*, 1913
Pen and wash
8.8 × 12 (3 ½ × 4 ¾)
Paul Klee-Stiftung, Kunstmuseum, Berne

35 SOPHIA TÄUBER-ARP
Marionettes for *Le Roi Cerf*, 1918
Kunstgewerbemuseum, Zürich

36 *Acrobats (Akrobaten)*, 1914
Ink drawing from *Der Sturm*

37 *Acrobats and Jugglers (Akrobaten und
Jongleurs)*, 1916
Ink drawing from *Der Sturm*

38 *Miserable Circus (Jämmerlicher Circus)*,
1917

Pencil
19.3 × 13.9 (7 ⅝ × 5 ½)
Paul Klee-Stiftung, Kunstmuseum, Berne

39 AUGUSTE RODIN
Nijinsky, 1912
Bronze
Musée Rodin, Paris
Photo B. Jarret

40 *Nude Sketch, with Raised Right Leg
(Aktskizze, mit erhobenem rechtem Bein)*,
1912
Pencil
23.3 × 15.1 (9 ⅛ × 6)
Paul Klee-Stiftung, Kunstmuseum, Berne

41 *Dancing Exercise (Tänzerische Übung)*,
1928
Pen and ink
45.4 × 27.4 (17 ⅜ × 10 ¾)
Private Collection

42 *Nude (Akt)*, 1905
Pencil and wash
9.5 × 8.5 (3 ¾ × 3 ⅜)
Paul Klee-Stiftung, Kunstmuseum, Berne

43 *Nude, Dancing Venus (Akt, tanzende
Venus)*, 1907
Pencil
13 × 7.6 (5 ⅛ × 3)
Paul Klee-Stiftung, Kunstmuseum, Berne

44 *Drawing for Salome (Zeichnung zur
Salome)*, 1920
Pen and ink
20.8 × 19.5 (8 ⅛ × 7 ¼)
Galerie Rosengart, Lucerne

45 FRANZ VON STUCK
Salome, 1906
117 × 93 (46 × 36 ½)
Städtische Galerie im Lenbachhaus, Munich

46 *Dance of the Veils (Schleiertanz)*, 1920
Watercolour drawing
18.5 × 27.5 (7 ⅜ × 10 ⅞)
Galerie Stangl, Munich

47 *Oh, you are so strong! (Du Starker, o – oh
oh du!)*, 1919
Pen and ink
32.6 × 24.3 (12 ¾ × 9 ½)
Paul Klee-Stiftung, Kunstmuseum, Berne

48 *Nature Theatre (Naturtheater)*, 1914
Tempera
23.5 × 30 (9 ⅛ × 11 ⅞)

49 OSKAR SCHLEMMER
Drawings of variations on a mask for a
Bauhaus class in stage theory, 1925
From *Die Bühne im Bauhaus*

50 *Small Contribution to Physiognomy
(Kleiner Beitrag zur Physiognomik)*, 1925
Pen and ink
11 × 8.4 (4 ⅜ × 3 ⅜)
Paul Klee-Stiftung, Kunstmuseum, Berne

51 *Flower Face (Blütenantlitz)*, 1922
Watercolour
35 × 22 (13 ⅜ × 8 ¾)
Collection Edgar Kaufmann Jr, New York

52 *Child with Toy (Kind mit Spielzeug)*, 1908
Pen and ink
14.2 × 10 (5 ⅝ × 4)
Private Collection

53 *Child (Kind)*, 1918
Pen and ink
22.5 × 10.4 (9 × 4)
Paul Klee-Stiftung, Kunstmuseum, Berne

54 *Senecio*, 1922
Oil on linen
40.5 × 38 (16 × 15)
Kunstmuseum, Basle

55 *Clown*, 1929
Oil with chalk
68.1 × 39.8 (26 ¾ × 15 ⅝)
Private Collection

56 Puppet theatre with devil and Kaspar
puppets, 1922
Collection fk, Berne

57 KURT SCHMIDT
The tailor, tailor's wife and hunchback
puppets for *The Adventures of the Little
Hunchback*, 1923
From *Die Bühne im Bauhaus*

58 LOTHAR SCHREYER
Design for a figure for the stage production
Der Mensch, 1921

59 *Performing Puppet (Schauspielende
Marionette)*, 1923
Pen and ink
17.8 × 8.2 (7 × 3 ¼)
Paul Klee-Stiftung, Kunstmuseum, Berne

60 *Costumed Puppets (Kostümierte Puppen)*,
1922
Pen and ink
24.1 × 17.1 (9 ½ × 6 ¾)
The Solomon R. Guggenheim Museum, New
York
Photo Robert E. Mates

61 *The Singer L. as Fiordiligi (Die Sängerin L.
als Fiordiligi)*, 1923
Oil and watercolour on chalk-coated ground
49.8 × 33 (19 ⅝ × 13)
Collection Norman Granz

62 *Dr Bartolo*, 1921
Pen and violet ink
18.6 × 28.2 (7 3/8 × 11 1/8)
Paul Klee-Stiftung, Kunstmuseum, Berne

63 *Perspective with Inhabitants
 (Zimmerperspective mit Einwohnern)*, 1921
Watercolour and oil drawing
48.4 × 31.5 (19 × 12 1/2)
Paul Klee-Stiftung, Kunstmuseum, Berne

64 *The Equilibrist above the Swamp (Die
 Equilibristin über dem Sumpf)*, 1921
Pen and ink
29.5 × 18 (11 5/8 × 7)
Kunstsammlung Nordrhein-Westfalen,
Düsseldorf

65 The Bauhaus stage production
 Equilibristics
From *Die Bühne im Bauhaus*

66 Andreas Weininger as a musical clown in
 a Bauhaus production
From *Die Bühne im Bauhaus*

67 *Mr Jules, the Art Magician (Mr Jules, der
 Zauberkünstler)*, 1920
Pen and ink
Photo by courtesy of Berggruen & Cie, Paris

68 *Doll Theatre (Puppentheater)*, 1923
Watercolour on chalk
51.9 × 37.4 (20 1/2 × 14 1/2)
Paul Klee-Stiftung, Kunstmuseum, Berne

69 *Theatre of Animals (Theater der Tiere)*,
 1921
Pencil
22.4 × 28.3 (8 7/8 × 11)
Paul Klee-Stiftung, Kunstmuseum, Berne

70 *Carnival Music (Jahrmarktmusik)*, 1924
Watercolour
26.5 × 30.5 (10 3/8 × 12)
Private Collection

71 *Harlequin on the Bridge (Harlequin auf der
 Brücke)*, 1923
Crayon
Photo by courtesy of Berggruen & Cie, Paris

72 *Captive Pierrot (Gefangener Pierrot)*, 1923
Watercolour
34.8 × 27.2 (13 7/8 × 10 7/8)
Bequest of Robert H. Tannahill, Courtesy of
 The Detroit Institute of Arts

73 *The End of the Marionette (Das Ende der
 Marionette)*, 1927
Watercolour
32.5 × 45.5 (12 7/8 × 18)
Photo by courtesy of Berggruen & Cie, Paris

74 *Allegorical Figurine (Allegorische Figurine)*,
 1927

Oil on panel
47 × 43 (18 1/2 × 16 7/8)
Private Collection

75 *Three Gentle Words from a Fool (Drei
 sanfte Narrenworte)*, 1924
Pen and ink
27.4 × 22 (10 3/4 × 8 1/4)
Private Collection

76 HENRI DE TOULOUSE-LAUTREC
Loïe Fuller, 1892
Lithograph
43 × 27 (16 7/8 × 10 5/8)

77 *Spiral Blooms (Spiralblüten)*, 1926
Watercolour and pen
41.3 × 31.1 (16 1/4 × 12 1/4)
Private Collection

78 *Botanical Theatre (Botanisches Theater)*,
 1924/34
49.9 × 67 (19 5/8 × 26 3/8)
Private Collection, Switzerland

79 *Pandora's Box (Die Büchse der Pandora)*,
 1920
Pen and ink
27.8 × 18.6 (11 × 7 1/4)
Collection fk, Berne

80 *Messenger of the Air Spirit (Botschaft des
 Luftgeistes)*, 1920
Watercolour
Private Collection

81 *Dance of the Night Moth (Zum
 Nachtfaltertanz)*, 1922
Drawing
Private Collection

82 *Storm Spirit (Sturmgeist)*, 1925
Pen and ink
22.7 × 28.6 (9 × 11 1/4)
Paul Klee-Stiftung, Kunstmuseum, Berne

83 OSKAR SCHLEMMER
*Female Dancer (or Gesture) (Tänzerin (Die
 Geste))*, 1923
Oil and tempera on canvas
199 × 130 (78 3/8 × 51 1/4)
Staatsgalerie moderner Kunst, Munich

84 *The Runner (Der Läufer)*, 1920
Watercolour
21.5 × 30.3 (8 1/2 × 11 7/8)
Photo by courtesy of Marlborough Fine Art
 Ltd

85 KURT SCHMIDT, K. W. BOGLER, GEORGE TELTSCHER
Design for *Mechanical Ballet*, 1923
Tempera
33 × 48.5 (13 × 19)
Private Collection

86 OSKAR SCHLEMMER
Diagram of *Gesture Dance*

87 *Rays and Rotation (Strahlung und
 Rotation)*, 1924
Oil on paper
35.5 × 51.5 (14 × 20 1/4)
Photo by courtesy of Marlborough Fine Art
 Ltd

88 *Fragment from a Ballet to Aeolian Harp
 (Ausschnitt aus einem Ballett zur Aeolsharfe)*,
 1922
Watercolour
23.5 × 20.3 (9 1/4 × 8)
Collection Angela Rosengart, Lucerne

89 *Young Lady's Adventure (Abenteuer eines
 Fräuleins)*, 1922
Watercolour
43.8 × 31.8 (17 1/4 × 12 5/8)
Tate Gallery, London

90 WASSILY KANDINSKY
Sketches of the dancer Palucca
From *Das Kunstblatt*, 1926

91 WASSILY KANDINSKY
*To the Right, To the Left (Vers la droite, vers la
 gauche)*, 1932
Oil on canvas
60 × 70 (23 5/8 × 27 1/2)
By courtesy of Galerie Maeght, Paris

92 *Dance of the Grieving Child (Tanz des
 trauernden Kindes)*, 1921
Pen and ink
19.3 × 22 (7 5/8 × 8 5/8)
Paul Klee-Stiftung, Kunstmuseum, Berne

93 *Height! (Höhe!)*, 1928
Etching
22.8 × 23 (9 × 9)
Paul Klee-Stiftung, Kunstmuseum, Berne

94 *Outbreak of Fear (Angstausbruch)*, 1939
Pen and ink
27.1 × 21.5 (10 3/4 × 8 1/2)
Paul Klee-Stiftung, Kunstmuseum, Berne

95 *Dancing from Fear (Tänze vor Angst)*,
 1938
Black watercolour
48 × 31.4 (18 7/8 × 12 1/2)
Paul Klee-Stiftung, Kunstmuseum, Berne

96 *With Green Stockings (Mit grünen
 Strümpfen)*, 1939
Watercolour on blotting paper
34.9 × 20.6 (13 3/4 × 8)
Collection fk, Berne

97 *Mask of Fear*, 1932
Oil on burlap
Reproduced by permission of the Estate of
 Beatrice Mathieu Roos

Index

Italic numerals refer to black and white illustrations, Roman numerals to colour plates